A catalogue record for this book is available from the British
Library.

First Edition 2013
Published in Great Britain by Carpet Bombing Culture.
An imprint of Pro-actif Communications
www.carpetbombingculture.co.uk
email: books@carpetbombingculture.co.uk
© Carpet Bombing Culture. Pro-actif Communications

Noel Kerns 2013
The right of Noel Kerns to be identified as the author of this
work has been asserted by him in accordance with the Copyright,
Designs and Patents Act 1988.

WWW.CARPETBOMBINGCULTURE.CO.UK

ISBN: 978-1908211026

Photo, page 264: "Noel at Work" by Robert Feuille (Rob Fuel).

NIGHTWATCH
PAINTING WITH LIGHT

NOEL KERNS

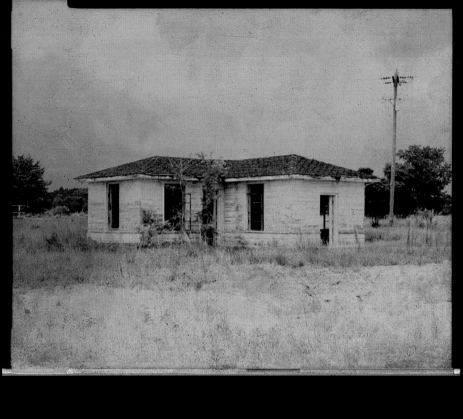

IF I COULD SAY IT IN WORDS,
WOULDN'T NEED TO PHOTOGRAPH

The quote is from legendary early 20th-century documentary photographer Lewis Hine, whose extraordinary work truly conveyed so much more than could be expressed with mere words on a page. I find myself leaning on his words from time to time in interviews and lectures when people ask the inevitable questions, "Why do you photograph these old places? What are you trying to say with your photographs?"

My fascination with abandoned places began at an early age, with an old house in a field near where I grew up in Austin, Texas. As a boy, I rode my bike through that field, often wondering about the tiny house set off in the weeds, away from the trails. It had clearly been abandoned for many years, but I never actually approached the old place. I suppose I was afraid of what I might find there... or what might find me.

Finally, when I was 13 or so, I gathered the nerve one day to wander over and investigate the old house. Leaving my bike at the trail, I made my tentative way through tall grass toward the ominous spectre of my youthful imaginings. I remember the whisper of dry weeds in the sweltering Texas summer heat, and the mounting anticipation of what would be the first of many abandonments to come. It was my first "urban exploration," long before the term existed

Of course, I had no camera with me, but what I found is still imprinted on my memory.

Inside the little house were all the belongings of the family that had inhabited and, for some reason abandoned the house. A faded sofa, a baby crib, dusty family photos... all the things people pack up and take with them when they leave. Except they didn't.

Even as a kid, I realized there was something odd about that. Why would they leave all their stuff behind? What befell this little family? Why did they walk out of their house one day and never come back? It was a mystery that captivated my imagination and instilled in me a lifelong fascination with abandoned places and the stories they have to tell.

Photography came into my life at almost exactly the same time as my discovery of abandonments. one day out of the blue, my father decided to give me his old Argus C3 Rangefinder Camera, and showed me how to use it. Serendipity struck once again when it turned out that one of my junior high teachers was offering black-and-white darkroom classes after school. I immersed myself in photography, experimenting with every subject imaginable, most of which were not artistically appealing to anyone but me. But these sophomoric efforts at photographic art planted in me

a passion for the medium. By learning the back-end darkroom processes as well, I gained an end-to-end understanding of photography that still serves me well, even though I haven't set foot in a darkroom in over twenty years.

Recognizing my love affair with photography as a good thing, my father surprised me one day with an entire starter darkroom kit: a small Vivitar enlarger, print trays, chemistry, paper, and a plastic single-reel Yankee film tank, complete with wildly inaccurate plastic thermometer.

I was in heaven. I could now shoot to my heart's content, and I could do all the processing myself in my very own darkroom. Well... actually, it was my father's bathroom.

As my fascination grew, I began to read every photography book I could get my hands on. I learned something of the history of photography and, in doing so, began to unconsciously shape my "style" based on what I was absorbing from the work of artists like Henri Cartier-Bresson, Edward Weston, and Minor White.

Ansel Adams' early technical book series, particularly "The Negative" and "The Print", cemented in me many of the principles by which I operate today, even in the digital realm. Perhaps most important, they engrained in me an attention to process and detail that, as a teenager in the 1970s, I did not naturally possess.

By this time, I had convinced my dad that I needed an SLR camera, but on a retired Army officer's income, big-name cameras were out of reach. So my sainted father bought me a relatively inexpensive Vivitar SLR with a thread-mount 50mm lens ... and I was ecstatic and thankful to get it.

Once in high school, I signed on as a photographer with the yearbook staff and began shooting their nice Canon AE-1 cameras, covering pep rallies, football games, and all those other events you shoot to ensure that we remember high school in perpetuity. A side benefit for me was that I had an entire arsenal of quality cameras and lenses at my disposal, plus all the film I could bulk-load. The trusty old Vivitar was effectively retired. I have no idea whatever became of it.

Nice as it was to have access to such good equipment, the greatest benefit of shooting for the Lanier High School yearbook in the late '70s was the teacher, Mr. George Edwards. He was a passionate and highly-skilled photographer who inspired us all. I'm forever indebted to him for the artistic possibilities he exposed me to, and for putting such master photographers as Ansel Adams and Joel Meyerowitz on my radar.

By 1979, I was working as a salesman at a local camera store, and I started amassing 35mm Nikon gear at an alarming rate. As a teenager living at home, with a completely disposable income (I was a very good salesman) ... well, let's just say a lot of photography gear got purchased.

That was also the year that changed everything for me — the year when two of the most influential large-format photography books of all time came out: "Yosemite and the Range of Light" by Ansel Adams, and "Cape Light" by Joel Meyerowitz.

Though the images in both books were shot with 8x10 view cameras, the subject matter was entirely different. I fell in love with both types of images, and these two books heavily influenced my sense of composition and style. These legendary photographers had set a standard for technical excellence in their work that was unmatched by any of their contemporaries or predecessors, and I immediately became obsessed with pursuing the same level of technical mastery in my photography that Adams and Meyerowitz had achieved in theirs.

Of course, I now had to have a view camera. But as I graduated high school in 1980 and moved out into the world on my own, the disposable income of yesterday became the rent, gas, and grocery money of today. It would be four years before I would have the funds to purchase all the tools I needed, including a 4x5 Omega view camera and a Beseler 45MCRX enlarger, both used. The big money went toward two brand-new Schneider lenses.

I shot that 4x5 for the rest of the decade, but in 1990, my day job forced me to move away from the scenic Texas hill country to the city of Dallas, some 200 miles to the north. Unlike Austin, with its rolling hills and countless landscape possibilities, Dallas is slightly flatter than your average pool table. Where Austin is quaint, quirky, and lazy, Dallas is huge and impersonal, a giant metropolis stuck in high gear.

A year later, my career as an IT professional was in full swing. With nothing in the Dallas area to inspire me photographically, I sold my entire large-format camera system and my darkroom equipment, getting out of photography altogether around 1992.

Fast-forward to 2007. I had been officially out of photography for fifteen years and hadn't picked up a camera for anything more challenging than family vacations in that time – but I was aware that digital SLR technology had been steadily advancing, and I felt it had reached a point where the images being produced rivaled what film equipment could render. With that in mind, I decided to purchase a Nikon D80 to document a San Francisco vacation I was planning for that August.

A couple weeks before I was to fly out to California, I began researching scenic locations in and around the bay area to photograph. With my new DSLR on the way, what had been intended as a simple vacation was quickly turning into a dedicated photographic excursion.

During my research, I happened upon a number of nocturnal images of abandoned locations around the bay area. They were the work of several local photographers, including Scott Haefner, Joe Reifer, Basim Jaber, Mike Hows, Bob Azzaro, and most notably,

Troy Paiva – the man generally regarded as the pioneer of the night photography / light-painting / urban exploration genre.

The images captured subjects in a way that was simultaneously compelling and forbidding. The techniques and compositional styles varied substantially from one photographer to the next, but a surreal, post-apocalyptic mood seemed to pervade all their work.

Inspired by these techniques and the artistic possibilities they offered, and with less than a week before I was to depart for San Francisco, I assembled the additional equipment I would need to experiment with creating light-painted images. After a brief night of testing these new tools and techniques, I was on my way to San Francisco.

I had relatively little experience with night photography, and virtually none with light-painting – but my lifetime of photographic experience provided a foundation that enabled me to "reverse engineer" a lot of the process for creating light-painted images. Coupled with the ability to immediately evaluate the results on the digital camera's LCD, this allowed me to modify the settings for each shot as needed to produce the desired results.

In many ways, the photos I took in San Francisco had exceeded my own expectations. I wanted to share them with friends and family, as well as with the photographers whose work had inspired me to experiment with this style in the first place. I had already established contact with many of them and discovered that the photo-sharing site "Flickr" seemed to be the way most of them were showing their work. I joined the site as well and began posting my photos for all to see.

I had no delusions about most of those very early images – the vast majority were rather mediocre. A few more showed potential, though they lacked technical refinement. But a handful were actually quality exposures, with the unique, dramatic style I had set out to achieve.

Unsure how these images would be received by the Flickr community, I was delighted by the very positive initial response, even from people I didn't know. Likewise, I was heartened by encouraging comments from the night photography community, with which I was starting to become connected.

That was all the motivation I needed to commit myself to the pursuit of this photographic style. I focused my attention on tracking down abandoned locations here in my home state of Texas. Soon, I was closely monitoring lunar phases and timing my excursions to coincide with the full moon, which would provide the perfect supplement to my growing array of lighting equipment.

Five years and thousands of photographs later, the collection of images in this book represents what I feel is the best of my work to date. From the Motor City to the Mojave, I've tried to capture the abandoned American night in a way that conveys something of my own experience as an explorer of these desolate, haunting places.

Setting up my tripod under a full moon in the shadow of an old schoolhouse, miles from any other trace of man... climbing through the ruins of a long-abandoned factory or ghost town... the kind of photography I do is generally a solitary pursuit, and at times carries a considerable degree of risk. But as far from civilization as my work often takes me, I find the longer and more compelling journey is through time.

I hope you enjoy viewing these photographs as much as I've enjoyed making them, and are moved by the mysterious resonance of these forgotten places. -NK

THE ROAD LESS TRAVELLED

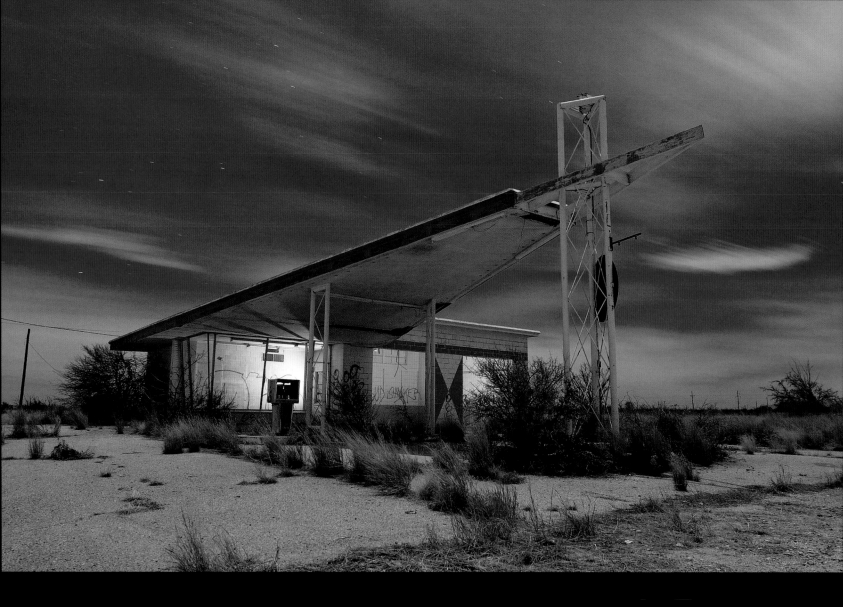

RETRO ROCKET FUEL
ABANDONED GAS STATION
WHITES CITY, NEW MEXICO . JAN 08

When I first visited this long-abandoned Phillips 66 station on the outskirts of Whites City, New Mexico, it was as fine a vintage gas station as I'd ever seen. Still in near-perfect condition structurally, it needed only a coat of paint, glass for the windows, and some new gas pumps to be put back into service.

Sadly, though, when I next visited the site in April 2009, demolition was underway. The proudly soaring canopy had been ripped from the building to make room for a new, wider highway. I shot what remained, and shortly thereafter, the rest of the structure was demolished as well, leaving no trace of this masterpiece of 1950s "Googie" architecture.

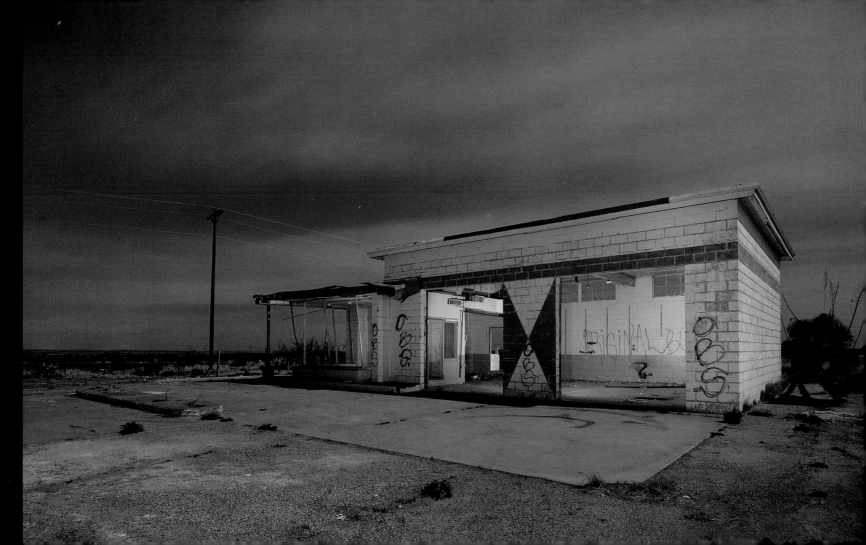

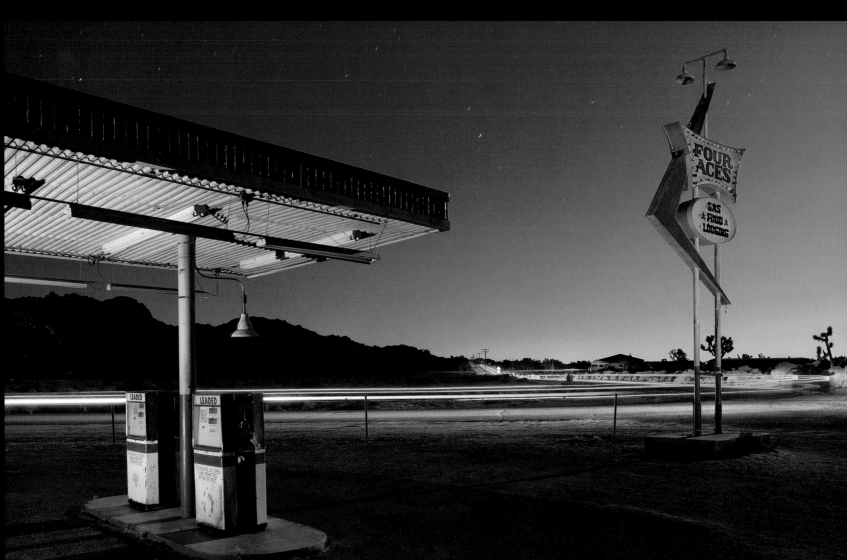

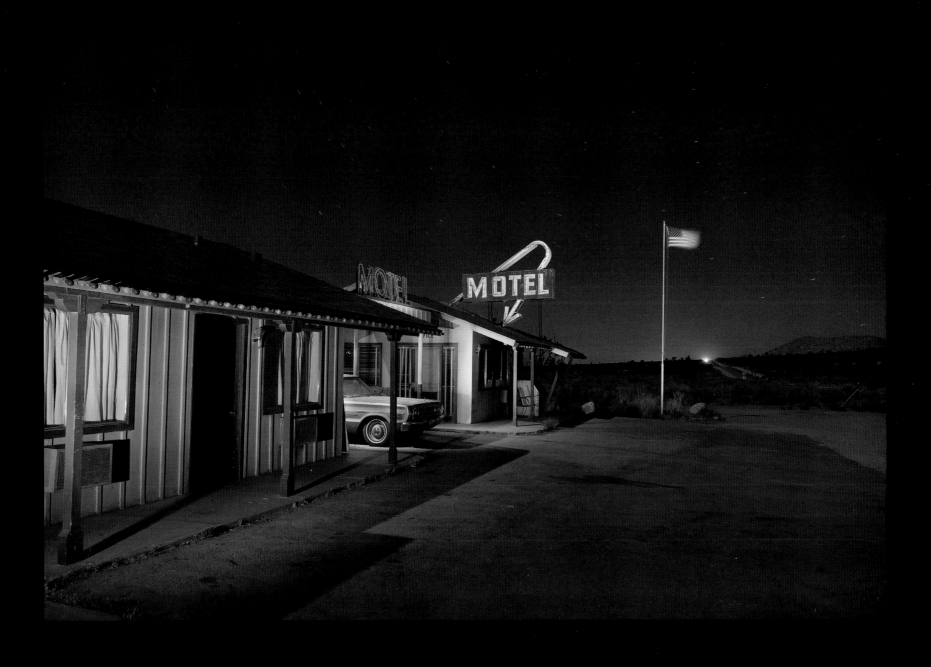

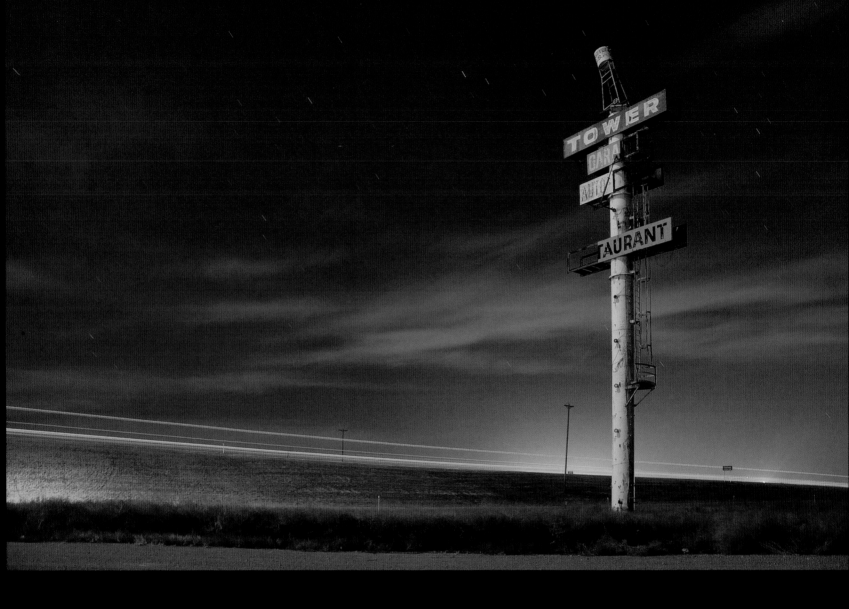

The writing on the side on the water tower says "Britten USA," even though it's located along the Route 66 / I-40 corridor in Groom, Texas.

So why is this structure located in Groom as opposed to Britten? Because rather than being the name of a town, "Britten" is in fact the last name of the man who was responsible for creating this roadside

water tower never actually stood straight; it was built intentionally crooked, in the hope of inducing travelers to exit the highway and visit the nearby "Britten USA" Truck Stop.

The truck stop is long gone now, but the highway sign (left) and water tower still stand (or lean) as reminders of happier times.

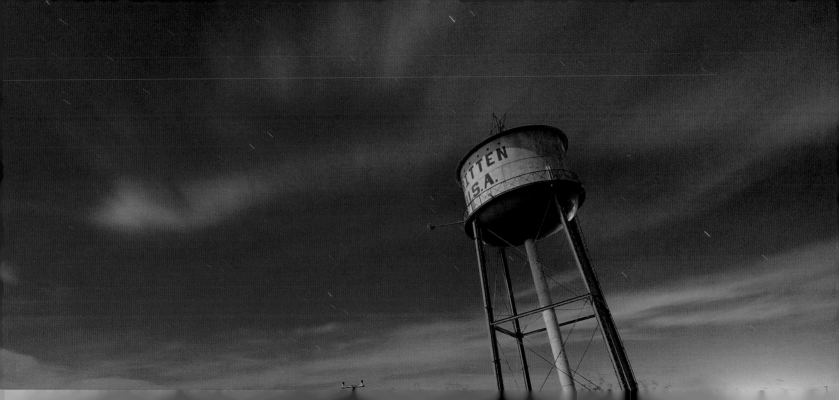

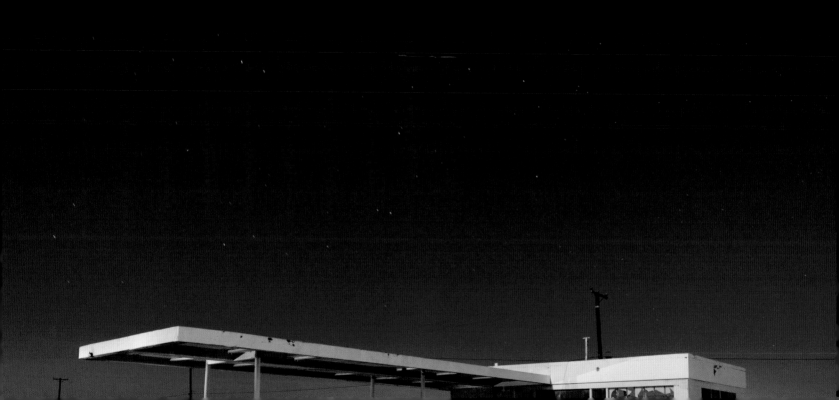

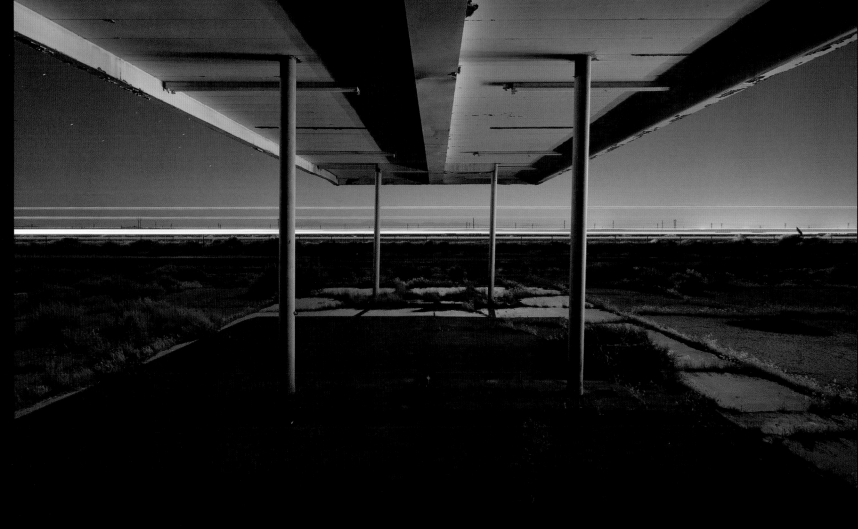

CA-58 . ABANDONED GAS STATION . NORTH EDWARDS, CALIFORNIA . JUN 11

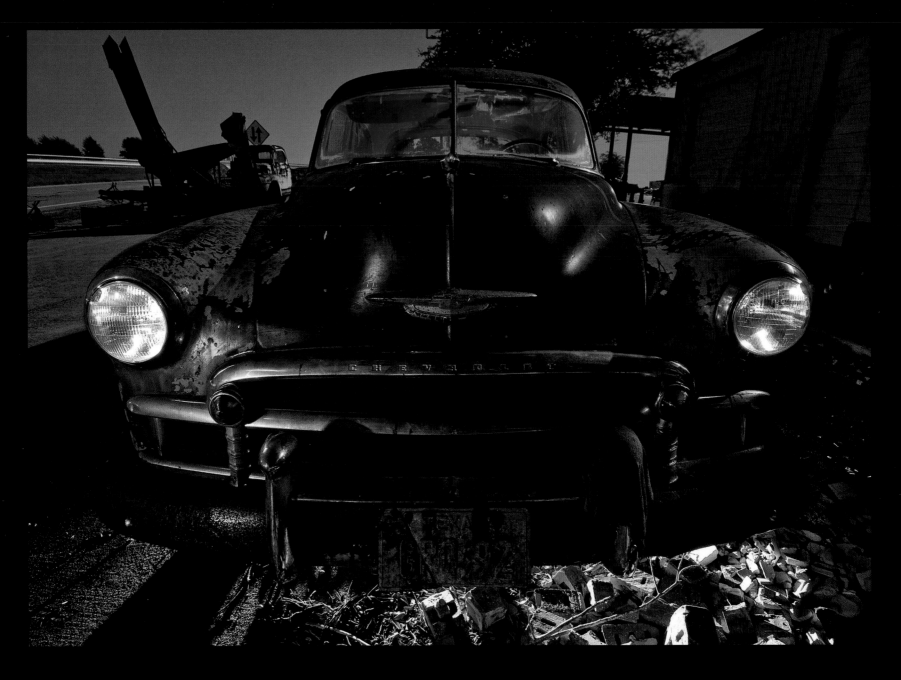

GPQ92
ABANDONED CAR
INTERSTATE 20, EAST TEXAS . AUG 09

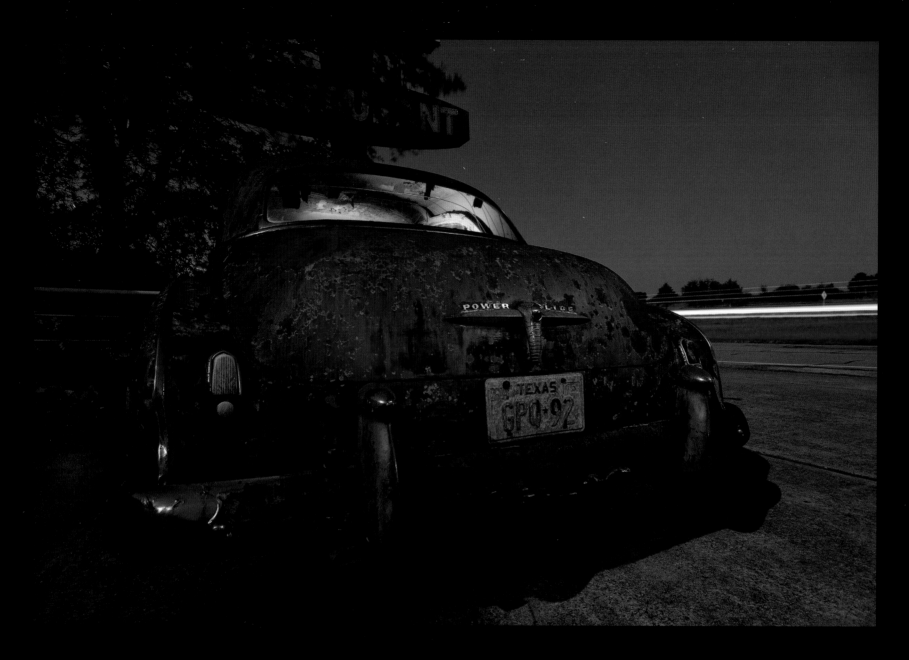

POWER GLIDE
ABANDONED CAR
INTERSTATE 20, EAST TEXAS . AUG 09

Abandoned automobiles litter the world around us, parked along highways and byways, in front yards and junkyards... sometimes left to rust quietly in a field in the middle of nowhere. Most of them don't merit much attention, but occasionally, you find a beauty like this 1950 Chevy Power Glide Deluxe.

I found this one in a junkyard along I-20 in east Texas, loaded with character not only from the classic styling of the 1940s and '50s, but also from decades of rust and neglect. I had to stop and make a couple images of it.

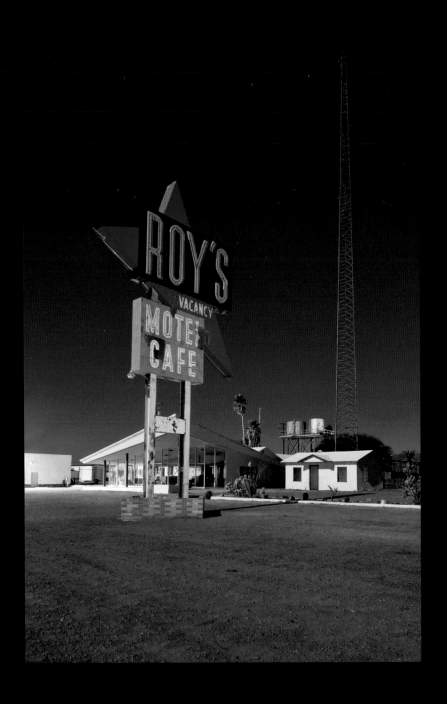

ROY'S
ABANDONED MOTEL
AMBOY, CALIFORNIA . JUN 11

Perhaps the most iconic and isolated of all Route 66 roadside spots, Roy's Motel & Cafe still stands in the tiny ghost town of Amboy. The gas station and cafe reopened on a limited basis in 2008, but the motel and cottages remain empty.

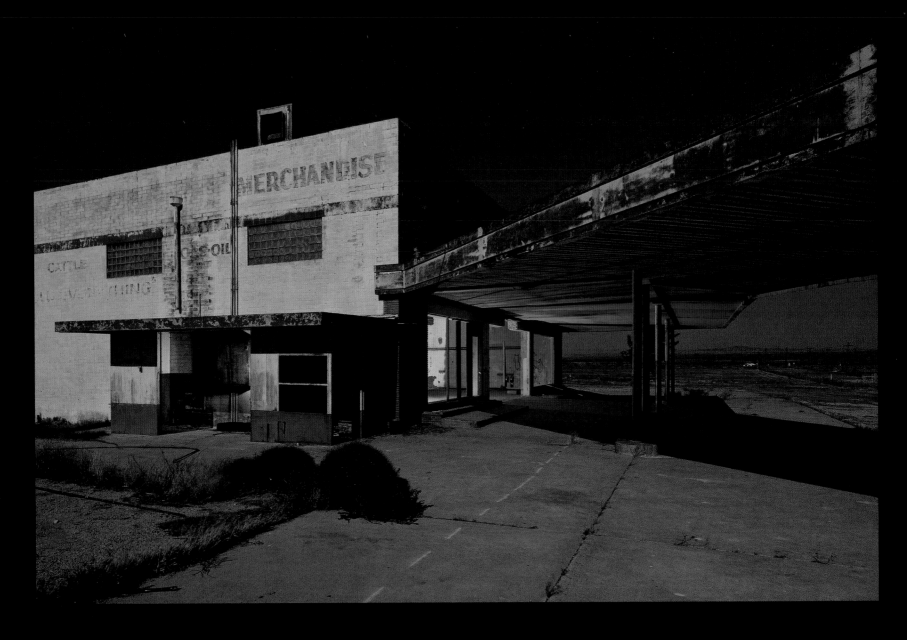

LOCKHART BLUES
ABANDONED STORE
LOCKHART, CALIFORNIA . JUN 11

The enormous Lockhart General Store sits gutted and abandoned in the virtual ghost town of Lockhart, California. Two stories high, with the roof missing and a basketball goal installed on the side wall, it looks more like a gymnasium or an inner-city playground inside than a retail store.

By 2012, progress had paid a visit to Lockhart and the old general store was completely demolished to make way for a new solar power plant.

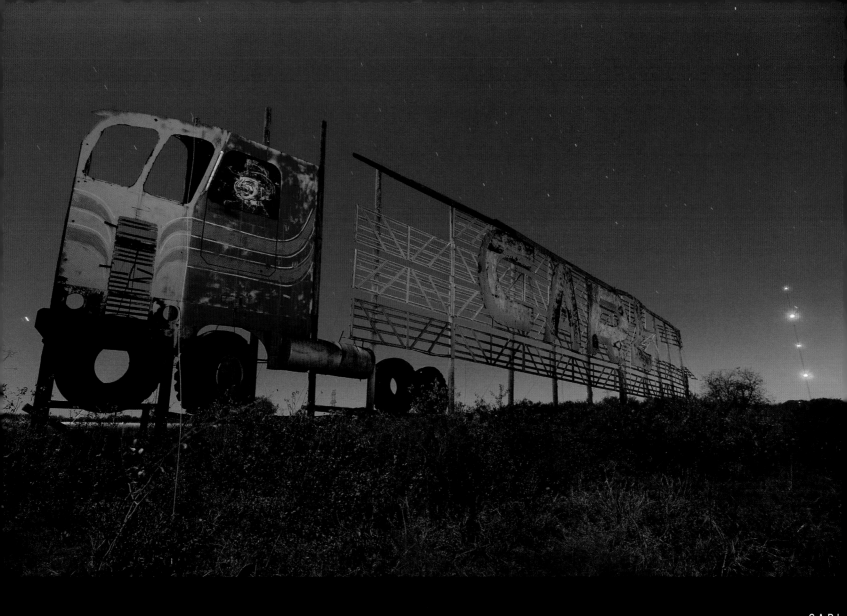

CARL
OLD HIGHWAY SIGN
CARL'S CORNER, TEXAS . NOV 09

Carl's Corner is a small town on Interstate 35 in central Texas, founded by a fella named Carl Cornelius, who used to run a truck stop there. Incorporated in the 1980s, the town boasted 134 residents as of 2000.

Just down the road is this huge sign made of plywood, truck tires, and as many ranch fence gates as they could find. Carl's truck stop became Willie's Place in 2008, its centerpiece a honky-tonk bar owned by

legendary Texas music icon Willie Nelson. Willie's Place lasted only three years, and the property is shut down at this writing - but the old homemade billboard still points to Carl's Corner.

Over the years, I've seen this great old sign every time I've made the drive between Austin and Dallas. It's rather like an old friend, so I wanted to make a photograph of it before it slips away.

PCH . HIGHWAY 1 . SANTA MONICA, CALIFORNIA . JUN 11

MULHOLLAND . HOLLYWOOD HILLS . LOS ANGELES, CALIFORNIA . JUN 11

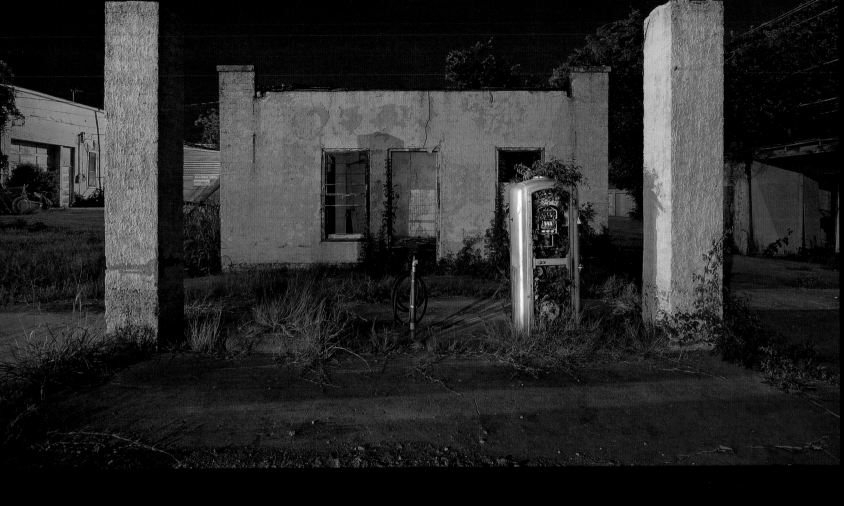

BIO-FUEL
VINTAGE GAS PUMP
PILOT POINT, TEXAS . JUL 08

Just off the square in downtown Pilot Point, Texas,
nature is reclaiming an old gas pump.

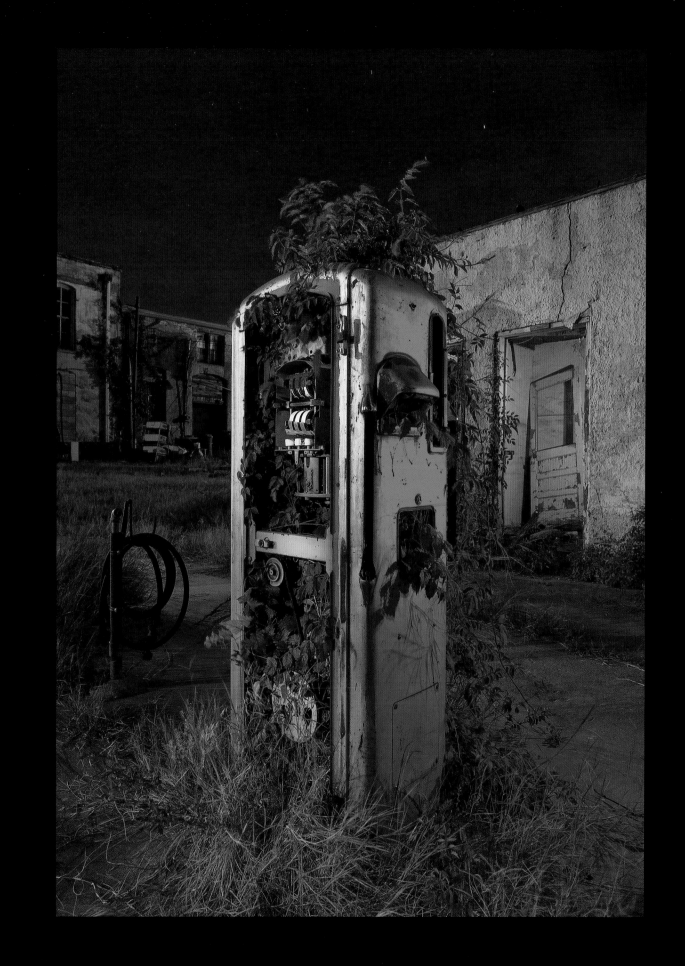

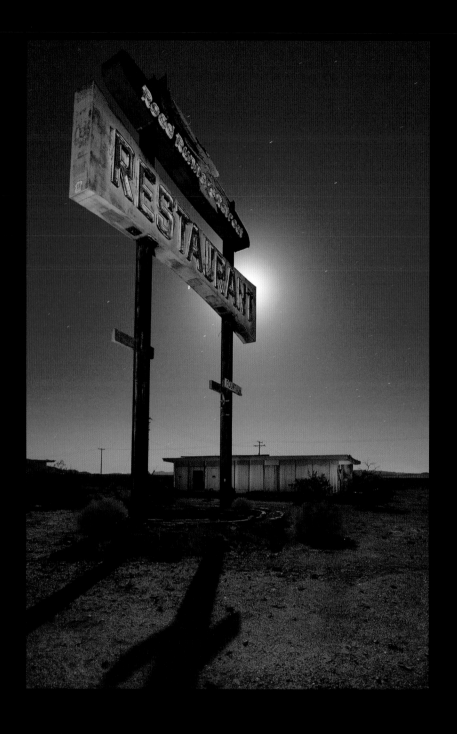

MOONLIGHT RETREAT
ROAD RUNNER'S RETREAT SIGN
CHAMBLESS, CALIFORNIA . JUN 11

Moonrise over the long-abandoned Road Runner's Retreat
Restaurant, with its classic, oft-photographed
sign. Taken on a still and silent night in the most
remote stretch of Route 66 in the Mojave Desert, east
of Amboy, California.

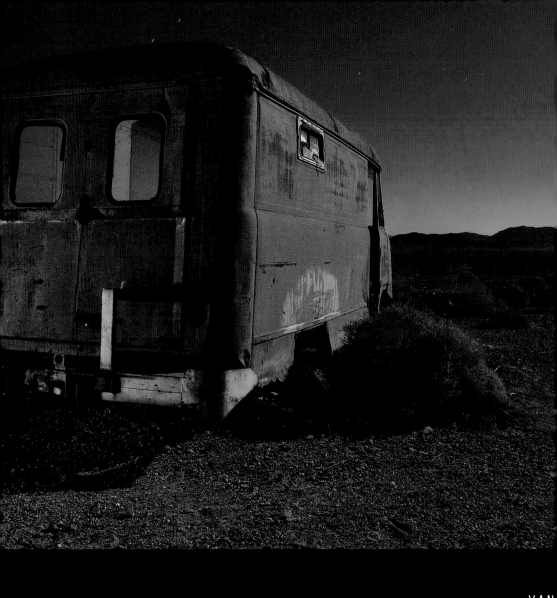

VAN
ABANDONED DELIVERY VAN
CHAMBLESS, CALIFORNIA . JUN 11

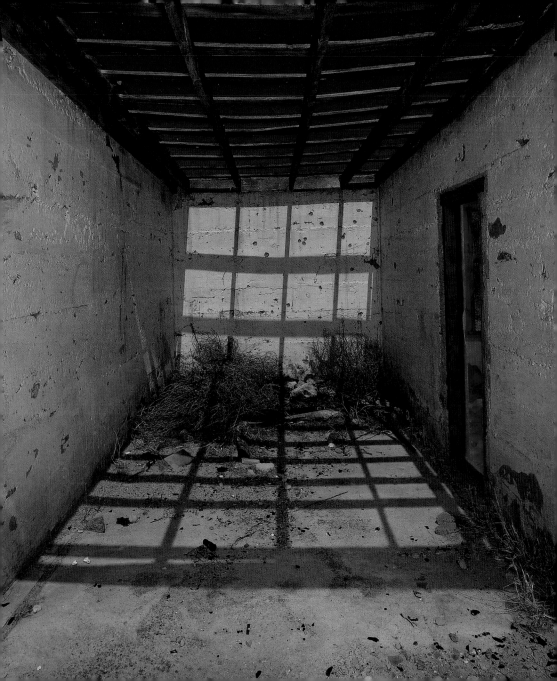

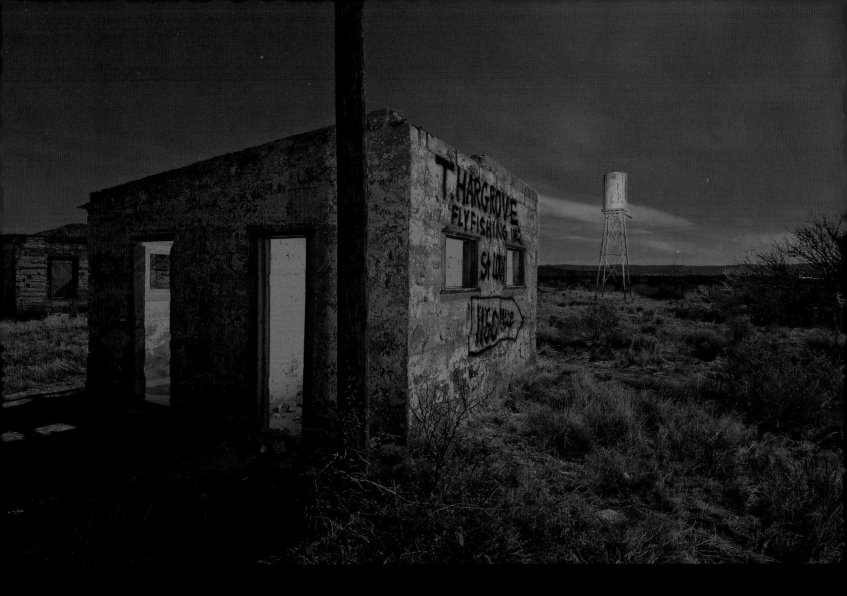

. HARGROVE FLYFISHING INC.
BANDONED TOURIST COURT
ALT FLAT, TEXAS . JAN 08

Back in the 1940s and '50s, when touring the country by car was becoming commonplace, inexpensive roadside motels or "tourist courts" began popping up all over — some in exactly the places you'd expect, others in some of the most out-of-the-way locations imaginable. That's certainly the case here with this little tourist court in the middle of the west Texas desert, just east of a large salt flat for which the area is named.

As desert locations go, this one is a beauty, with a view of El Capitan – not the one in Yosemite, but another commanding peak located in the Guadalupe Mountains National Park. This little spot is one of my favorite places to shoot.

STUCKEY'S
ABANDONED GIFT SHOP
NEAR STRAWN, TEXAS . AUG 08

Stuckey's Candy & Gift Shops were an icon of the
American roadside for over forty years, providing
traveling families a place to "Relax, Refresh, and
Refuel" on those cross-country summer vacations.
There are still a couple hundred of them in operation
around the country, but this particular location
along Interstate 20 near the small town of Strawn has
clearly seen better days. The pecan logs and divinity
are long gone.

Still, whether abandoned or reopened as another
business altogether, this architectural design is
instantly recognizable as classic Stuckey's.

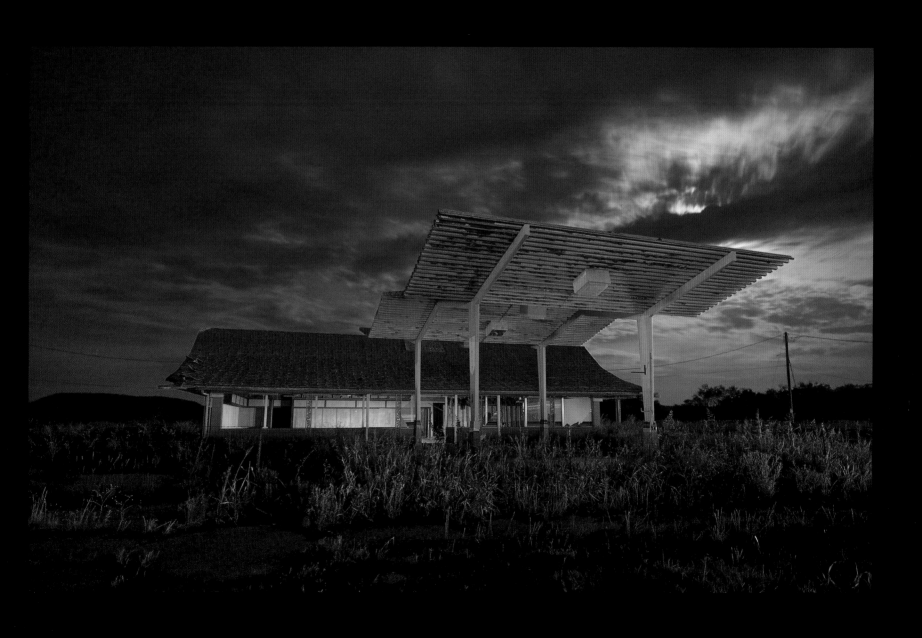

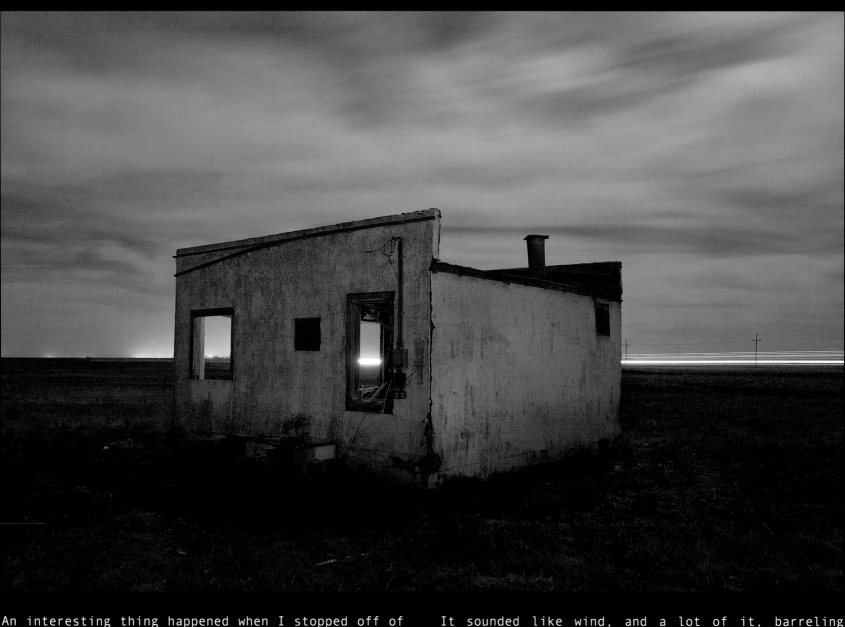

An interesting thing happened when I stopped off of Route 66 to shoot this old Skeet Range in Groom, Texas. As I got out of my Explorer to set up for the shot on the opposite page, I noticed that the outside temperature was 55 degrees Fahrenheit. A few minutes later, I had closed the shutter and was waiting for the long-exposure NR to process the shot when I heard a sound off to the northwest (out the right side of the frame).

It sounded like wind, and a lot of it, barreling in from that direction. It was pitch-dark, and I couldn't see much of anything out there, which was a bit unnerving.

Concerned that I was about to be hit with the full force of a notorious Texas panhandle dust storm, I replaced the lens cap and shielded the camera from the approaching... whatever.

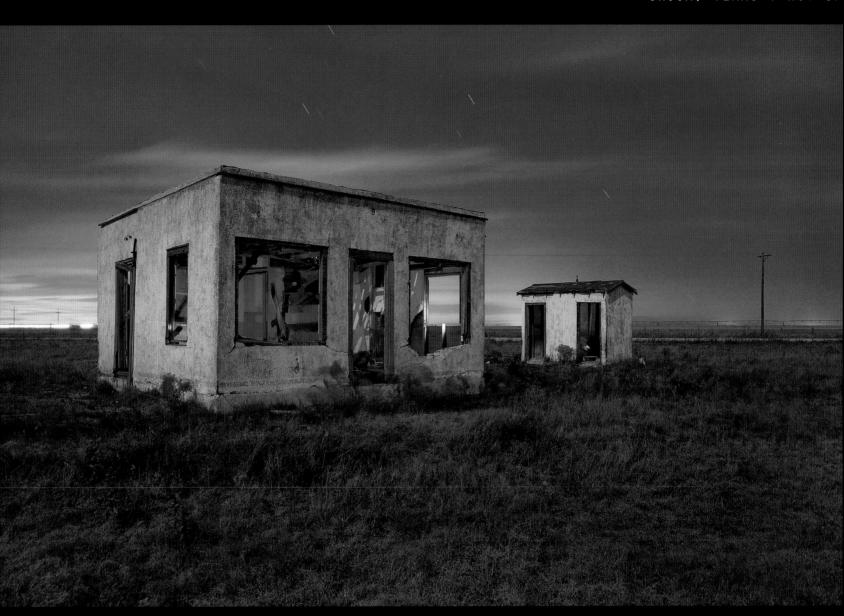

Then it arrived: an incredible rush of warm wind, easily twenty degrees warmer than the ambient temperature had been just seconds earlier. It blew so hard I feared for my tripod, so I grabbed it and held on. The wind blasted for about two minutes, then stopped as suddenly as it had begun. Within seconds, the temperature dropped back down to 55 degrees.

I now knew what was happening, I had just never experienced it so dramatically in person.

A minute or two later, I was setting up for another shot when a second wave of warm wind hit, this time lasting only twenty or thirty seconds, Then the temperature began to fall steadily; by the time I left the site forty minutes later, it was 39 degrees.

So now you know what it feels like when a cold front blasts across the west Texas plains!

ARE WE THERE YET?
CADILLAC RANCH, ROUTE 66
AMARILLO, TEXAS . NOV 07

At the famous Cadillac Ranch alongside historic Route
66 just west of Amarillo, Texas, the lead car is a
1949 Cadillac Series 61 Fastback.

Created in 1974, Cadillac Ranch was the product of
a collaboration between eccentric Texas art patron
Stanley Marsh and several members of Ant Farm, a San
Francisco-based art and design group.

The ranch consists of ten vintage Cadillac sedans,
partially buried nose-down in the dirt. In 1997,
the whole installation was moved two miles west of
its original location, farther from the growing city
of Amarillo. It was a good decision; otherwise the
Ranch's next-door neighbors would be a shopping mall
and a Hooter's.

As I was shooting this image, I heard a rumbling
behind me that sounded, I thought, just like a herd
of cattle stampeding in my direction. And that's
exactly what it was. As I turned, the cattle slowed
to a walk, and eventually the small herd set up shop
on the other side of the cars from me. Always nice to
have company during a shoot.

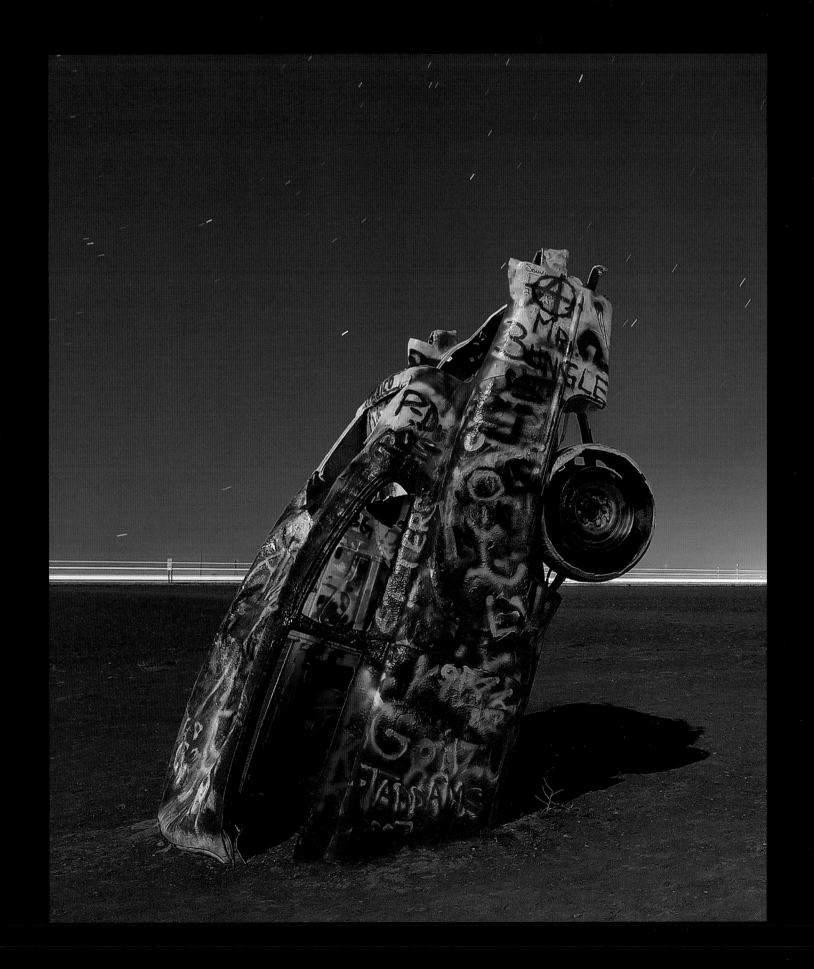

EXODUS
CADILLAC RANCH, ROUTE 66
AMARILLO, TEXAS . NOV 07

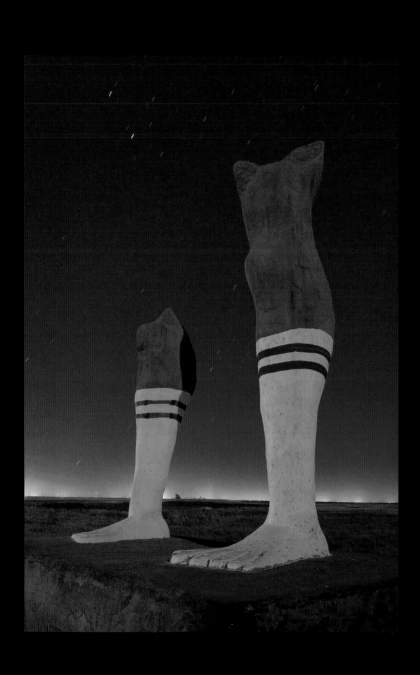

Stanley Marsh, the Amarillo millionaire responsible for Cadillac Ranch, is behind several other offbeat art installations in the Amarillo area. While the Ranch is easily the best known of his ventures, another unusual creation is the sculpture in the smaller picture on this page, inspired by Percy Bysshe Shelley's Ozymandias. In 1819, on the Spanish plains, Shelley wrote:

I met a traveler from an antique land who said: Two vast and trunkless legs* of stone stand in the desert.

Near them on the sand, half sunk, a shatter'd visage lies, whose frown And wrinkled lip and sneer of cold command tell that its sculptor well those passions read which yet survive, stamp'd on these lifeless things, the hand that mock'd them and the heart that fed.

And on the pedestal these words appear:

"My name is Ozymandias, king of kings: Look on my works, ye mighty, and despair!"

Nothing beside remains: round the decay of that colossal wreck, boundless and bare, the lone and level sands stretch far away.

I like that verse. Its images mirror the experience of visiting the forlorn and abandoned places I tend to frequent.

* As a point of historical accuracy, it should be pointed out that the "trunkless legs" Shelley encountered in 19th-century Spain were probably not wearing tube socks.

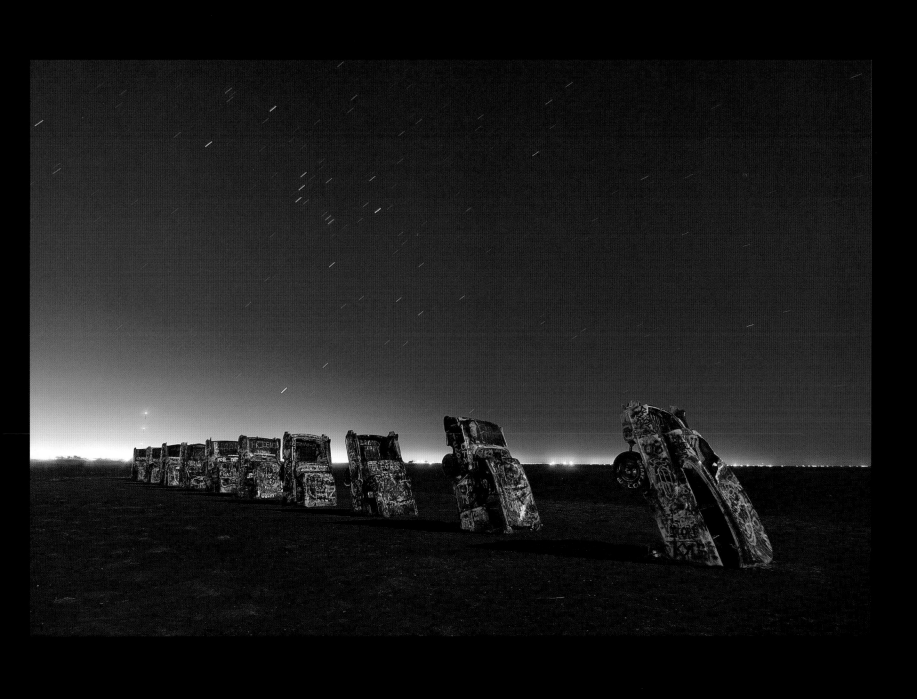

_ _ X _ _ 0
FORGOTTEN ROUTE 66 SIGN
HYDRO, OKLAHOMA . NOV 07

This was one of my earliest experiments with
integrating car trails into my photographs. The single
separate red line you see is a lone car traveling
along the access road, which is actually on the old
Route 66 roadbed. The bulk of the traffic races past
on Interstate 40, the Oklahoma stretch of which was
built in the middle and late 1960s... and, sadly,
decommissioned in 1985.

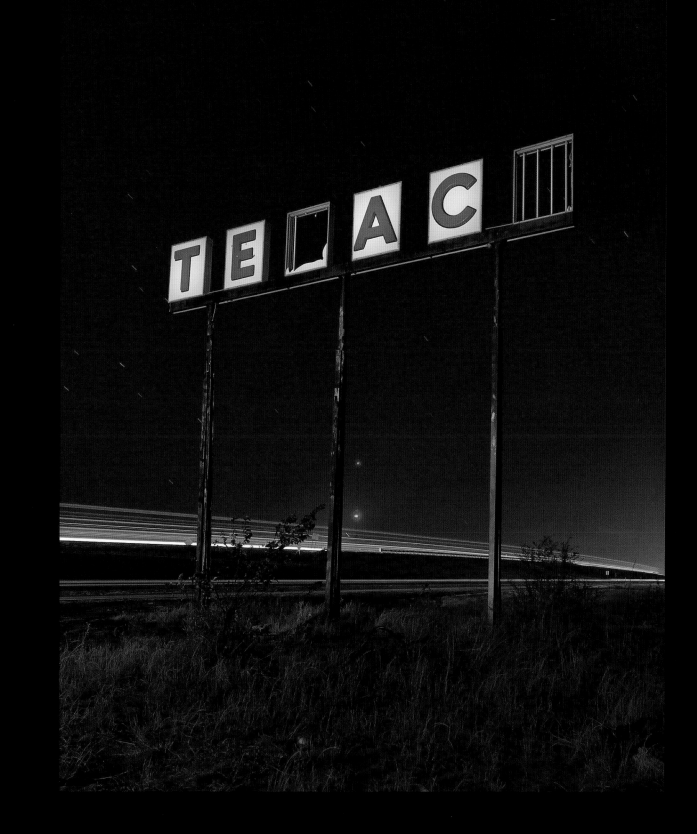

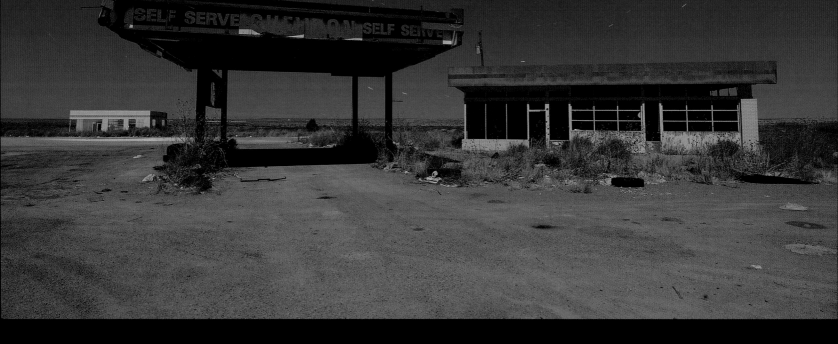

EXIT 0
ABANDONED GAS STATIONS
GLENRIO, TEXAS . NOV 07

Along Interstate 40 at "Exit 0" on the Texas / New Mexico border sit two lonely and forgotten gas station shells: one a 1960s Texaco, the other of unknown age and origin. At some point, its garage doors were sealed shut and the building was turned into a typical Chevron gas station and convenience store. (The green branches in the lower left corner are parts from an artificial Christmas tree among the random castoffs.) This is a very remote location, and as such, a wonderful place to shoot. Both gas stations are set back surprisingly far from I-40, where cars racing by provide a dynamic backdrop for a light-painted interior scene. In 2007, these two structures wore virtually no graffiti — a testament to their isolation on the western edge of the Lone Star State.

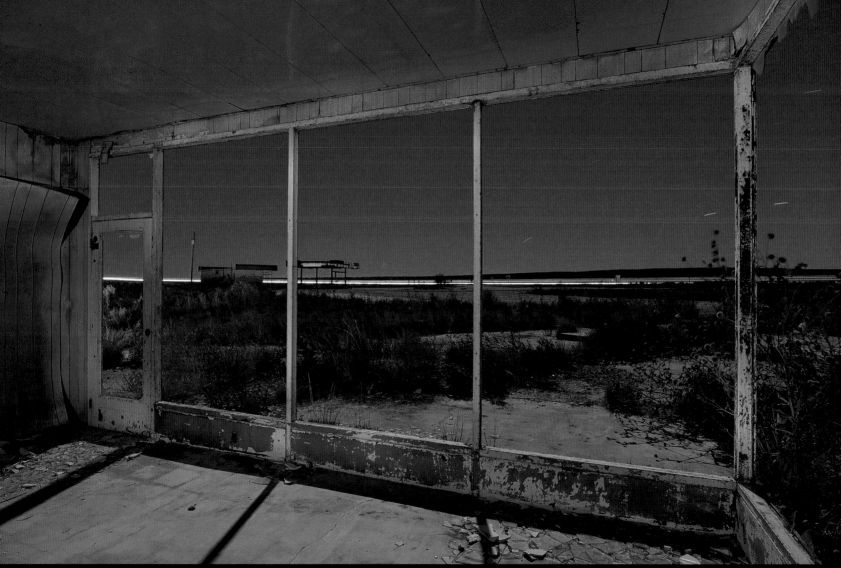

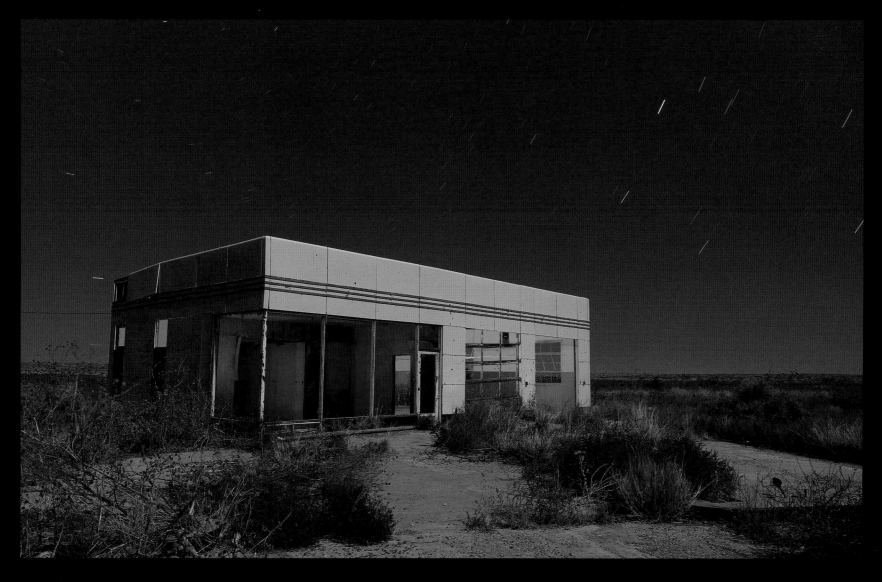

This is a six-minute exposure of an abandoned Texaco station along Interstate 40, just a tiny fraction of a mile east of the New Mexican border, near the Route 66 ghost town of Glenrio.

Research has shown this to be a style of Texaco station that was built between 1938 and 1962... which means this one was probably built when the new highway came through in the late '50s or early '60s.

Like many roadside abandonments, this isolated spot is popular with long-haul truckers, who park overnight to rest in their sleeper cabs. I've lost a few shots that way, but on this night, I was fortunate – I managed to catch this spot and shoot it early in the evening, before tired truckers turned the area into a parking lot.

MOONLIGHT CAFE
ABANDONED SIGN, ROUTE 66
ADRIAN, TEXAS . NOV 07

The cafe itself is long gone, but this ubiquitous
sign, located west of Amarillo along Route 66 in
the tiny town of Adrian, still stands. This familiar
sign style can be seen in several towns along this
stretch of Route 66, still advertising for locally-
owned cafes... most of which no longer exist.

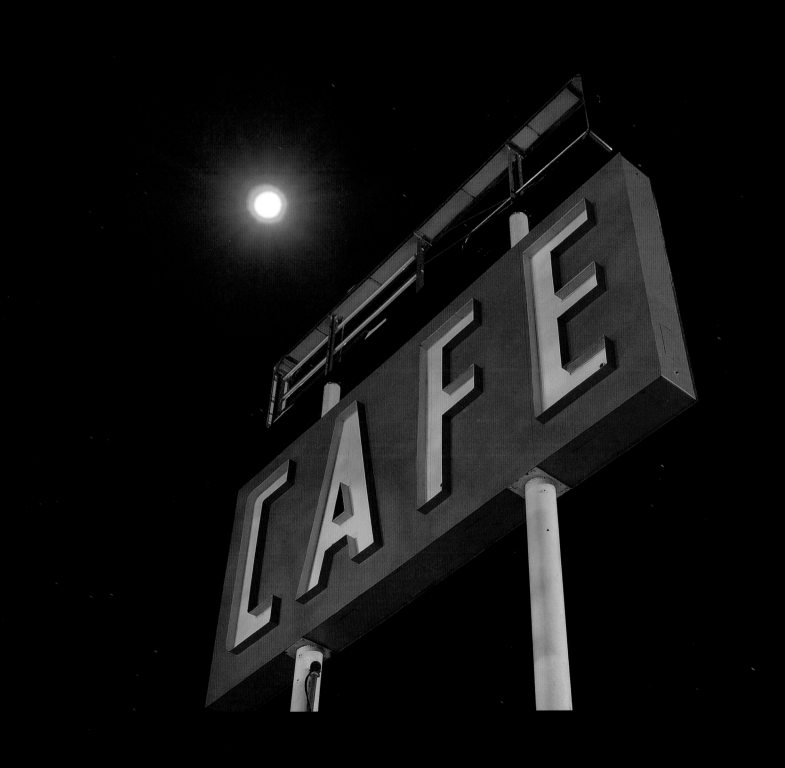

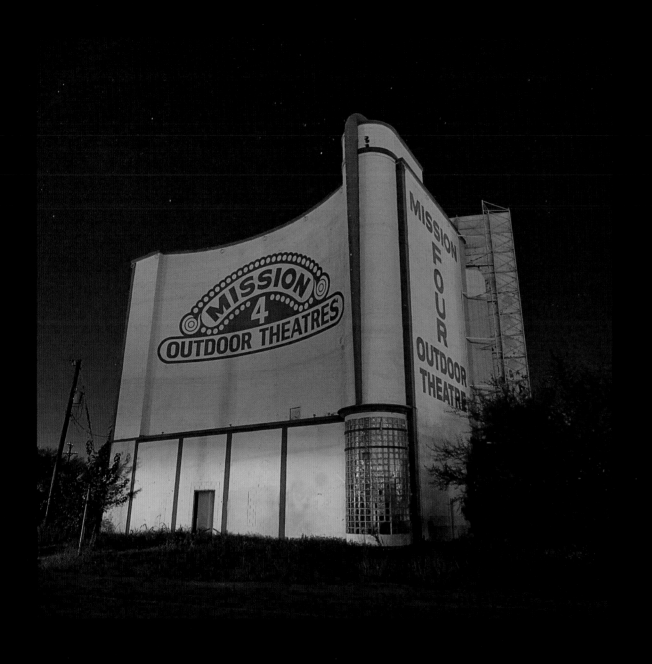

MISSON 4 DRIVE-IN
ABANDONED DRIVE-IN THEATER
SAN ANTONIO, TEXAS . OCT 07

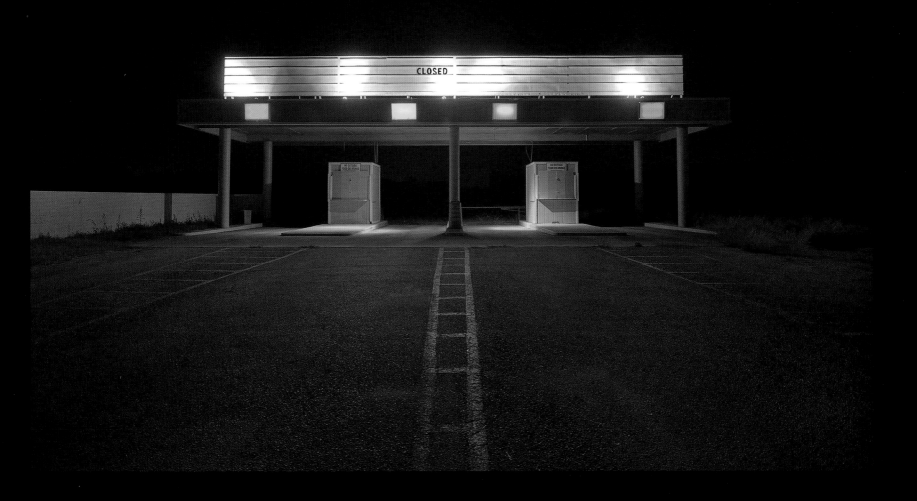

CLOSED
ABANDONED DRIVE-IN THEATER
SAN ANTONIO, TEXAS . OCT 07

The entrance to the defunct Mission Four Outdoor
Theatre in San Antonio, Texas, discovered by accident
as I was on the way to Mission San Jose.

The fact that the power was still on led me to believe
this was a very recent closure, but beyond this booth,
the cracked pavement and overgrown weeds suggested it
may have been shutdown somewhat longer.

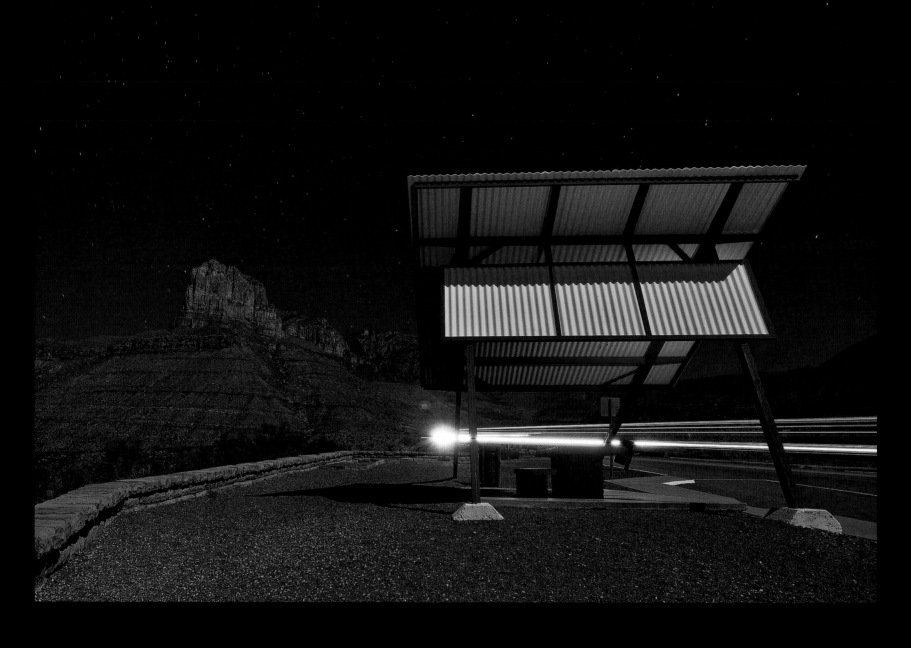

GUADALUPE PASS
EL CAPITAN PEAK, GUADALUPE MOUNTAINS
GUADALUPE PASS, TEXAS . APR 09

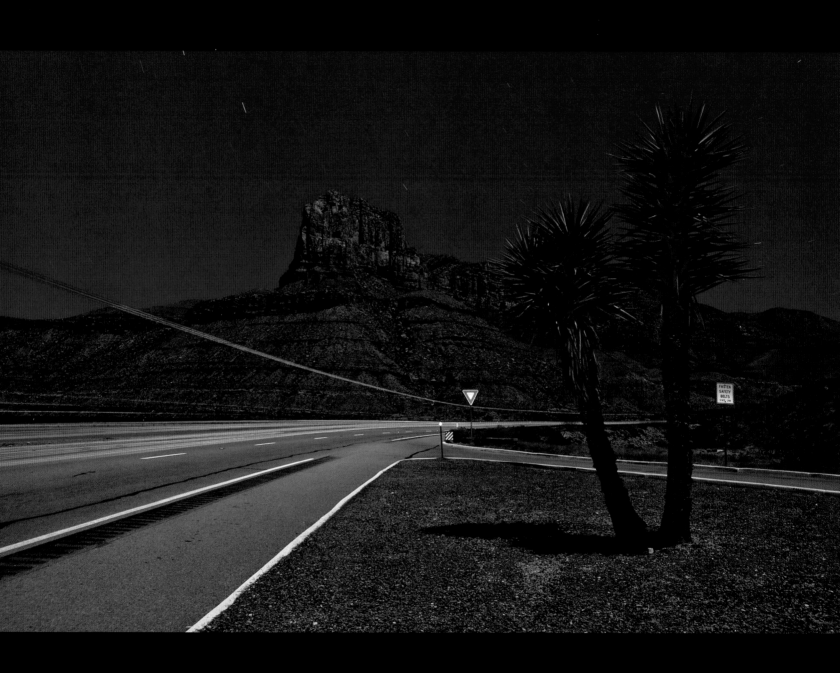

late in the evening, a lone 18-wheeler makes its way

CLIMBING GEAR

FASTEN
SAFETY
BELTS

REGULAR

TOTAL $6.00 SALE

W A Y N E

0 0 0

GALLONS

PER
GALLON 3 4 ½

INCLUDES
ALL TAXES

ACCURATE DELIVERY FROM 5 GALLONS PER MINUTE TO FULL FLOW

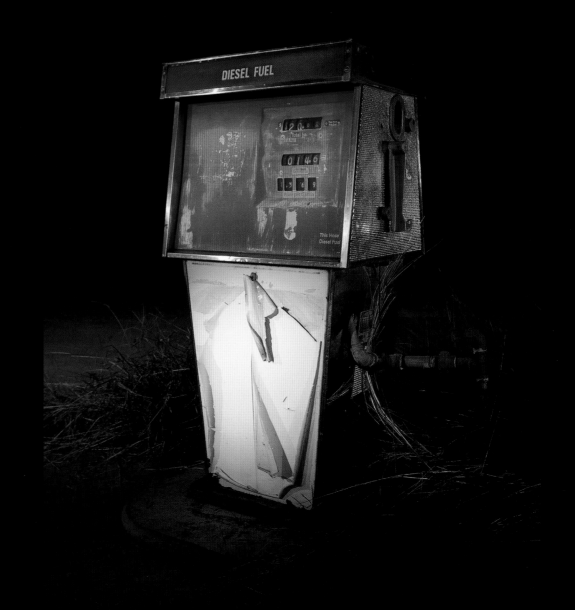

DIESEL FUEL

PSYCHO-PUMP
ABANDONED GAS STATION
NEAR GORDON, TEXAS . NOV 07

On one of my first ghost town trips back in 2007, I happened upon a little place by the side of the road called Trolley 373, an abandoned diner / gas station / truck stop. On an empty stretch of I-20 between Dallas and Abilene, the trolley stands, predictably enough, at exit 373. During my quick survey of the exterior, an eighteen-wheeler pulled off on the edge of the access road right in front of the place and settled in for the night.

My exterior shot was blocked, and I decided that, with a witness on hand, I'd better not try to get into the building for an interior. But I did notice this lone gas pump out behind the station, and I had to shoot it. It was a moonless night, so I generated all the light in this image, except for the green on the right side; that's ambient light from a mercury vapor lamp.

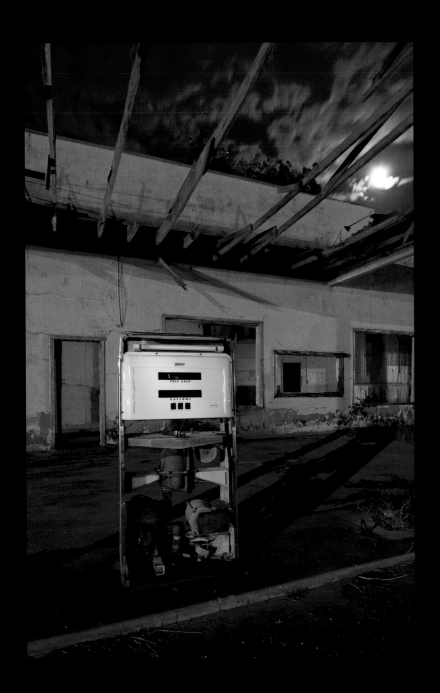

MOON BEAMS
ABANDONED SERVICE STATION
RANGER, TEXAS . AUG 08

The town of Ranger was bypassed when Interstate 20 came through, and like so many small towns, it has been withering away ever since. My lifelong best friend lived there when he was very young, so I decided to stop by and see what remained.

What I found surely bore little resemblance to the thriving community he knew in the early 1960s. The road into town was lined with abandoned homes and businesses, and the downtown area hadn't fared much better. Since I photographed it back in 2008, this service station has been cleaned up, apparently in preparation for reopening – but when I rolled through Ranger in 2010, it still sat vacant.

The road back to prosperity will be a long one for Ranger, Texas.

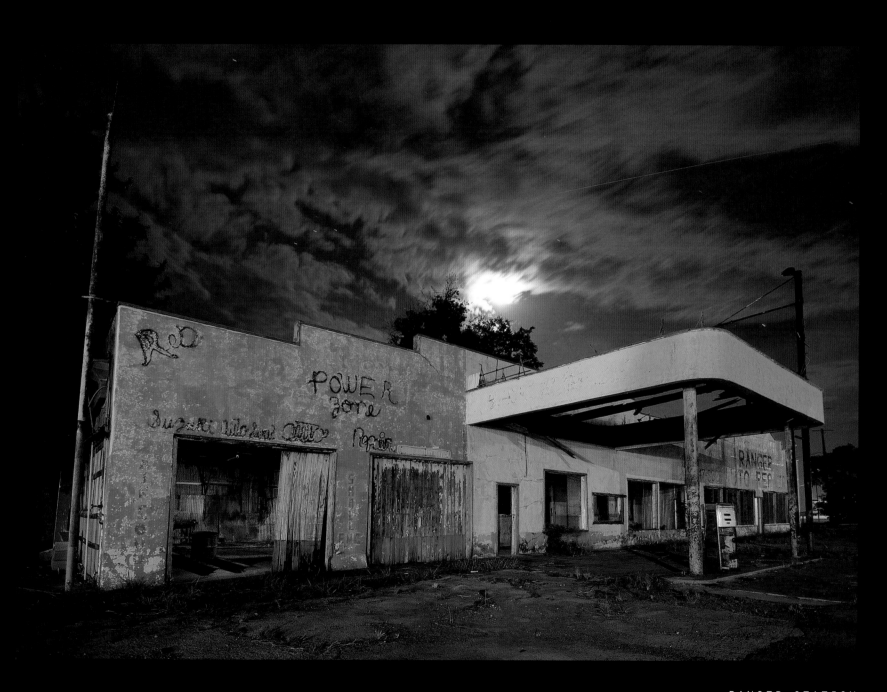

RANGER STATION
ABANDONED SERVICE STATION
RANGER, TEXAS . AUG 08

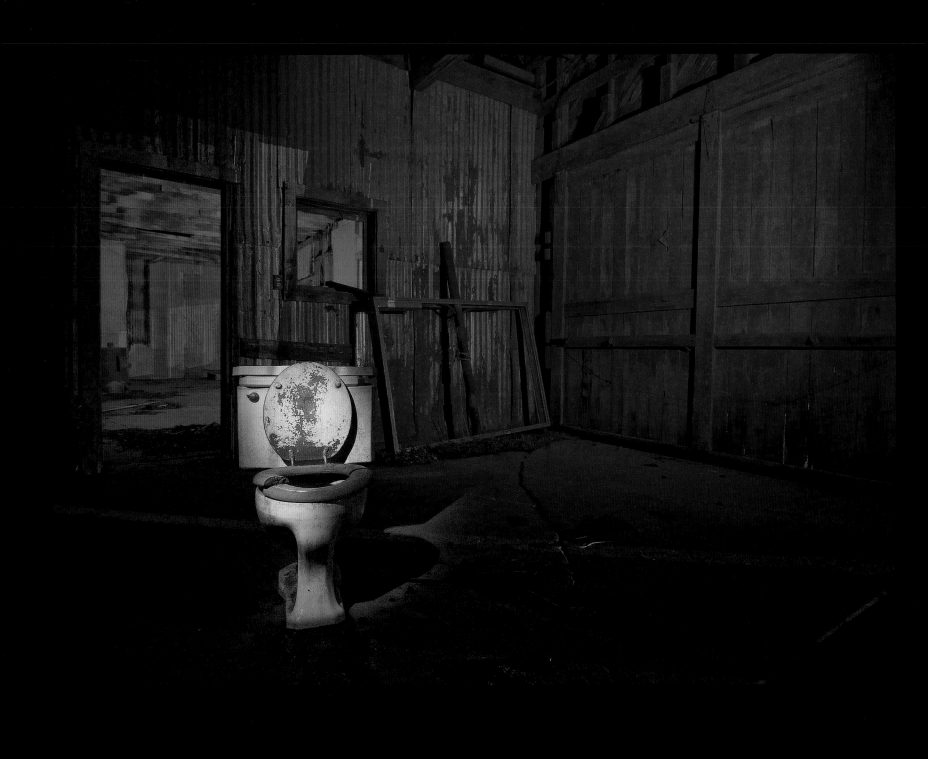

IT'S POTTY TIME!
ABANDONED SERVICE STATION
RANGER, TEXAS . AUG 08

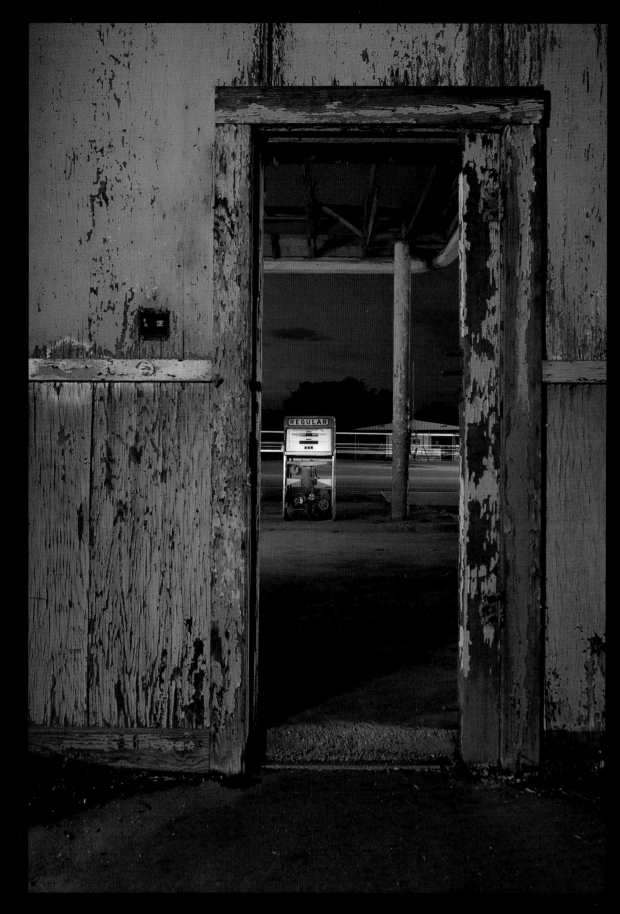

REGULAR
ABANDONED SERVICE STATION
RANGER, TEXAS . AUG 08

MOTEL VACANCY
FORGOTTEN MOTEL SIGN
RANGER, TEXAS . AUG 08

The little community of Ranger seems to be dying a
long, slow death amid decaying reminders of more
prosperous times - like this spectacularly weathered
sign by the roadside as you roll into town.

Renovation appeared to have begun on the cabin-
style motel court, with new window glass installed
in several of the units and construction materials
stacked in many of the rooms. But the sheetrock and
ceramic tiles have been collecting dust for a long
time now, so it seems the project has fallen by the
wayside.

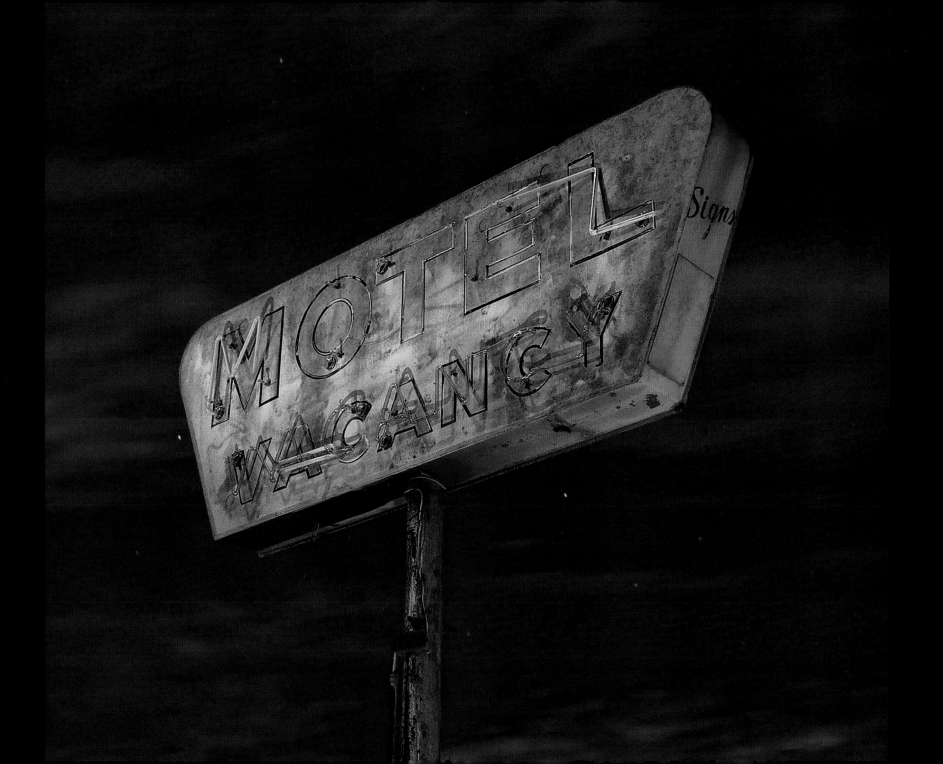

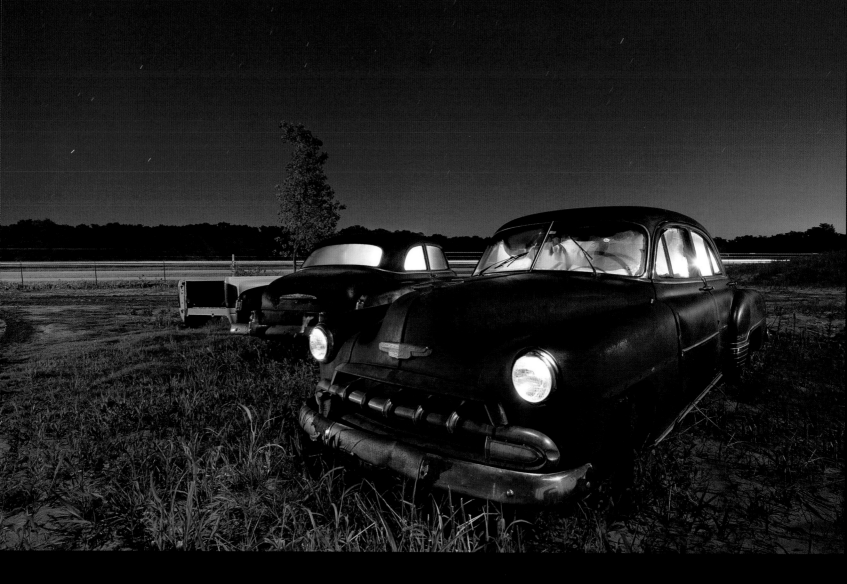

CHEVYS
ABANDONED AUTOMOBILES
BOWIE, TEXAS . APR 09

Those who know me know that, in general, I don't shoot a lot of cars, and especially not cars lined up in rows at a junkyard somewhere. I prefer cars that are still standing right where they were last parked by their owners...preferably, decades ago.

That said, I do occasionally make exceptions to my own rule...as with these beautiful old Chevrolets parked near the frontage of a wrecking yard near the town of Bowie, Texas. There's just something about these vintage cars that, to my mind, lends itself to

44 NO MORE
ABANDONED INTERSTATE HIGHWAY
CATOOSA, OKLAHOMA . JUL 10

This abandoned section of Interstate 44 near Catoosa, Oklahoma, has a dream-like feel to it. At one time, this '50s-era stretch was a toll road, but its toll booth has been torn down. This section of I-44 was disconnected in the early 2000s and bypassed to the

Many people are surprised to learn that this is, in fact, a night photograph. The exposure time here was two minutes and fifteen seconds, and the bright spot in the sky is the moon, sliding down towards the horizon.

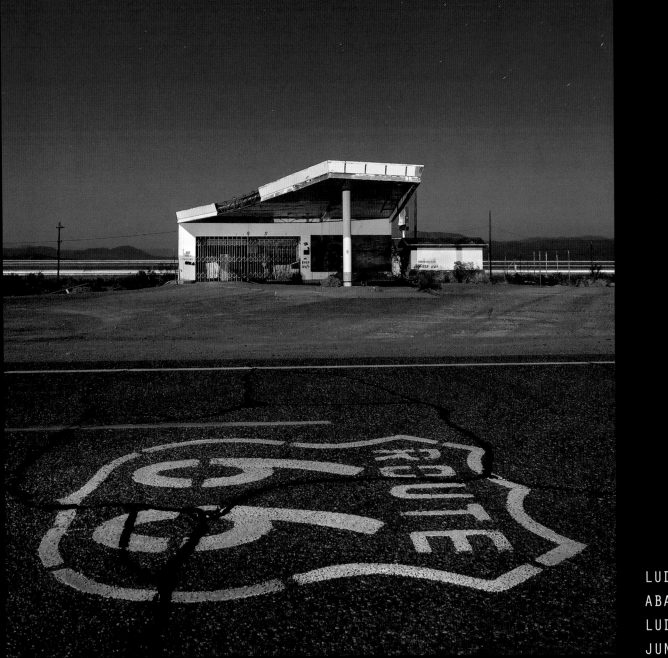

LUDLOW GAS
ABANDONED GAS STAT
LUDLOW, CALIFORNIA
JUN 11

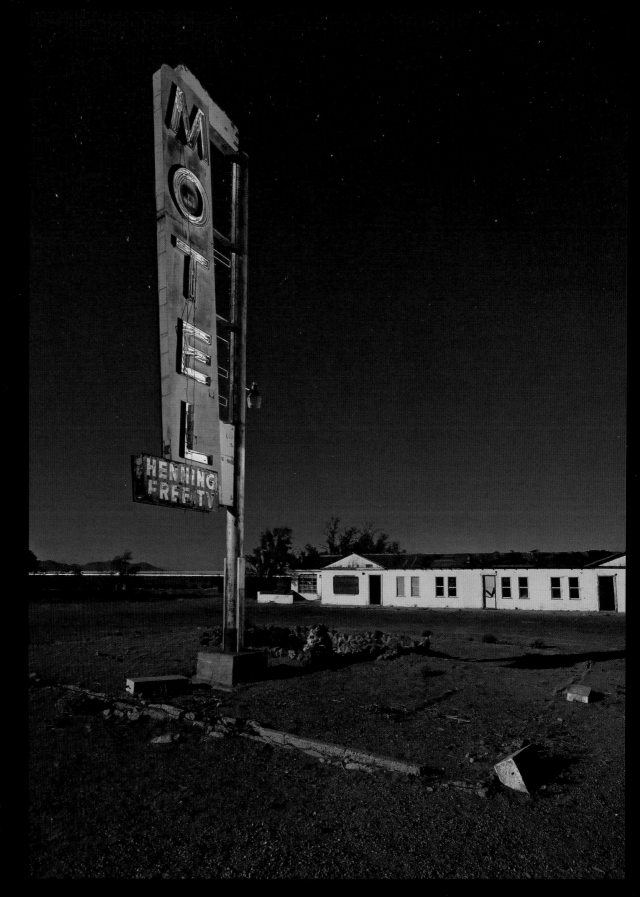

HENNING MOTEL
ABANDONED MOTEL
NEWBERRY SPRINGS,
CALIFORNIA . JUN 11

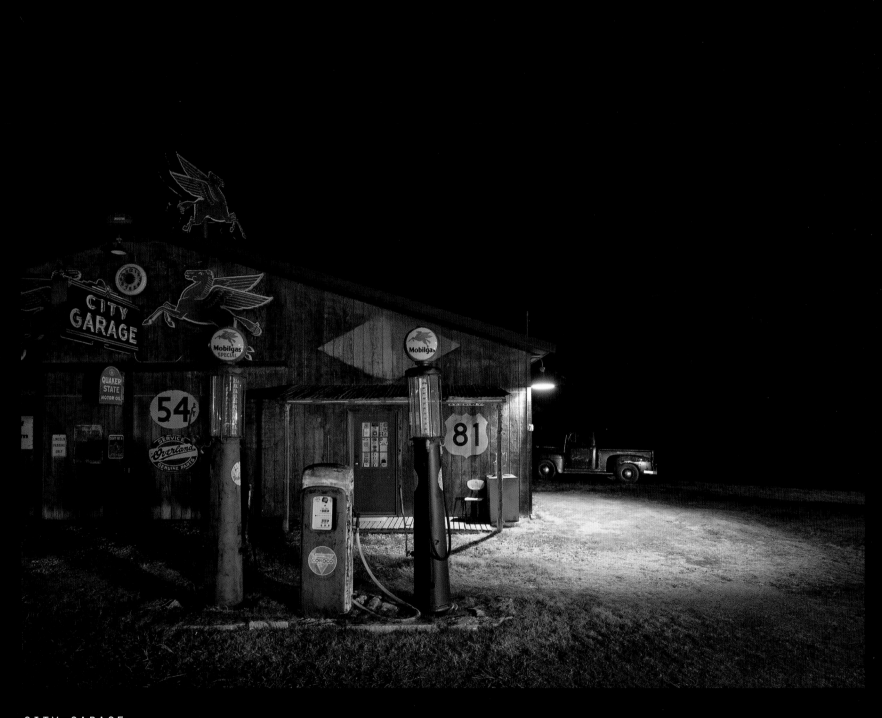

CITY GARAGE
ROADSIDE CURIO SHOP
SALADO, TEXAS . JUL 09

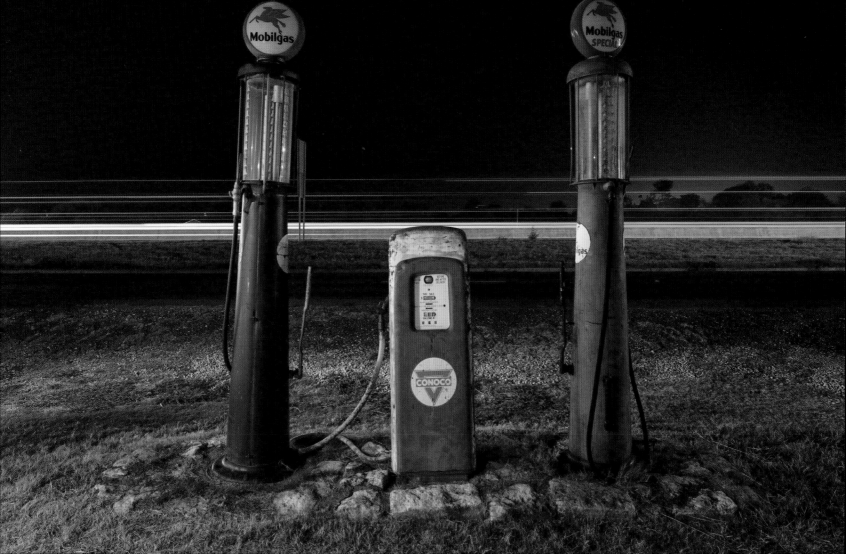

LIMITED SEATING
ABANDONED RESTAURANT
CELINA, TEXAS . NOV 09

In Texas, Dairy Queens are ubiquitous. Every small
town has one, and it's generally a gathering place
for young and old alike.

This one, on the outskirts of Celina, Texas, is a
rare example of a Dairy Queen that didn't make it. I
believe it was simply a matter of a poor, speculative
location. This store was built quite a distance from
the center of town, and it appears the town never
grew large enough to reach it.

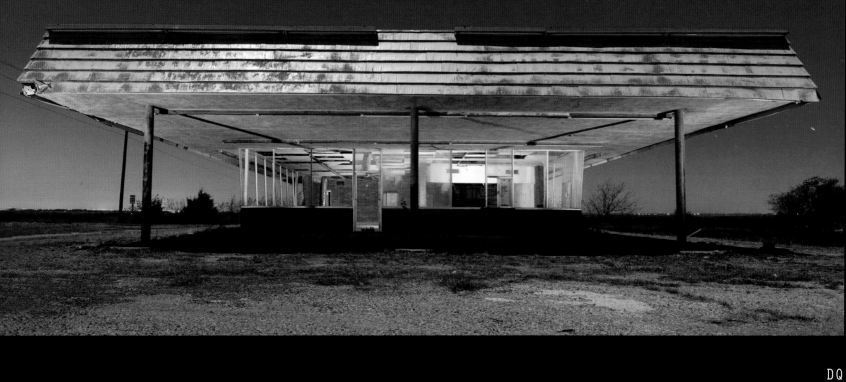

DQ
ABANDONED RESTAURANT
CELINA, TEXAS . NOV 09

STARLITE
ABANDONED DRIVE-IN TICKET BOOTH
SCHERTZ, TEXAS . OCT 07

Though very few traces of America's drive-in culture
remain today, watching a movie under the stars was
once a national pastime. This jaunty old ticket booth
survived intact longer than most, but sadly, the sign
is gone now, and the building itself is probably not
far behind.

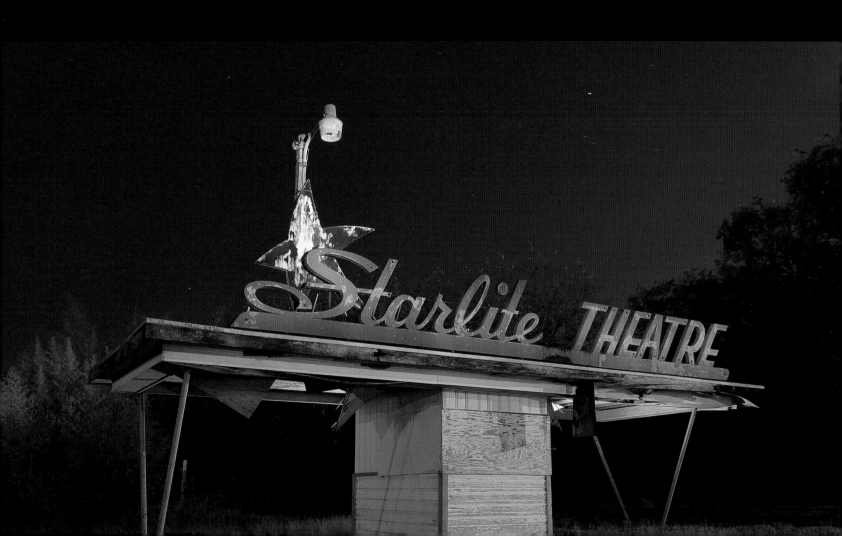

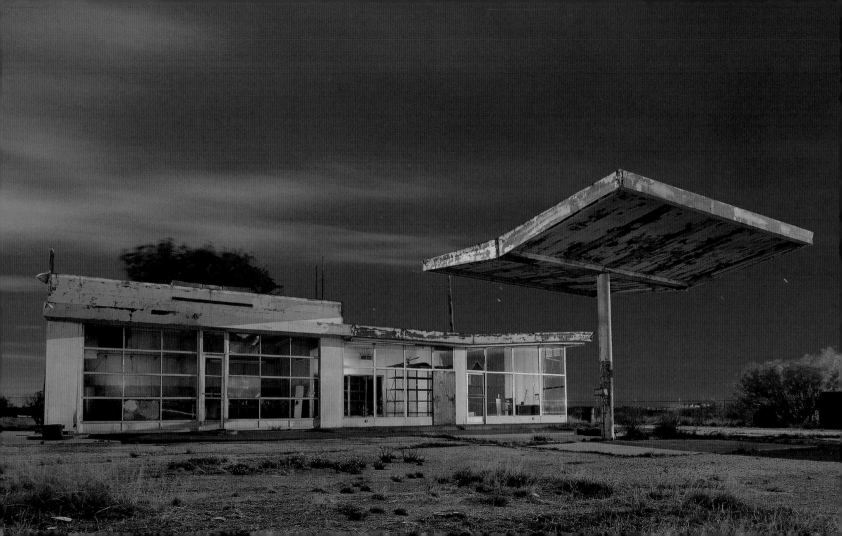

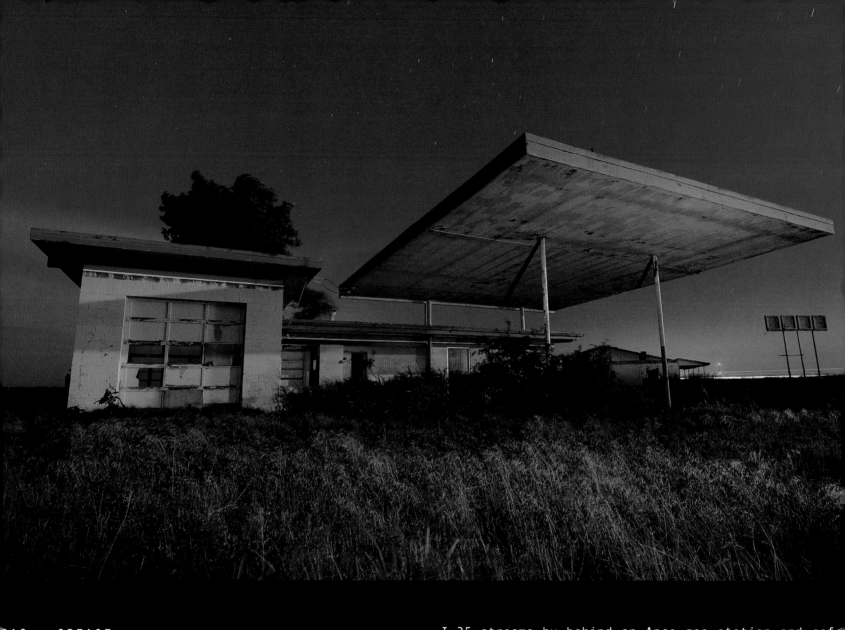

GAS & GREASE
ABANDONED GAS STATION
NORTHERN OKLAHOMA . JUL 09

I-35 streams by behind an Apco gas station and cafe
at the junction of State Route 15 and Interstate 35
in northern Oklahoma. Originally built as a Champlin
station back in the 1960s, the structure was later
put into service as an APCO. The architecture has
some unique Googie features to it, including the
acutely pointed corner of the office, shown at left

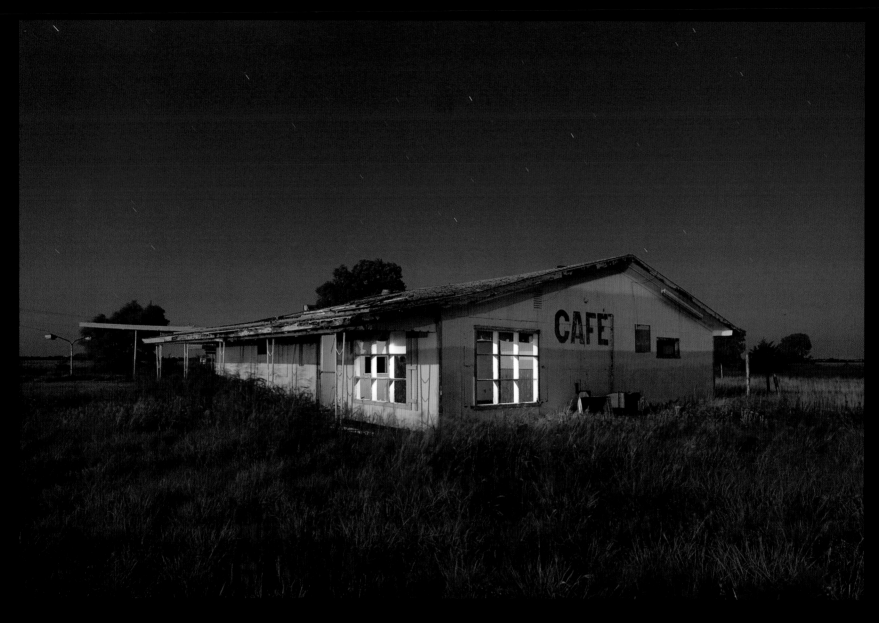

CAFE OKLAHOMA
ABANDONED DINER
NORTHERN OKLAHOMA . JUL 09

FOOD
ABANDONED DINER
NORTHERN OKLAHOMA . JUL 09

At the crossroads of I-35 and SR-15 in northern Oklahoma
stands this succinct invitation to a long-abandoned
cafe, shown above. The letter panels themselves were
fashioned from canvas, or perhaps vinyl, leading
me to believe this sign might have originally been
installed for the former APCO station next door.

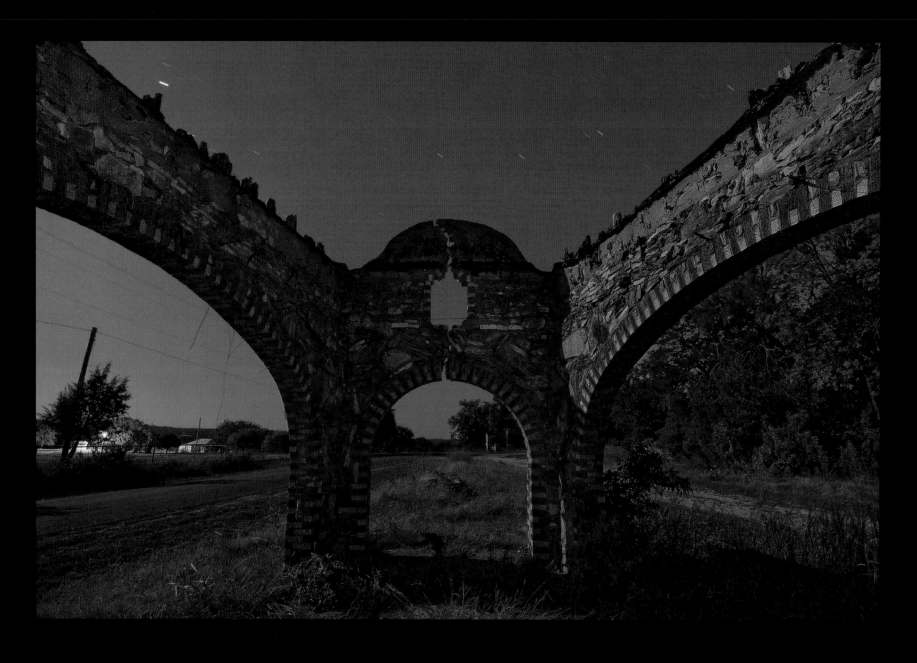

PETRIFIED
ABANDONED ROADHOUSE
GLENROSE, TEXAS . JUL 08

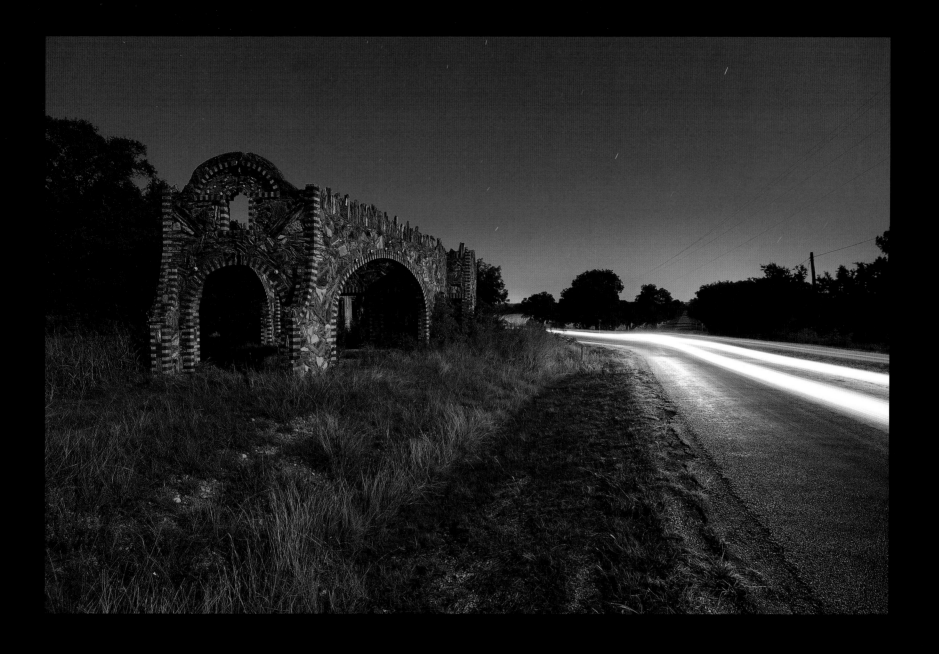

THE OUTLAW STATION
ABANDONED ROADHOUSE
GLENROSE, TEXAS . JUL 08

This is what remains of a filling station and prohibition-era speakeasy along old highway 67 on the north side of Glenrose, at a place historically referred to as Sycamore Grove. Reportedly built in 1925, the building incorporates multi-colored brick, local rock, and even petrified wood in its construction. Somervell County evidently had quite a cache of petrified wood at one time, and there are several structures in the area built in a similar fashion. Thus far, the ancient wood has stood the test of time... unlike whatever material they chose for the roof.

Now referred to as the Outlaw Station, this fascinating structure stands by the highway as a reminder of the days of the great depression, white lightnin' moonshine, and roadhouse dancehalls.

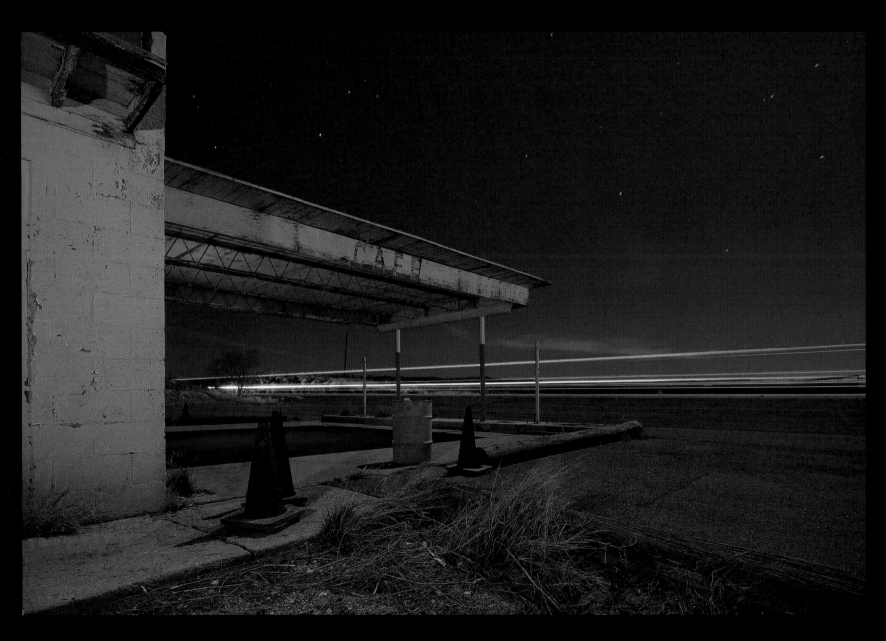

CAFE NOCTURNE
ABANDONED CAFE
NEAR SALT FLAT, TEXAS . APR 09

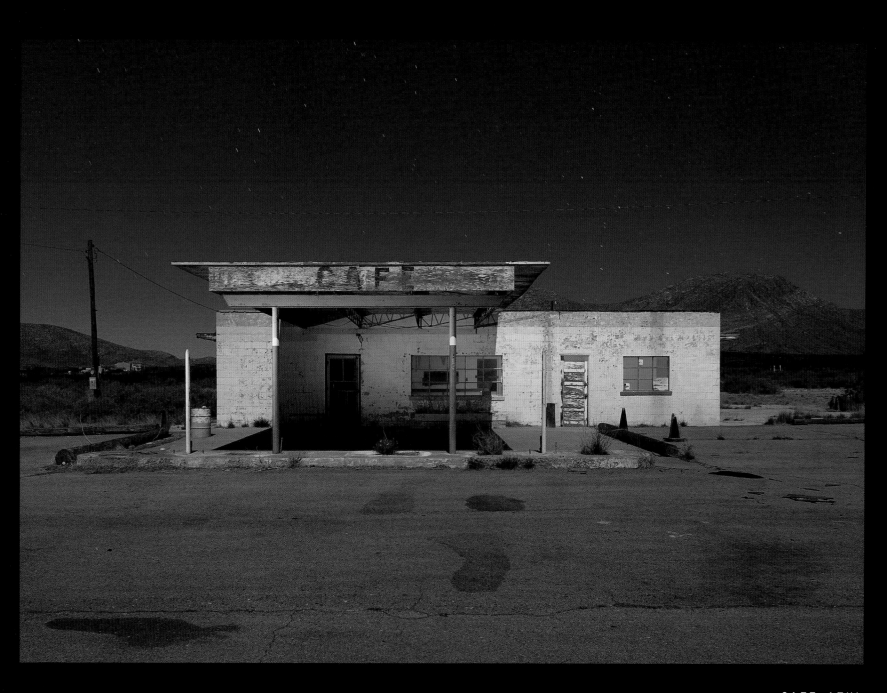

CAFE AZUL
ABANDONED CAFE
NEAR SALT FLAT, TEXAS . APR 09

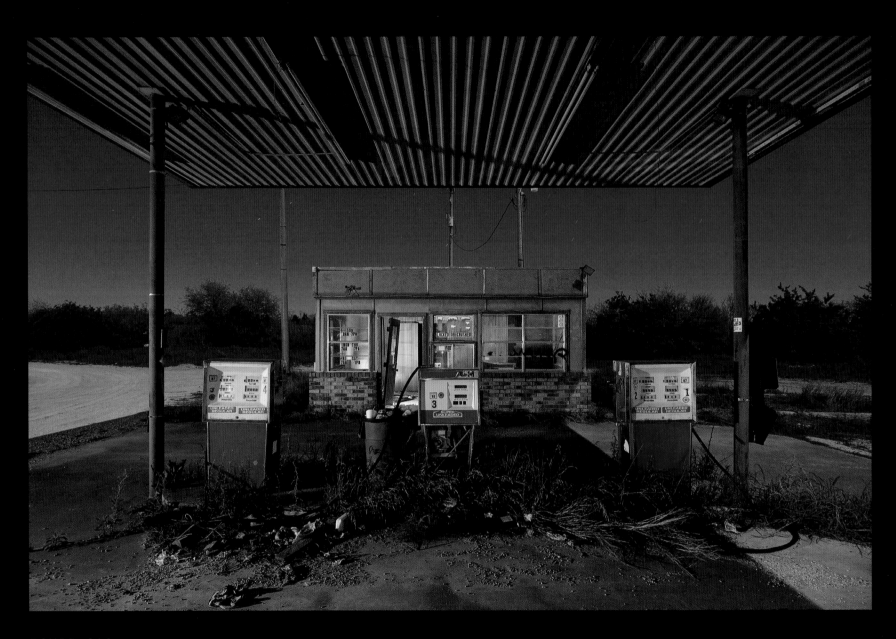

BOWIE GAS
ABANDONED GAS STATION
BOWIE, TEXAS . APR 10

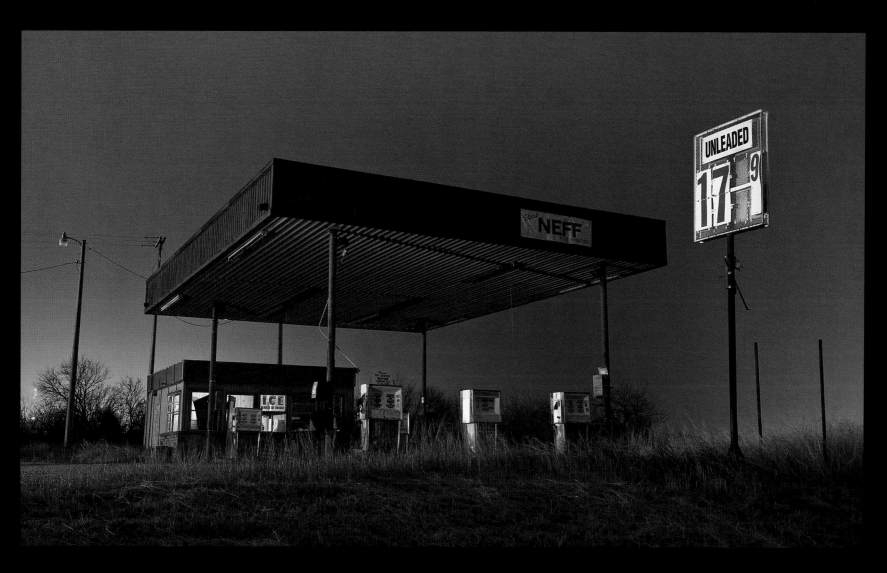

ICE
ABANDONED GAS STATION
BOWIE, TEXAS. FEB 09

TRUCK STOP
ABANDONED TRUCK STOP
SIERRA BLANCA, TEXAS . JAN 08

Like so many other small communities across the
southwest, Sierra Blanca is a partial ghost town.
There's a hotel, a restaurant or two, even a couple
of places to buy gas and get your car repaired if
need be. But on the edges of this dying town, you'll
find places like this splendid old shell of a truck
stop and the diner across the street. Both are
vacant, unsecured, and exposed to the elements...
just waiting for the rest of the town to join them in
their architectural afterlife.

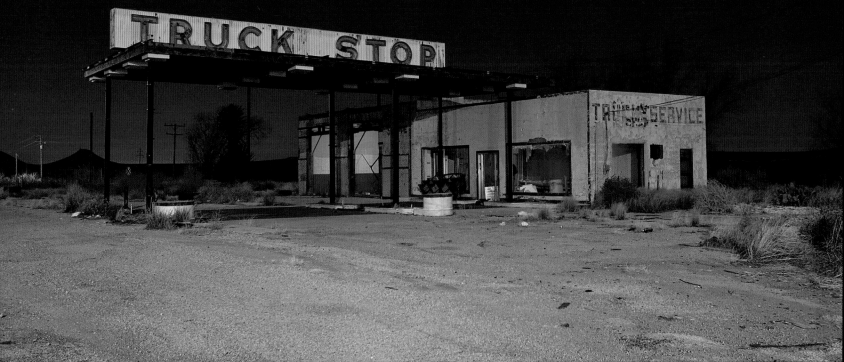

HIGHBALLIN'
PASSING BIG-RIG
NEAR SALT FLAT, TEXAS . APR 09

For many, there's an allure of the road that just can't be captured in words. The insatiable desire simply to be somewhere you're not – to get in the car and just drive...if only just to see what you may find. Maybe that's a start.

When I plan my shooting road trips to the desert, I find myself lying awake at night for days beforehand, thinking through the trip, imagining shot ideas for each researched location and wondering what other places I'll find along the way...barely able to contain myself until the moment when I can pack up the truck and finally get on the road again. There's no greater feeling of freedom in the world...and along with these photographs, I can offer no other explanation for my love affair with the highway than that.

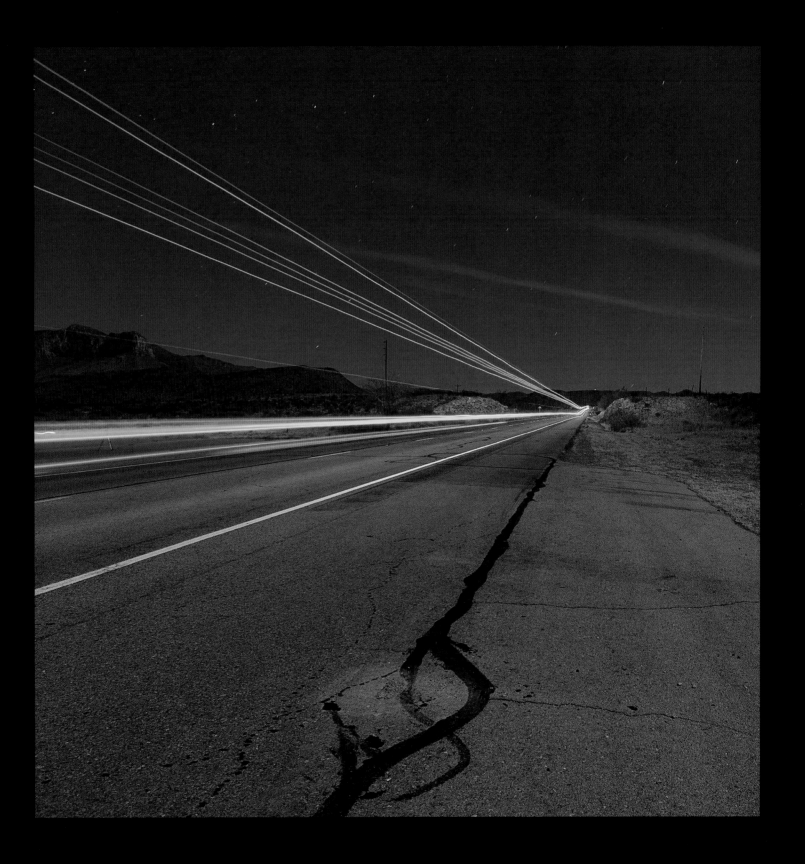

CASUALTIES OF WAR

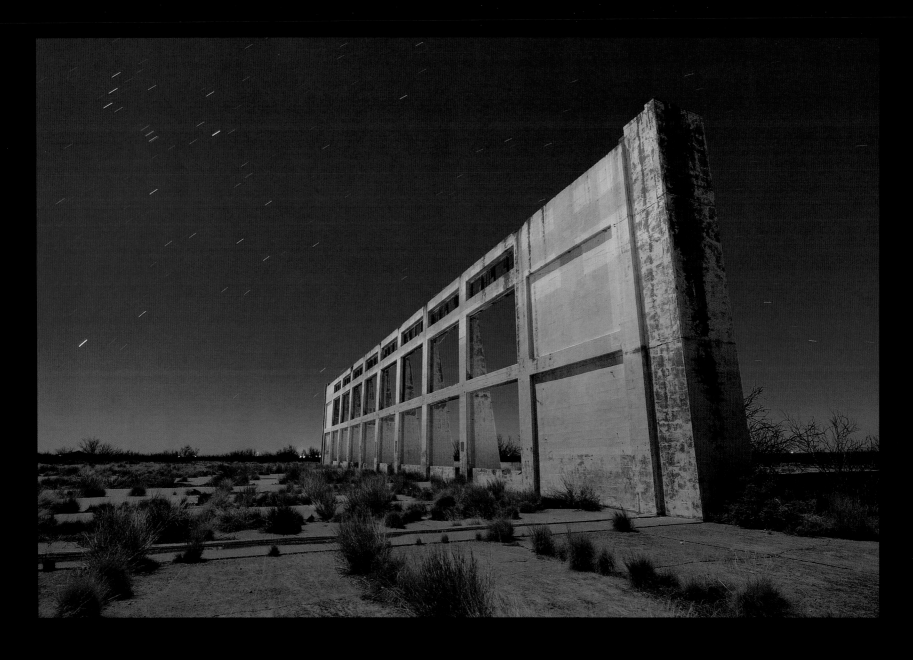

WESTERN WALL
ABANDONED HANGAR RUINS
PYOTE, TEXAS . JAN 08

This shell is all that remains of the massive 3rd Echelon Maintenance Hangar at the Pyote Air Force Station.

Built in 1942 as a bomber training base, the hangar was used after the war to melt aircraft down for scrap metal. Both the Enola Gay (which dropped the first atomic bomb) and the Bataan (Douglas MacArthur's plane) had been sent here for destruction, but were rescued and preserved by the Smithsonian Institute.

The station was commonly referred to as the Rattlesnake Bomber Base, because of the concentration of rattlers in this remote West Texas location; it was not a

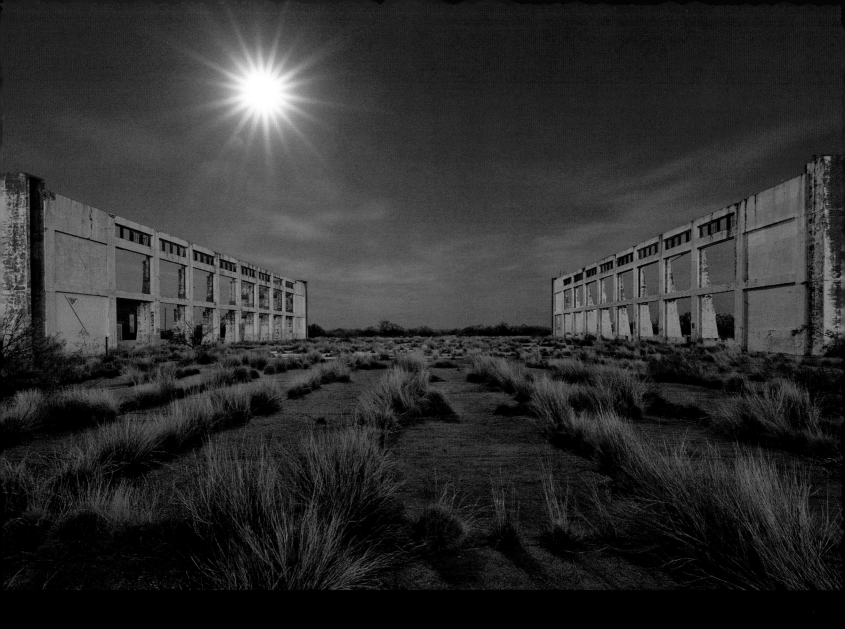

MIDNIGHT SUN
ABANDONED HANGAR RUINS
PYOTE, TEXAS . APR 09

pleasant hike out here in the middle of the night. My first visit here was in January of 2008 on a brisk, but stock-still 15-degree night, but the image on this page was taken on a milder April evening the following year.

In 1985, the remains of the airfield, and this hangar specifically, were used as a set in the Kevin Costner movie "Fandango." At some point thereafter, all the metal parts of the hangar were scrapped, leaving only the two concrete monoliths rising out of the desert. Passersby on Interstate 20 must surely wonder what noble purpose these mighty structures once served

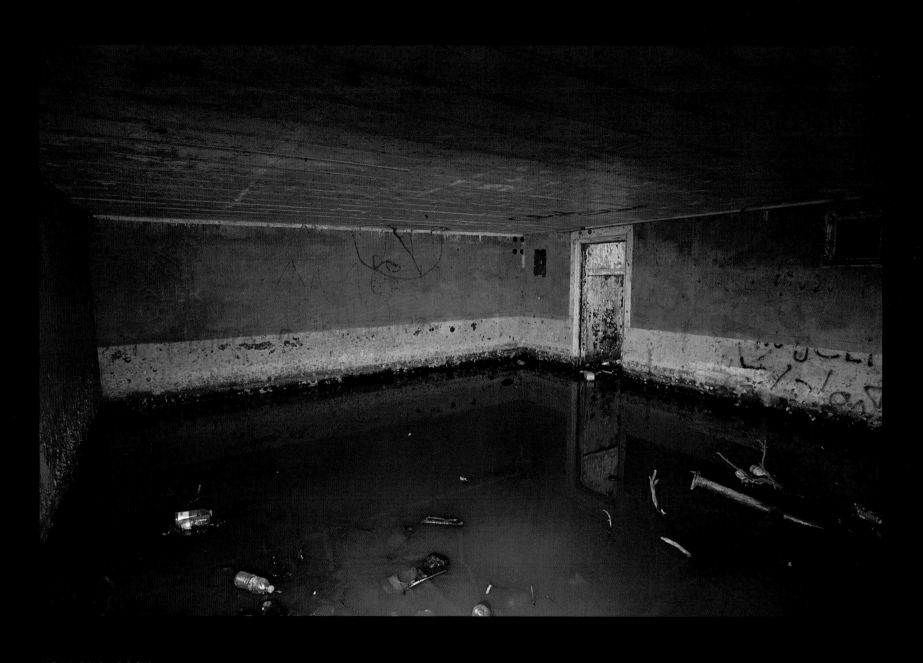

KILLING ROOM
NIKE MISSILE SITE
HAWK HILL, SAN FRANCISCO, CALIFORNIA
AUG 07

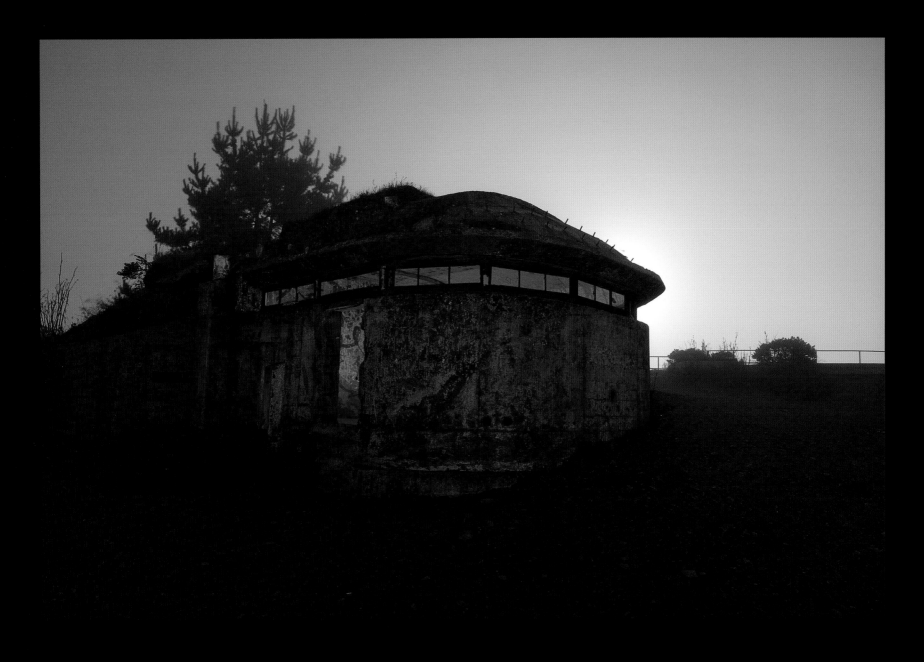

SF-87C
NIKE MISSILE SITE
HAWK HILL, SAN FRANCISCO, CALIFORNIA
AUG 07

The spectacular scenic drive out Conzelman Road in the Marin Headlands is punctuated by several WWII-era coastal defense installations, including this Nike Missile Integrated Fire Control Station atop Hawk Hill, known as SF-87C. It was the Control site for SF-87L, a Nike missile Launch site located down the hill at Fort Cronkhite. When the fog lifts, a spectacular view of the Golden Gate can be seen just over the railing in the background.

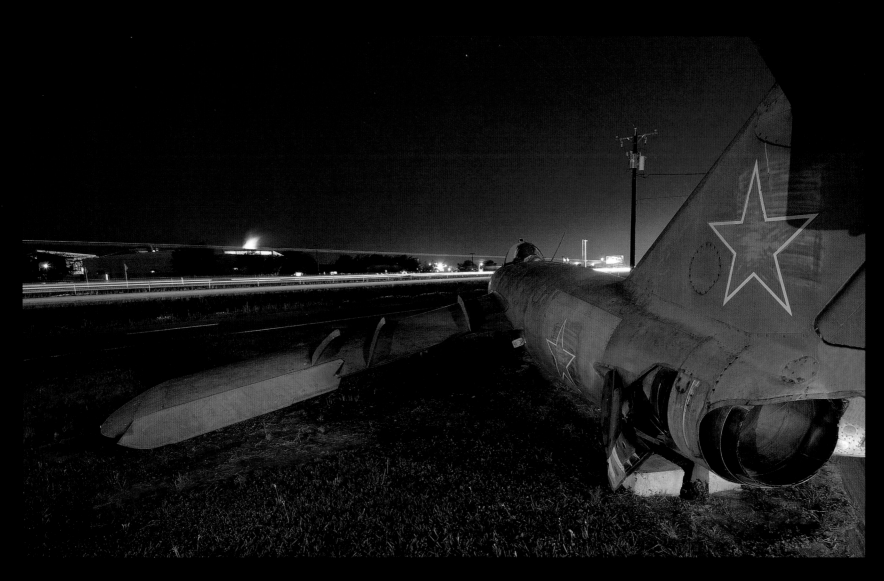

SPEED BRAKE
SOVIET FIGHTER JET
FORNEY, TEXAS . APR 08

It's not every day you encounter a Soviet-era fighter
jet parked along the highway in north Texas, so when
I saw this one, I figured I'd better shoot it.

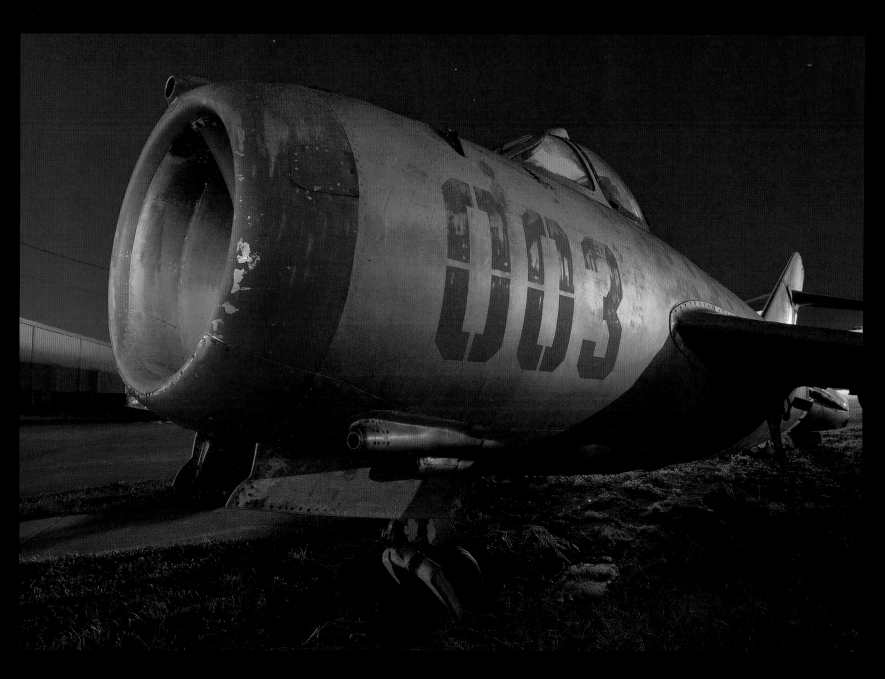

RED SCARE
SOVIET FIGHTER JET
FORNEY, TEXAS . APR 08

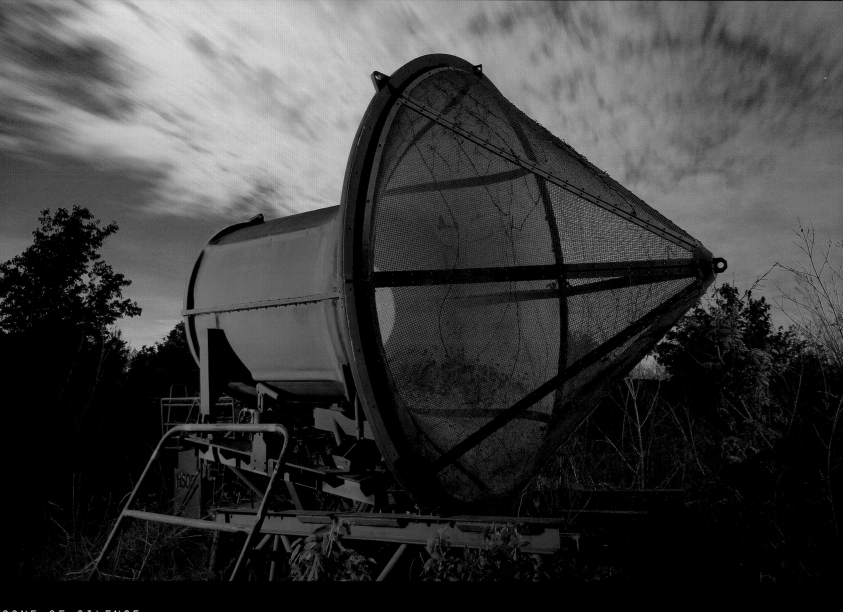

CONE OF SILENCE
DISCARDED MILITARY EQUIPMENT
SAN ANTONIO, TEXAS . APR 08

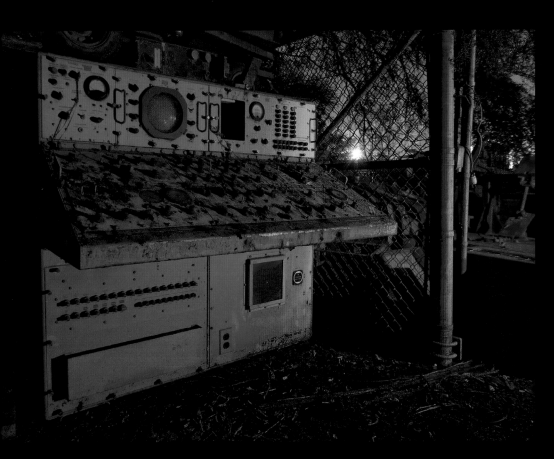

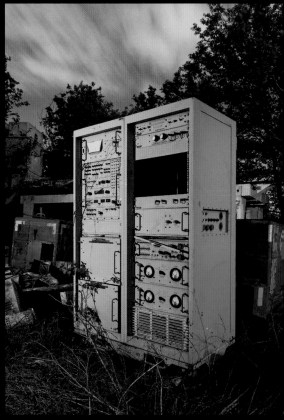

own San Antonio way, tucked back in an industrial airport neighborhood, lies a military junkyard where the armed services send outdated equipment to rust away under the Texas sun.

This collection of arcane hardware is stored along the edges of a series of dirt trails worn through the yard. In the middle of the night, it's not too difficult to get lost on these winding trails that lead in all directions.

The center image is of some sort of radar simulation equipment designed for educating trainees, probably at one of the Air Force bases in the greater San Antonio area. I've been told the device on the facing page was used to test jet engines – easily one of the more exotic-looking items on the tour.

The image above right is named for some old DYMO labels that were still stuck to the unit, proclaiming its purpose as "spectrum analysis and power management."

Wandering through this maze of discarded military hardware, I couldn't help thinking of the remarkable cost associated with the development of such technical equipment, and how transient those expenses are in this age of rapidly-advancing technology.

THERE'S CLEAN...AND THEN THERE'S ARMY CLEAN
ABANDONED ARMY HEADQUARTERS
BROWNWOOD, TEXAS . JUL 08

Active from 1940 to 1946, the 3rd Battalion Headquarters Building in Brownwood hasn't seen troops in nearly seventy years. But the motor pool still seems to be active.

This location will forever be linked in my mind to my good friend, the brilliant photographer Robert Feuille — better known as his public persona, Rob Fuel. An El Paso native, Rob resided in Austin at the time, and we agreed to meet up in Brownwood to shoot its many intriguing abandonments. It was an "epic trip," as we urban-exploration photographers say, and for Rob and me, it solidified our respect for each other as artists and our connection as good friends. I've seldom enjoyed shooting more than I did those three days in the summer of '08 in Brownwood.

In spring of the following year, Rob was blindsided by the news that he had cancer. Over the next twelve months, he underwent increasingly aggressive treatments to defeat it, but on May 29, 2010, the cancer ended Rob's life at the tragically young age of 28.

Rob left behind a beautiful wife, two sweet young daughters, and a baby boy. He also left a legacy of class, dignity, and compassion such as I've never seen in another human being. His many friends and fans not only enjoyed his extraordinary talent as a photographer and writer, but also his kind spirit and gentle personality. I was privileged to call him my friend.

ROB FUEL
IMAGE COURTESY OF JOSHUA CAMERON

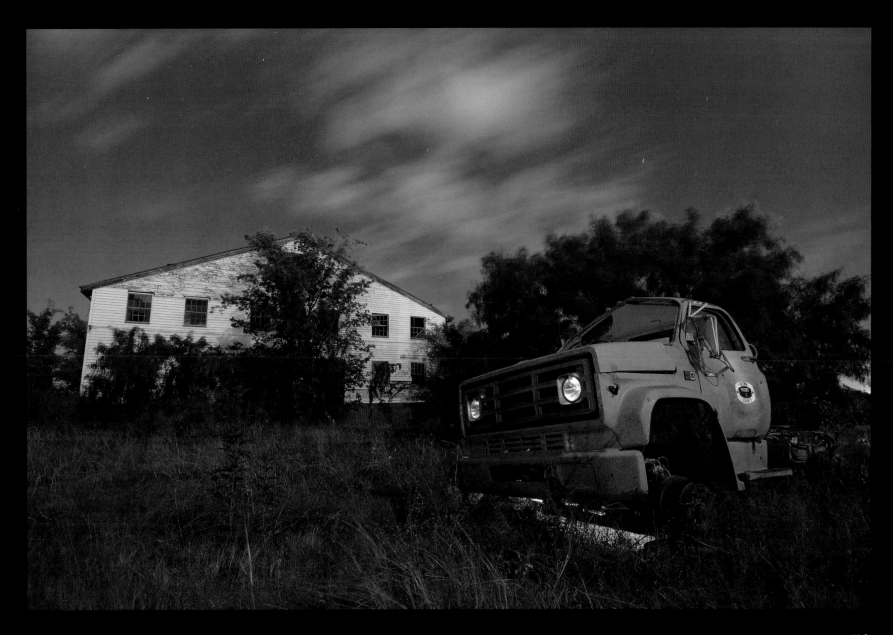

HQ
ABANDONED ARMY HEADQUARTERS
BROWNWOOD, TEXAS . JUL 08

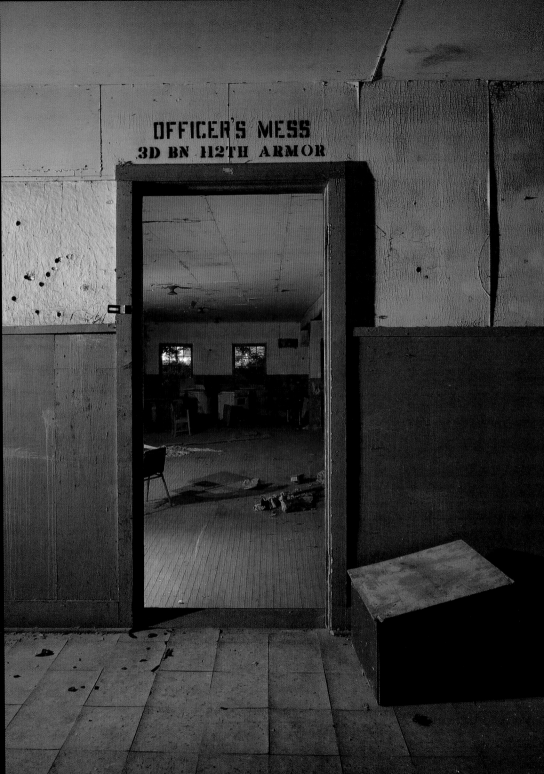

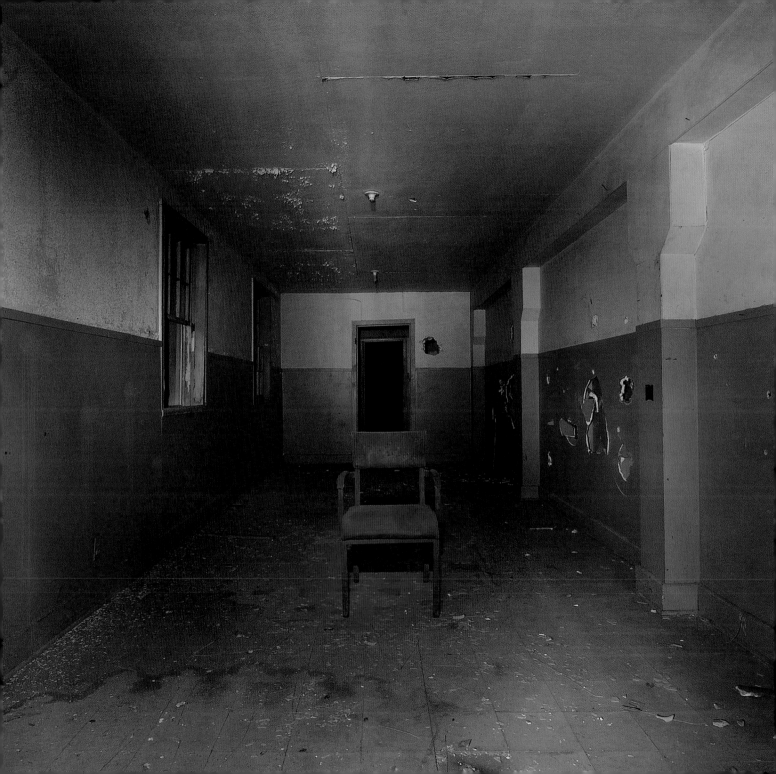

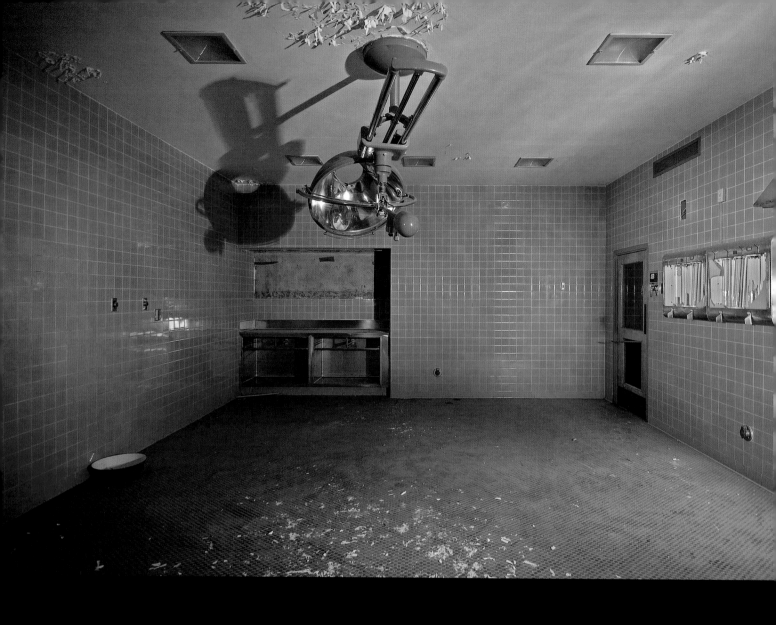

O.R.

ABANDONED ARMY HOSPITAL

MINERAL WELLS, TEXAS . AUG 08

Deep inside the third floor of the long-abandoned
Beach Army Hospital at what was once Fort Wolters

can find anything here, from '70s-era stereo e
to a small-block automobile engine in the

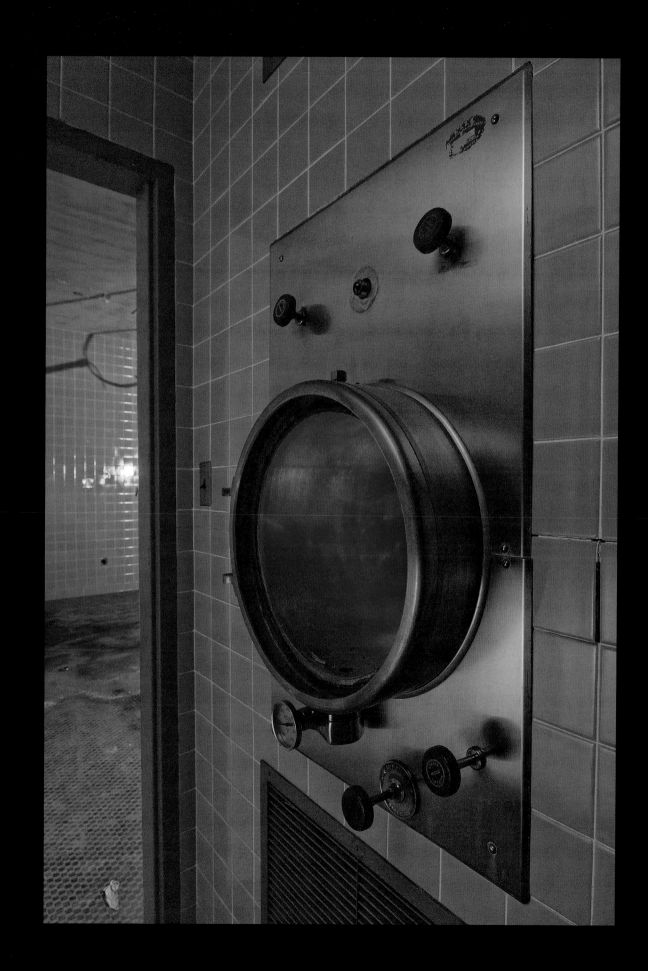

AUTOCLAVE
ABANDONED ARMY HOSPITAL
MINERAL WELLS, TEXAS
AUG 08

BOWL

ABANDONED NAVAL BASE

TREASURE ISLAND CALIFORNIA . AUG 07

PIERLESS

ABANDONED NAVAL BASE

TREASURE ISLAND CALIFORNIA . AUG 07

STO

ABANDONED NAVAL BAS

TREASURE ISLAND, CALIFORNIA . AUG C

Treasure Island is a man-made island in San Francis
Bay, halfway between Oakland and San Francisc
Created in the 1930s, the island hosted the World
Fair in 1939. During World War II, it was repurpos
as Treasure Island Naval Base and remained in servi
until its decommission in 1997.

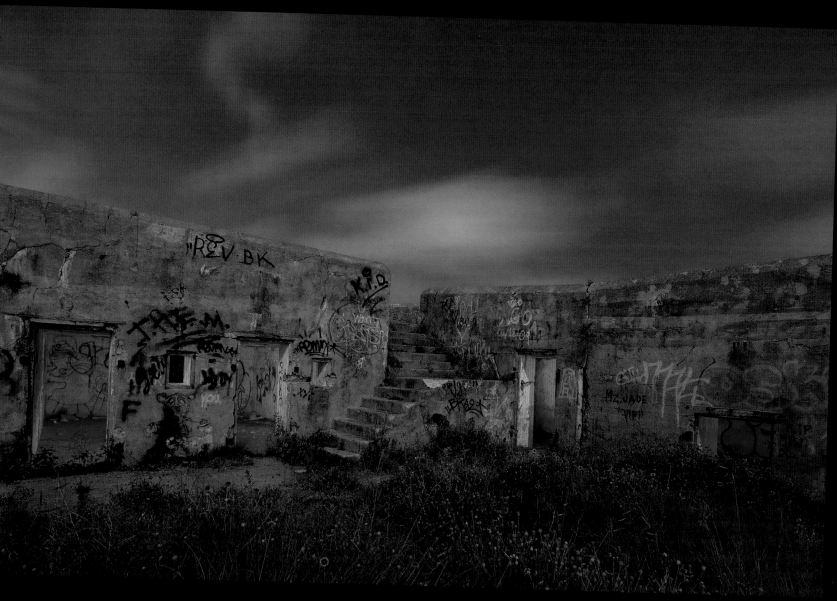

BATTERY CROGHAN
ABANDONED COASTAL DEFENSE BUNKER
GALVESTON, TEXAS . JUN 10

Battery Croghan was part of the Endicott-era Fort San Jacinto coastal defense complex located on the eastern end of Galveston Island, guarding the entrance to Galveston Bay. Built in 1899 and damaged in the great hurricane of 1900, it was restored to original condition and served the country until 1946, when it was decommissioned. It has stood abandoned and decaying ever since.

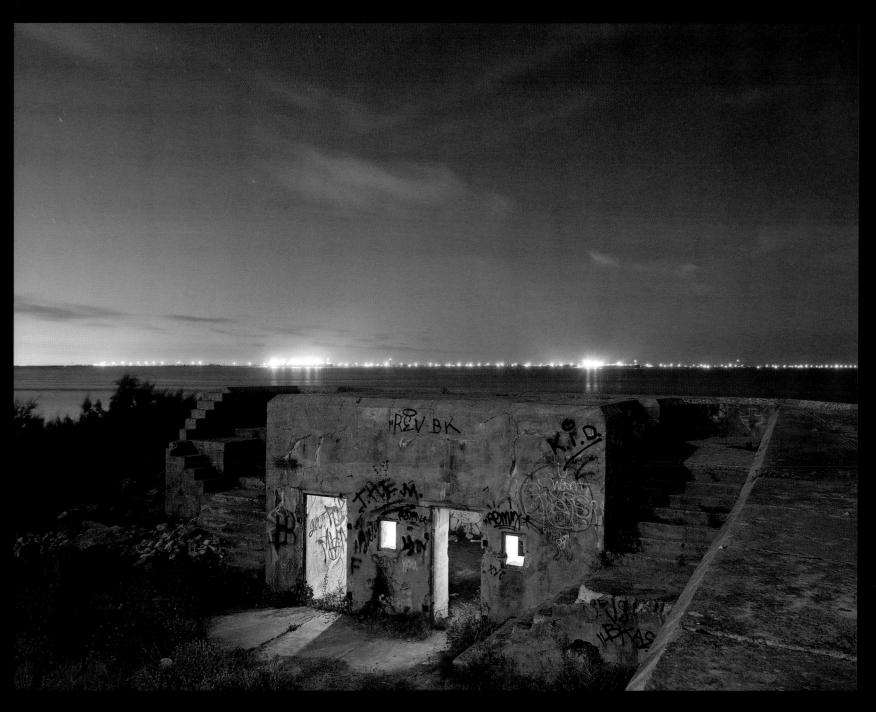

BATTERED BATTERY
ABANDONED COASTAL DEFENSE BUNKER
GALVESTON, TEXAS . JUN 10

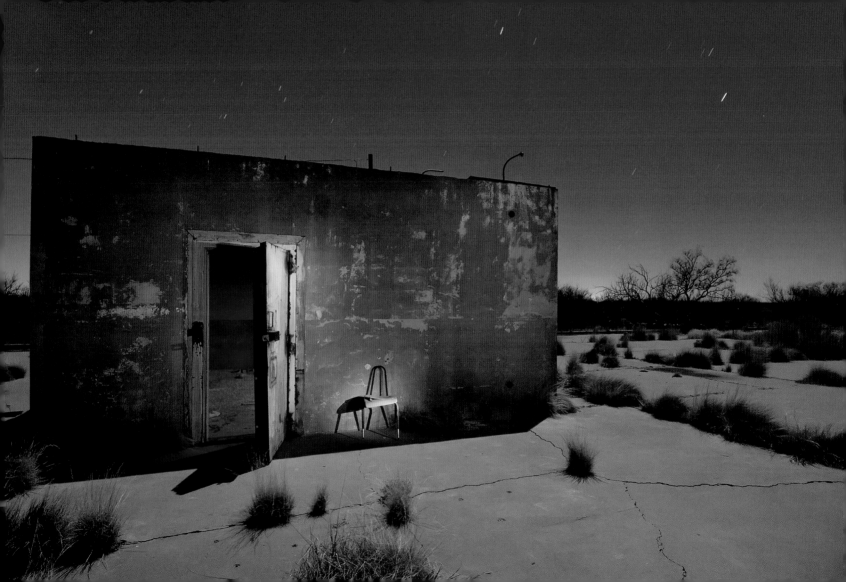

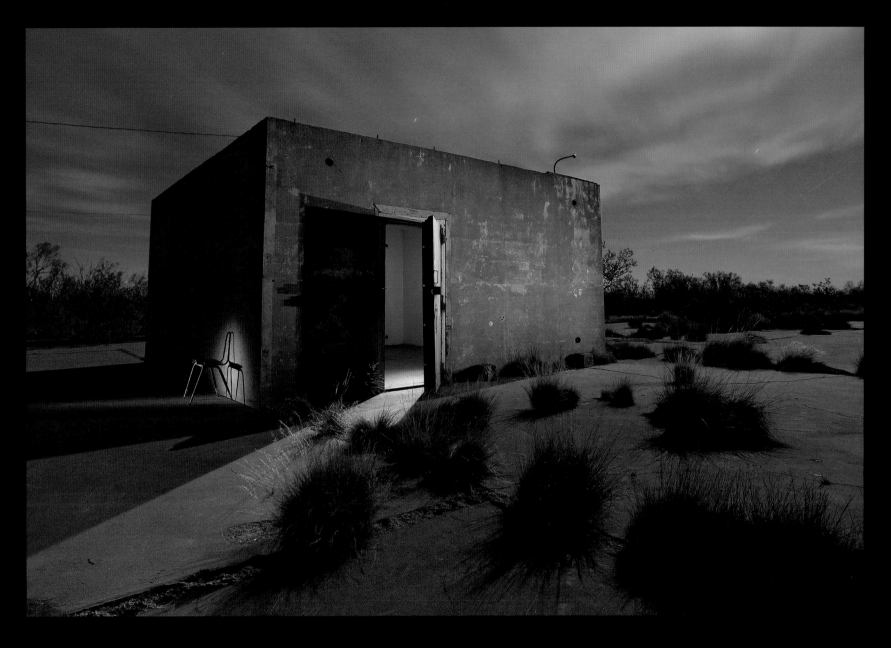

the trash had been removed and the floor swept clean. This building is truly in the middle of nowhere, on a fenced-off Air Force base abandoned for over 50 years. It's a half-mile hike through cactus, scrub, barbed wire, and rattlesnake-infested desert to get there.

So how this floor got swept clean is a mystery. It added a slightly eerie vibe to my exploration of this remote desert outpost.

BUNKER REVISITED
ABANDONED MUNITIONS STORAGE BUNKER
PYOTE, TEXAS . APR 09

GHOST TOWNS

CHRISTIAN CHURCH
CONDEMNED TOWN
PICHER, OKLAHOMA . JUL 10

An abandoned "Christian Church" in Picher, Oklahoma...
with a handy sign above the door in case you couldn't
tell from the architecture.

In 1926, Picher had a population of about 14,000;
by 1930, it was half that, and in 2008, only 150
remained. in the summer of 2010, it was hard to find
anyplace that was clearly still occupied. Why the
exodus? Because the air, water, and soil around Picher
are contaminated with runoff from over 70 million
tons of toxic "chat" left behind after decades of
lead and zinc mining in the area. These contaminants
poisoned Picher's residents; children were especially
susceptible.

In 1983, the federal government designated the whole
area a Superfund site and began buying up property to
help residents escape to... just about anywhere else.

The process of systematic evacuation was expedited
in 2008, when an F4 tornado ripped through Picher,
killing eight people and decimating some twenty blocks
of the already crippled community - surely a sign to
the remaining few that they should get the hell outta
town.

Since then, Picher's few remaining residents have
been steadily evacuating, and as of February 2011,
demolition had reportedly begun.

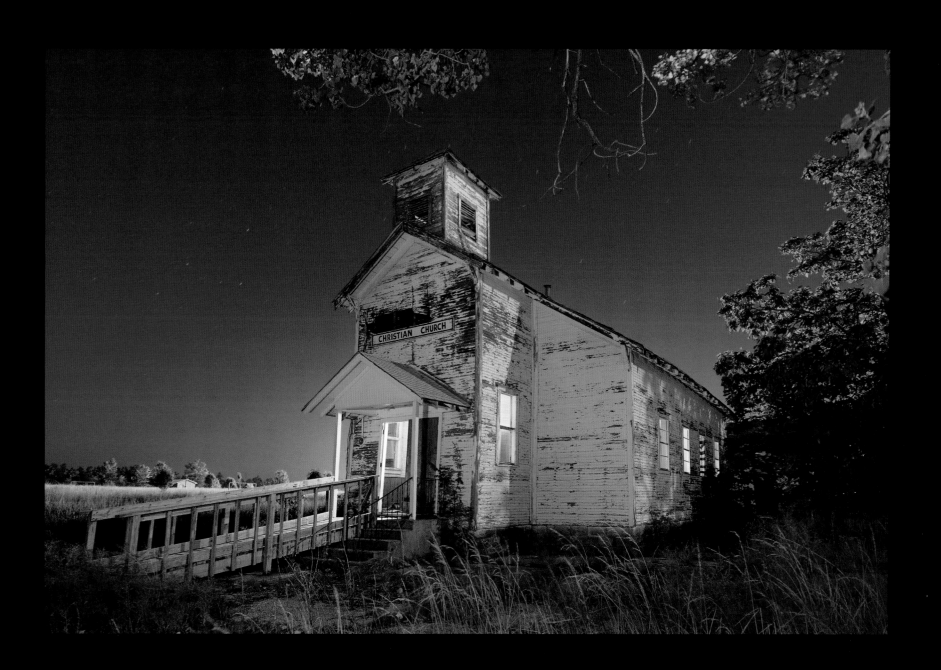

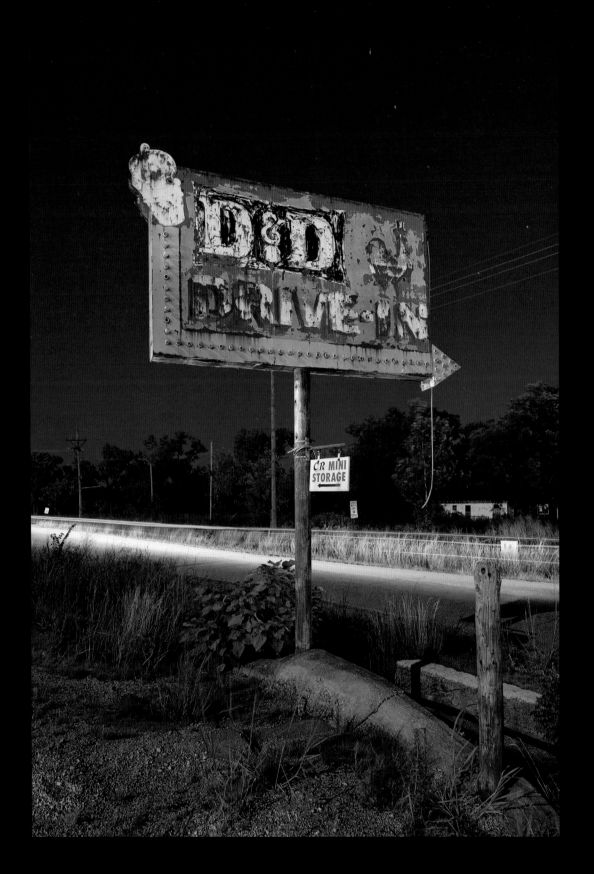

D&D
CONDEMNED RESTAURANT
PICHER, OKLAHOMA . JUL 10

Despite the allure of its dapper,
top-hatted rooster, Picher's D&D
Drive-In – "The Last Place In Picher"
– has served its last cone.

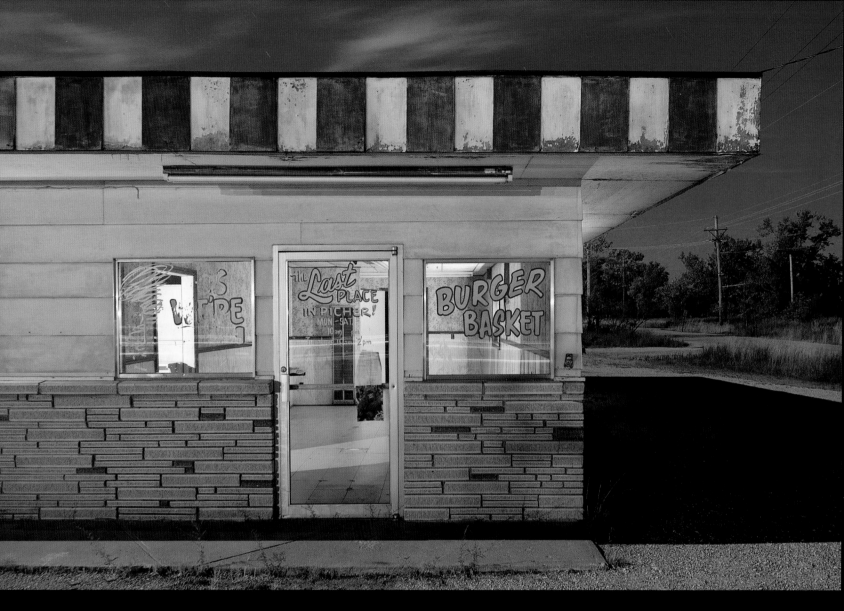

The town of Picher is part of what's known as the Tar Creek Superfund site, an area of northeast Oklahoma regarded as one of the most toxic places in America.

There are two smaller communities connected to the Superfund site, as well: Cardin, Oklahoma, which appeared at the time of my visit to have only a single resident remaining; and Treece, Kansas, about a mile north of Picher - similarly abandoned, and home to the defunct gas station on the next page.

The whole Tar Creek area is creepy and surreal — empty homes lining every street and massive mountains of chat looming over every treeline. On a satellite view of Picher prior to its demolition, the huge white mounds of toxic mining waste made it appear the town had been built in a sand desert.

Picher is an interesting place to visit — but you truly wouldn't want to live there.

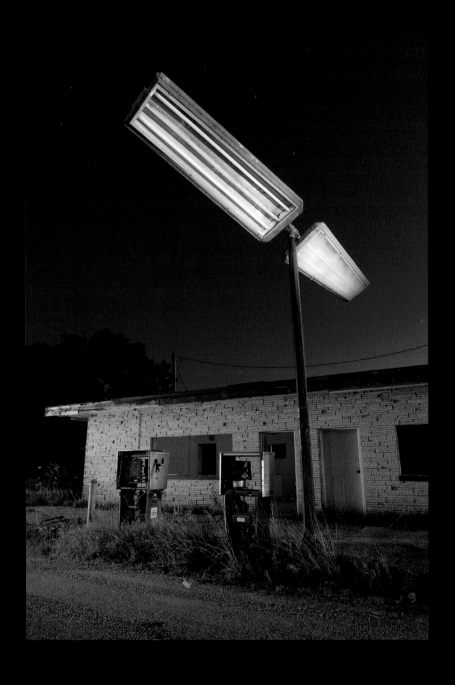

LIGHT WINGS
CONDEMNED GAS STATION
NEAR TREECE, KANSAS . JUL 10

SUBSISTENCE VANDALISM
CONDEMNED HOMESTEAD
PICHER, OKLAHOMA . JUL 10

This humble little homestead is another victim of the horrific pollution that first took some of Picher's townspeople, then began eating away at the town itself. Notice the wooden screen door here, seeming to melt into the poisonous soil beneath it. As always though, the weeds seem to find a way to thrive.

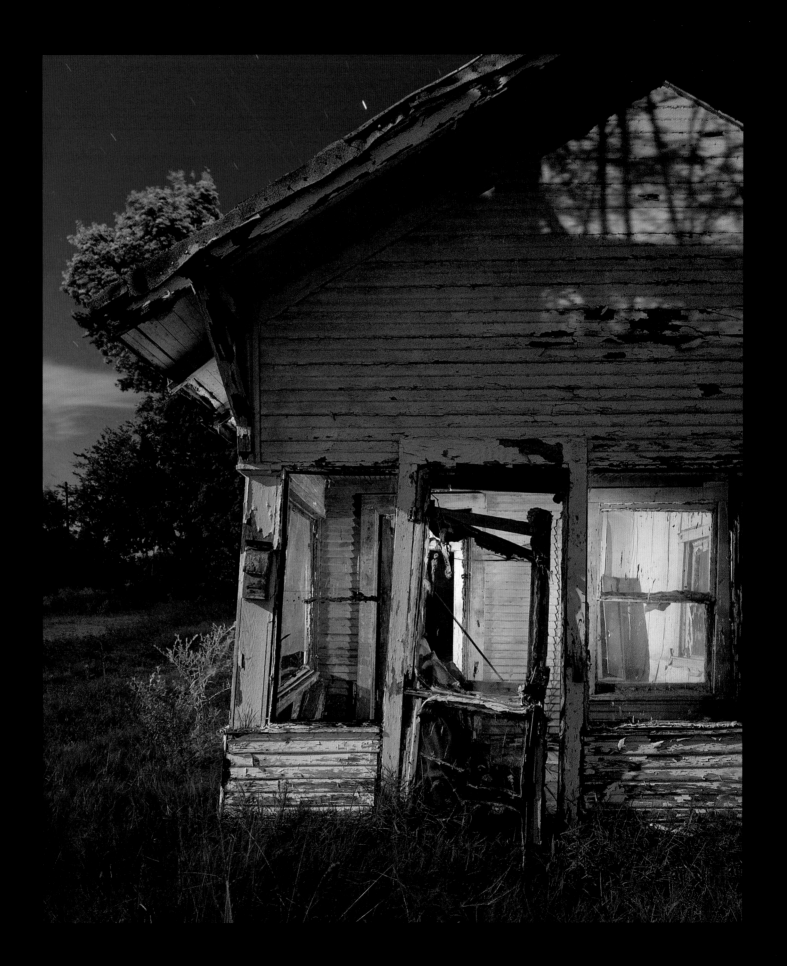

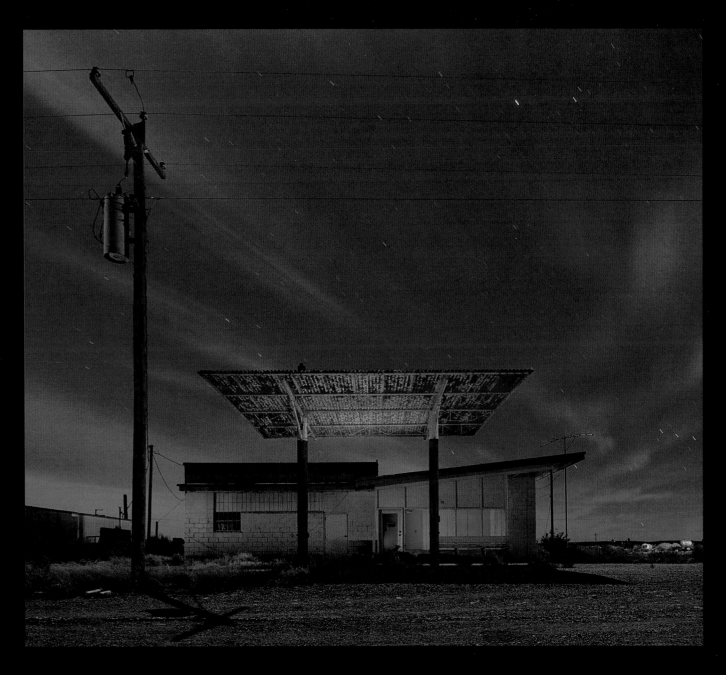

ORLA GAS
ABANDONED GAS STATION
ORLA, TEXAS . APR 09

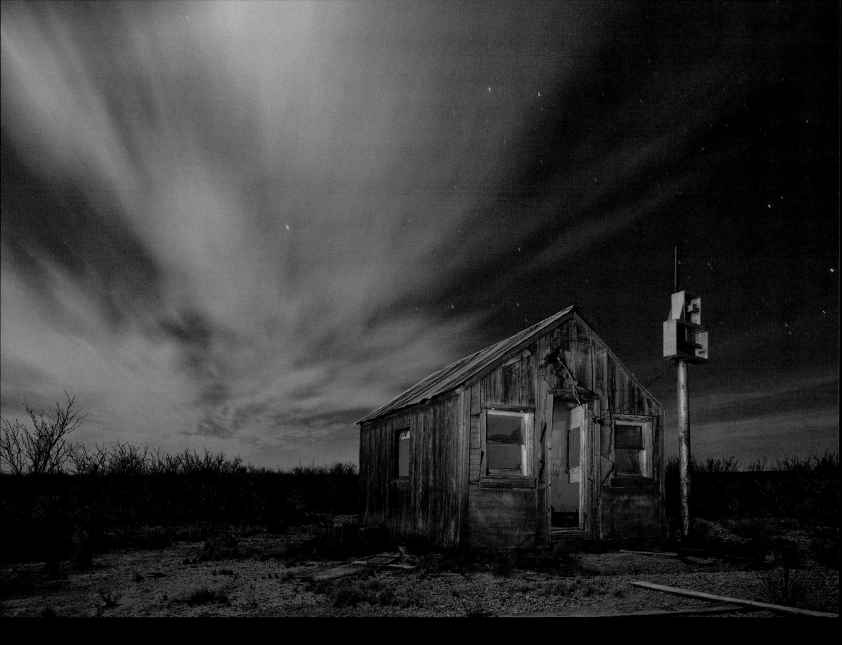

CURIOSITY
ABANDONED BUSINESS
ORLA, TEXAS . APR 09

Set nearly a hundred feet off the road amidst the brush and cactus, this little structure is typical of the abandonments to be found in the west Texas ghost town of Orla. I couldn't find a clue as to what sort of enterprise it had been, but at some point, it apparently merited an electric sign.

On the facing page is another once-going concern: a gas station with the classic soaring roofline of the 1950s, just down the road from the Curiosity Shop.

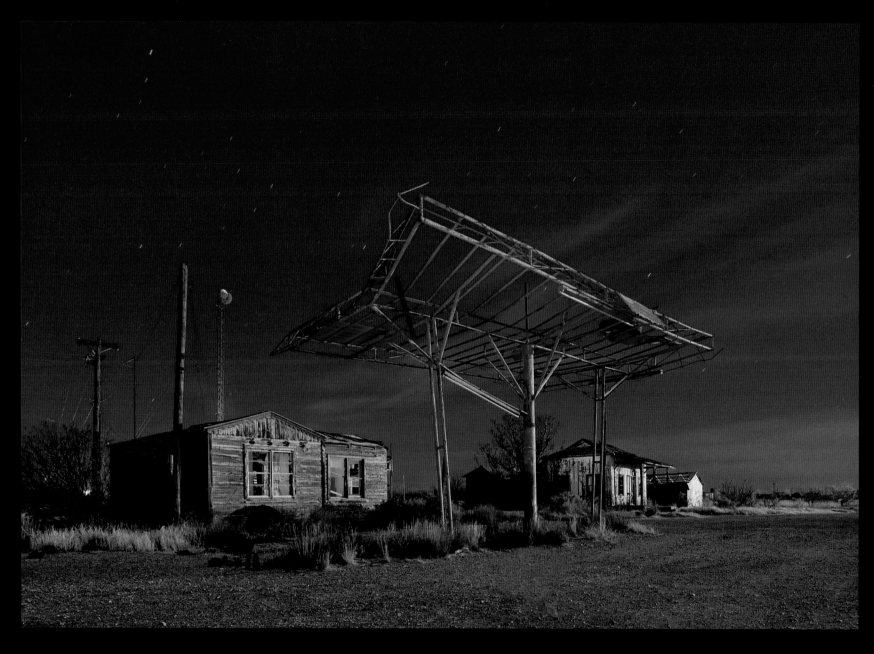

FUEL FOSSIL
ABANDONED GAS STATION
ORLA, TEXAS . APR 09

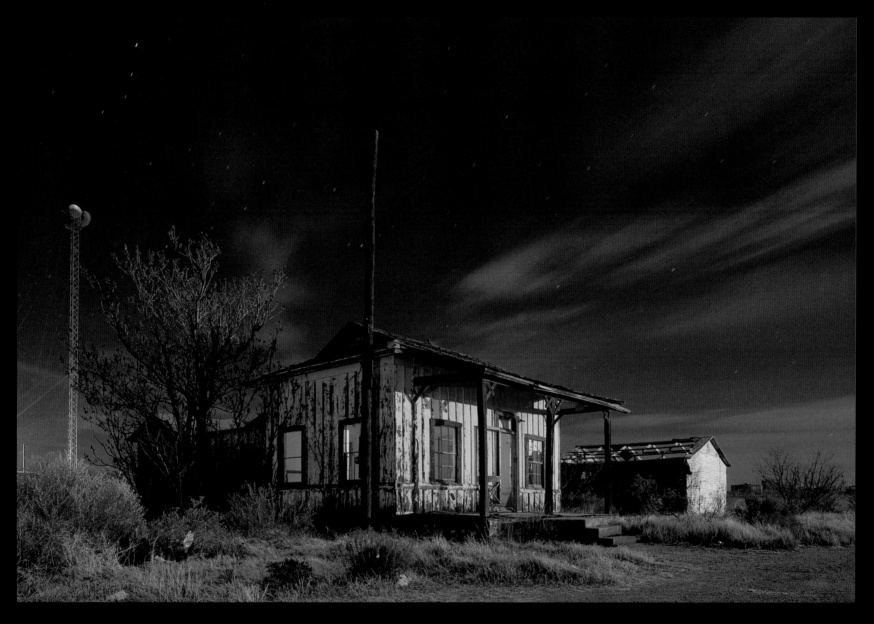

Rustic wooden shacks, a twisted metal framework, a
scruffy patch of desert...and a communications tower,
just about the only thing left in Orla that's still
in service.

THE NIGHTFLY
ABANDONED SHACKS
ORLA, TEXAS . APR 09

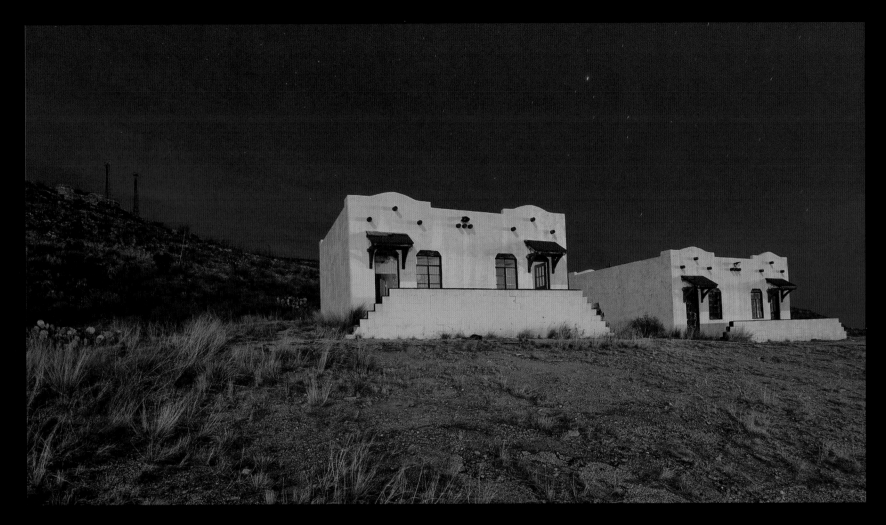

BUNGALOWS
ABANDONED MOTEL
WHITES CITY, NM . APR 09

Built in the early 1900s, Whites City was a tourist trap near the entrance to Carlsbad Caverns, located in the desert mountains of southern New Mexico. In 2008, I had rolled into town in the dead of night to shoot an old Phillips 66 station, but hadn't noticed the little gem on the facing page carved into the mountainside overlooking the town.

On this trip, my shooting partner and I were photographing some abandoned bungalows in town (above) around 2:30 in the morning when I noticed what looked like a castle up on the side of the mountain. No debate: we agreed that it had to be explored and photographed, so we loaded back into the SUV. After thirty minutes of bouncing around on the narrow, rocky trails that cling to the back edge of the hillside, we finally found a path that led off to the castle.

I immediately set up for a shot, while my partner forged ahead and entered the castle. Opening my shutter, I shouted out, "Hey, fire off a red strobe for me as you go!" He did, and this is the result.

When I researched the little castle's purpose, I learned it was built purely as a tourist attraction, something to lure drivers off the highway to spend their money in Whites City...now little more than a ghost town.

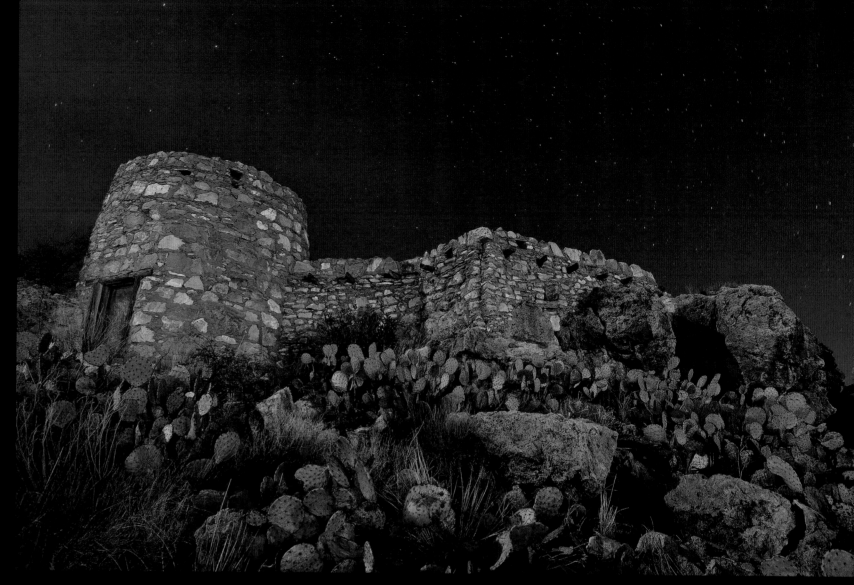

STORMING THE CASTLE
ABANDONED TOURIST ATTRACTION
WHITES CITY, NEW MEXICO . APR 09

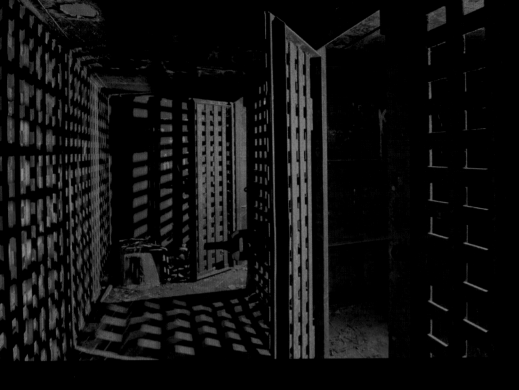

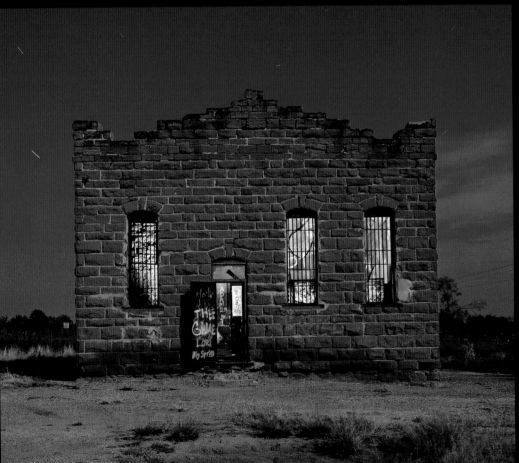

OPEN DOOR POLICY
KENT COUNTY JAIL
CLAIREMONT, TEXAS . SEP 07

Between Abilene and Lubbock on the
west Texas plain lies the little town
of Clairemont and the jail that once
served it. Built in 1895 with daunting
strap-iron cells, the Kent County Jail
is now a registered historical site.

The small sandstone structure has only
two cells, but in its day, it was known
across the state for being virtually
escape-proof.

TOXIC DUMP
OUTHOUSE
ESKOTA, TEXAS . FEB 08

Driving down the narrow dirt road that runs along the rail line into this little ghost town, you wouldn't think the place had ever warranted a name. There's not much there — just a farmhouse on the south side of the tracks, and the standard small-town railroad sign with the name of the town painted on it. But if you keep your eyes on the north side of that little road, you'll glimpse an abandoned homestead among the cactus and desert overgrowth.

Welcome to Eskota.

I shot this little outhouse behind that homestead on my second visit to Eskota. I had passed that way several months earlier and shot an old radio station in the middle of a field near Clairemont. As I drove away from that location, my headlights swept across a huge rattlesnake slithering off the trail into the very weeds I had just been tromping about in.

Eskota was to be my next stop that night, and as I made my through the darkness, I began to realize that the terrain around this little house was even more conducive to rattlesnake inhabitation than the place I'd just left. So I decided to curtail my nocturnal excursions into snake country until colder weather...or at least until I could buy some snake guards!

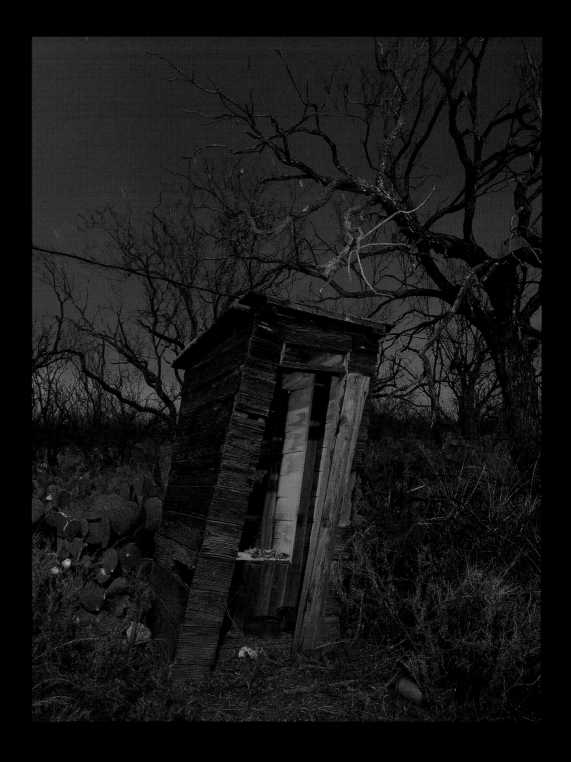

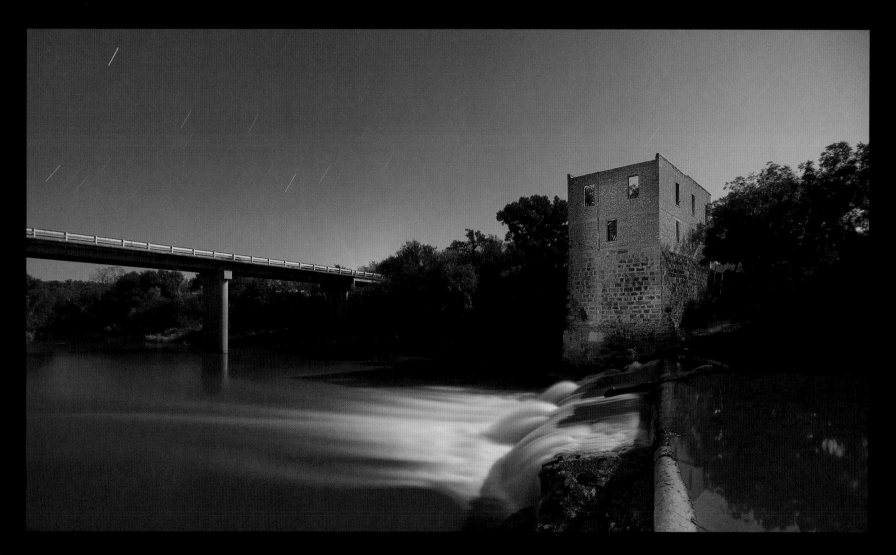

The old Donnell Mill was built in the late 1800s on the clear fork of the Brazos River and employed many of the town's residents. It burned in 1927 and never re-opened, leaving Eliasville to gradually fade away. The building in the picture at left is the most substantial structure left in this dying little community.

The elongated star trails were the result of an unusually long ten-minute exposure.

DONNELL MILL
ABANDONED GRAIN MILL
ELIASVILLE, TEXAS . SEP 07

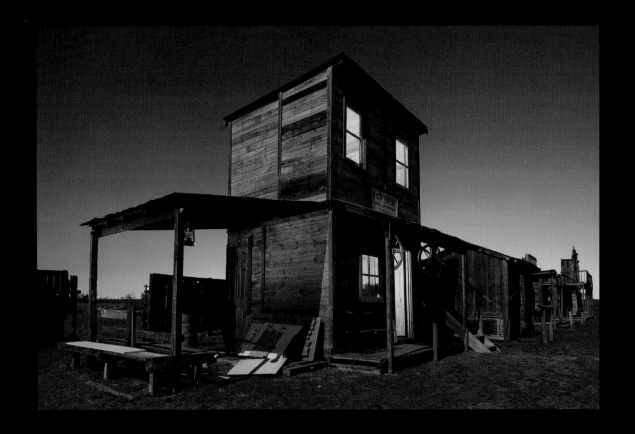

B&O HOTEL
FAUX OLD WEST GHOST TOWN
NEAR MANOR, TEXAS . MAR 09

TACK SHARP TACK
FAUX OLD WEST GHOST TOWN
NEAR MANOR, TEXAS . MAR 09

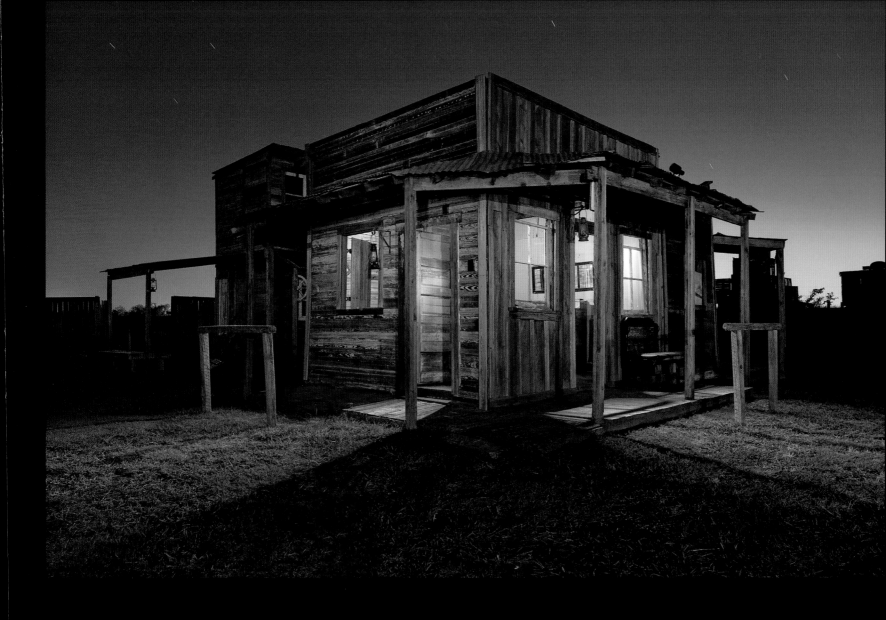

STAGE COACH OFFICE
FAUX OLD WEST GHOST TOWN
NEAR MANOR, TEXAS . JUL 09

By day, the commercial nature of the J Lorraine
"ghost town" might be noticeable, but by night, it's
possible to suspend your disbelief. Even the sunset
is false: these shots were made in full darkness
with the lights of a nearby industrial site in the
background.

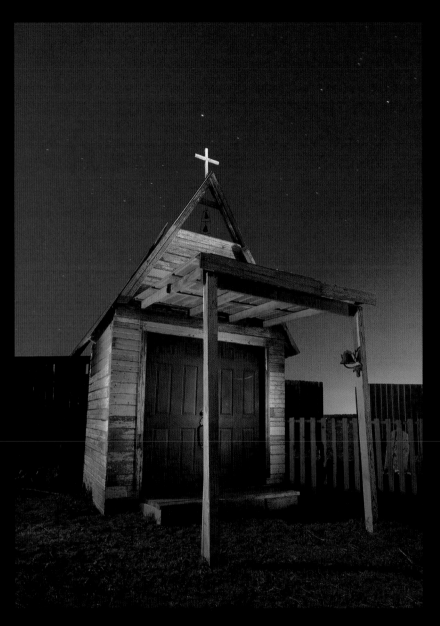

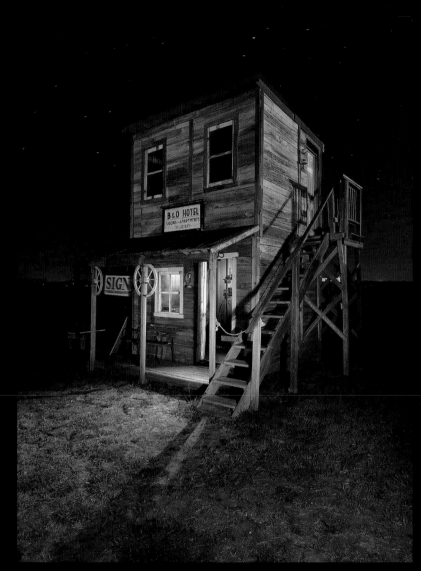

CHAPEL
FAUX OLD WEST GHOST TOWN
NEAR MANOR, TEXAS . MAR 09

B&O
FAUX OLD WEST GHOST TOWN
NEAR MANOR, TEXAS . JUL 09

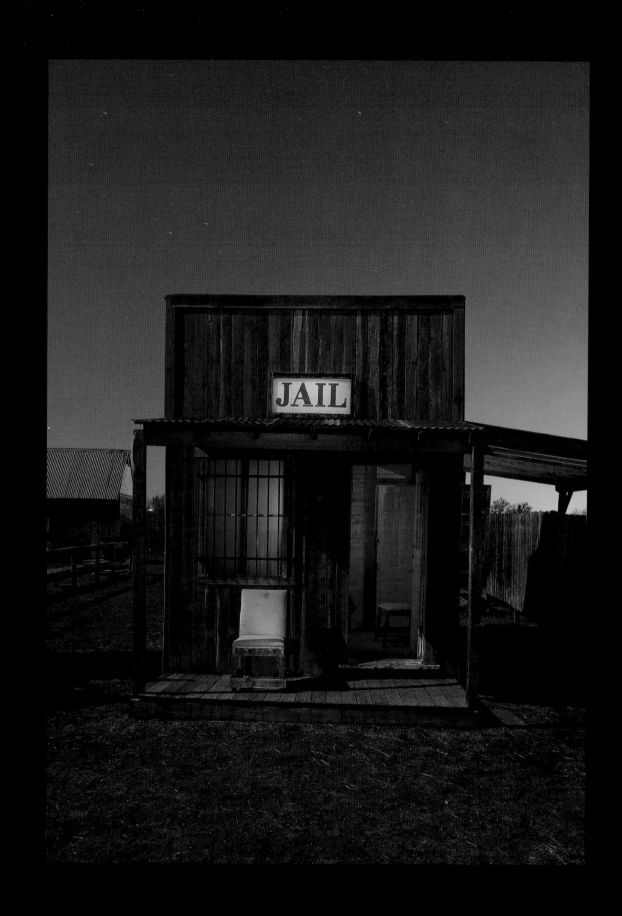

JAIL
FAUX OLD WEST GHOST TOWN
NEAR MANOR, TEXAS . MAR 09

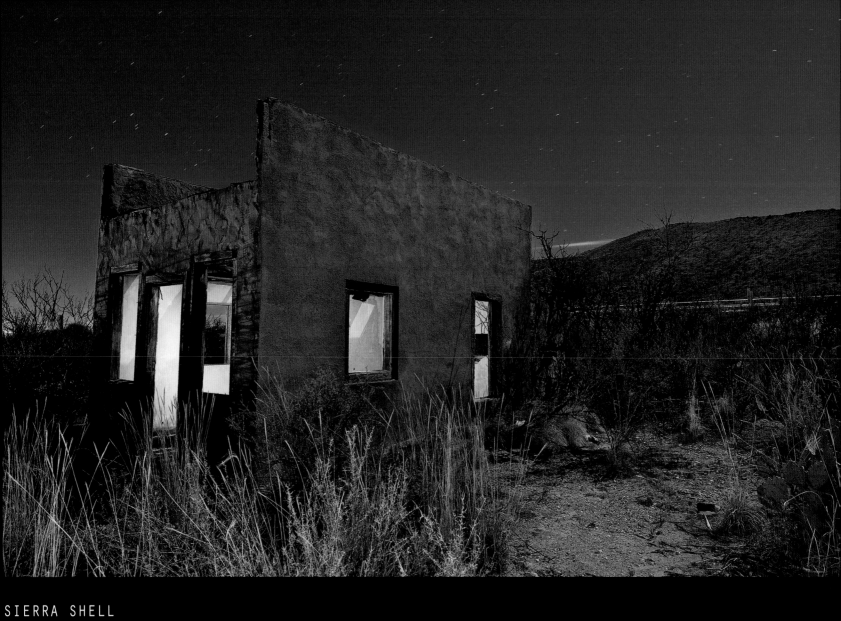

SIERRA SHELL
ABANDONED BUILDING
SIERRA BLANCA, TEXAS . APR 09

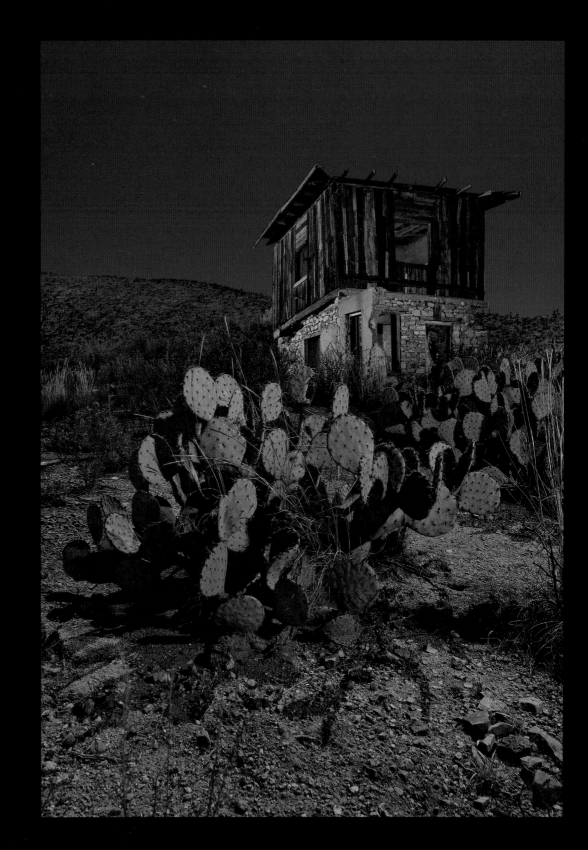

CACTUS SHACK
ABANDONED BUILDING
SIERRA BLANCA, TEXAS . APR 09

In the far southwest corner of the
state, not far from the Mexican
border, I found the town of Sierra
Blanca and this little stone
building, with its second story of
rough wood and its thriving cactus
garden. The arid climate here tends
to preserve these old structures...
just one of the many reasons I prefer
the desert to more humid locations.

THE CHUCK WAGON
ABANDONED CAFE
SIERRA BLANCA, TX . APR 09

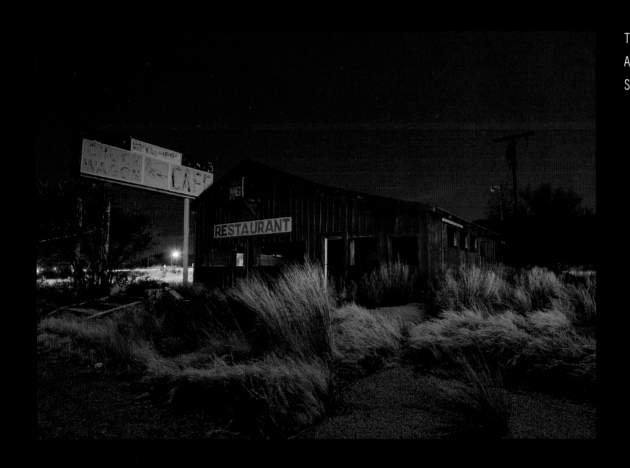

IF YOU CAN'T STAND THE HEAT...
ABANDONED DINER
SIERRA BLANCA, TEXAS . JAN 08

Inside the erstwhile Chuck Wagon
Cafe, a wagon-wheel chandelier
clashes with the marvelous old
glass block counter. A handy
wall poster offers Heimlich
instructions — mute testimony to
the cuisine.

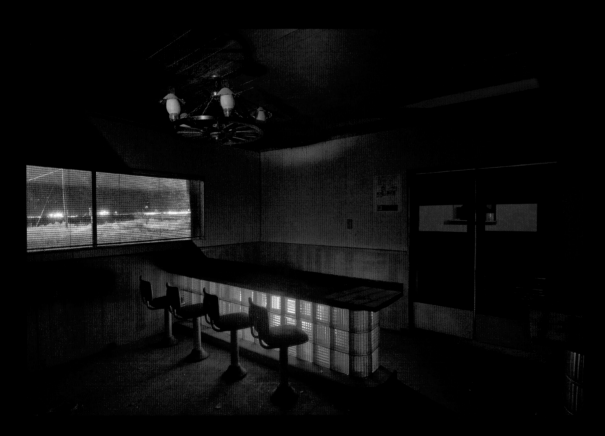

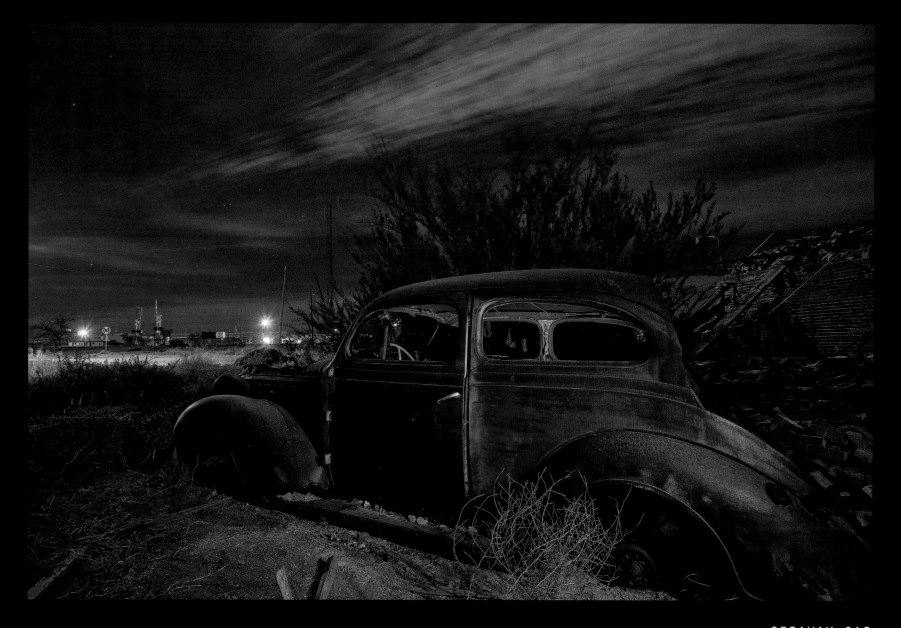

GETAWAY CAR
ABANDONED AUTOMOBILE
TOYAH, TEXAS . APR 09

This 1930s-era automobile stands outside - and partially under - the remains of the old bank building in what was once beautiful downtown Toyah, a trading post established in the west Texas desert in the mid-1800s.

In 1881, the railroad came through town. Business boomed and the population soared, but by 1915, the writing was on the wall for Toyah. The train stop had been moved down the line, and a steady exodus had begun. From a high of 1,100, the population dwindled to about 100 by the year 2000, and today, there seem to be fewer still.

Toyah's bank, once a stately structure marking the center of the little town, was reduced to a pile of rubble by a tornado on June 17th, 2004. This old sedan has clearly been rusting away here since long before that. Like the town itself, only a ghostly shell remains.

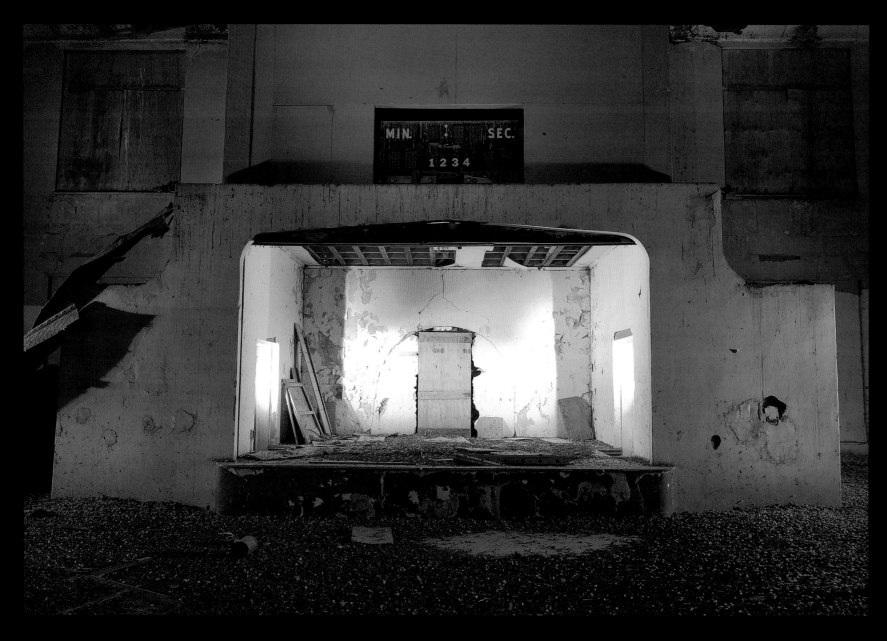

ALWAYS WITH THE DRAMA...
ABANDONED HIGH SCHOOL
TOYAH, TEXAS . JAN 08

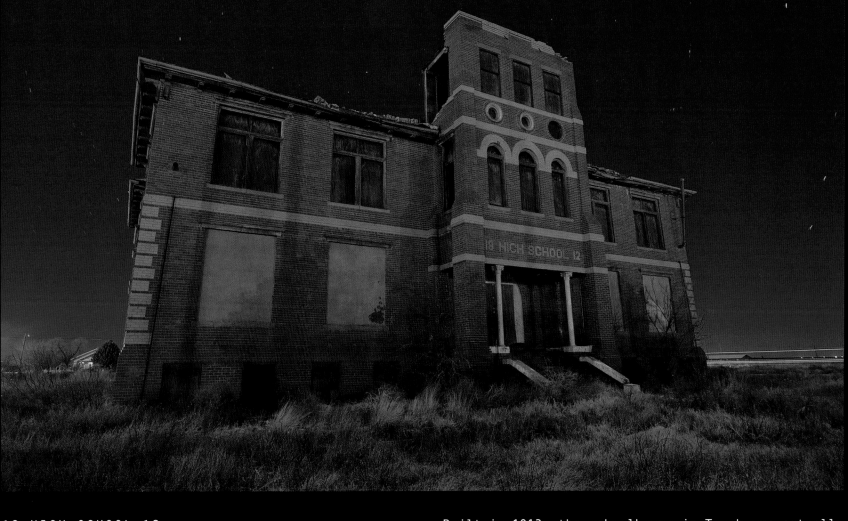

19 HIGH SCHOOL 12
ABANDONED HIGH SCHOOL
TOYAH, TEXAS . JAN 08

Built in 1912, the schoolhouse in Toyah was actually what they called an "El-Hi" school, meaning that both elementary and high school students were taught there. It served the town until about 1950, when Toyah was consolidated into the Pecos school system, nineteen miles away.

Retired as a schoolhouse, the building was then repurposed as a gymnasium and basketball court. Whether its stage was ever used again, I can't say — but the building is now home to countless pigeons, who are responsible for the floor decor in the picture at left.

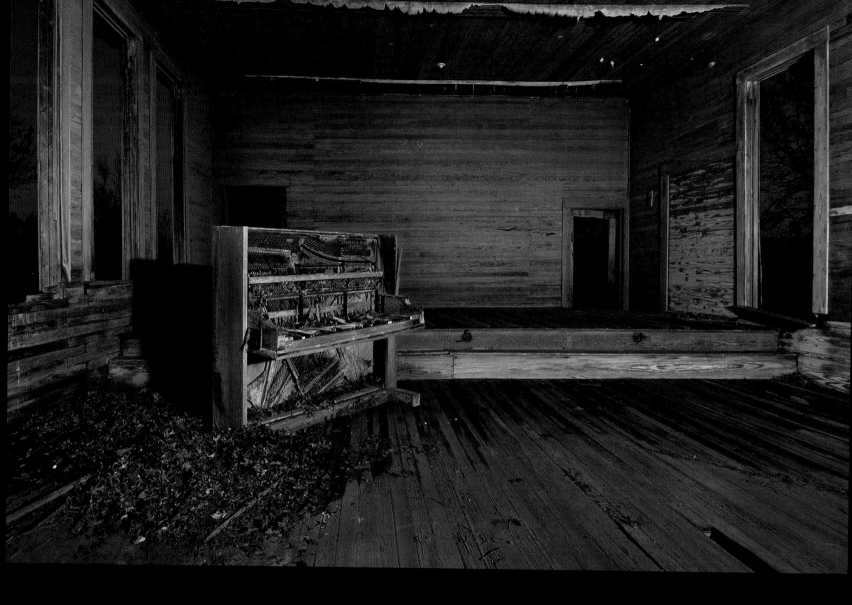

THE SCHOOL ON THE HILL
ABANDONED SCHOOLHOUSE
MOLINE, TEXAS . MAR 10

Abandoned for more than seventy years now, this one-room school house sits high atop a hill overlooking the Central Texas ghost town of Moline, not far from Brownwood.

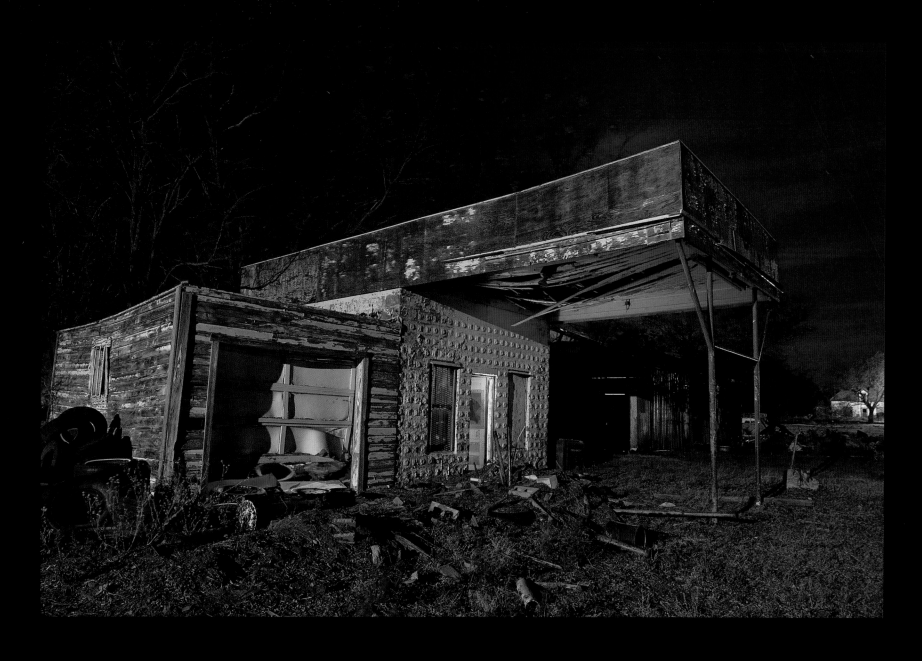

ZAPPED
ABANDONED FILLING STATION
TEXOLA, OKLAHOMA . NOV 07

This abandoned service station and "Fix-it Shop" sits right on the old Route 66 in Texola, Oklahoma, a ghost town on the Texas / Oklahoma border.

As I approached this place I noticed two very thin strands of wire running around its perimeter. Electric fencing, obviously; or it least it had been electric at some point.

But who would want to secure this old dump (literally) with an electric fence? Completely certain there was no risk, I swung one leg over the wire — and discovered that YES, in fact, someone did INDEED want to secure this place with an electric fence! I completed the fence-stepping-over process quite rapidly.

It turned out there was a herd of cattle in residence behind this building, which is why the fence was still hot.

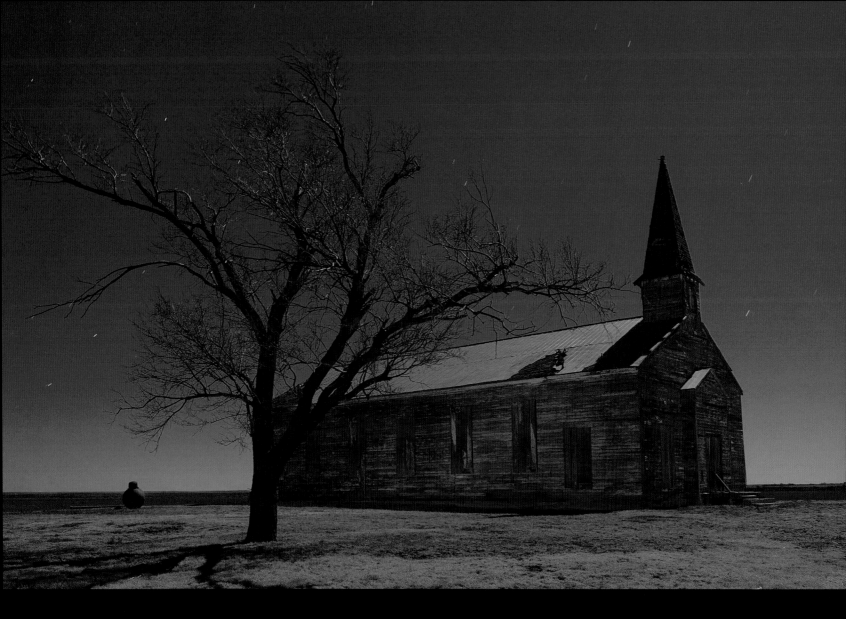

CEE VEE CHURCH
ABANDONED CHURCH
CEE VEE, TEXAS . JAN 09

Just outside the tiny prairie town of Cee Vee, out
near the West Texas panhandle, this beautiful old
church seemed to be dissolving into dust when I shot
it in 2009. But abandonment isn't always forever:
this church has since been renovated, restoring its
usefulness to the community, but destroying its
unique, rustic character.

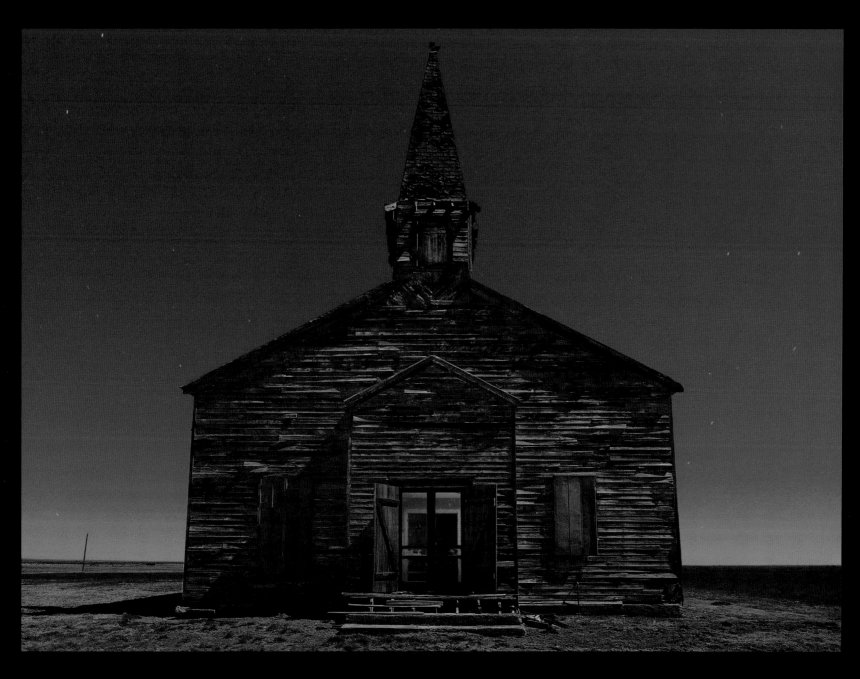

CEE VEE
ABANDONED CHURCH
CEE VEE, TEXAS . JAN 09

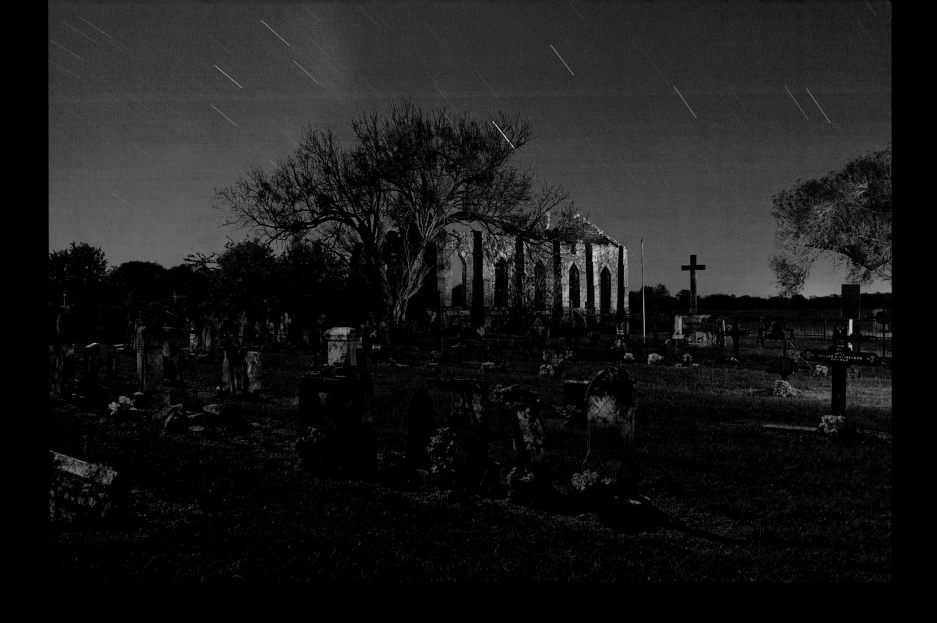

AT PEACE
CHURCH & CEMETERY RUINS
D'HANIS, TEXAS . OCT 07

Though it resembles some of the old churchyards you
might find in Ireland and Scotland, St. Dominic's is
located in the town of D'Hanis, not far from San
Antonio. Disused for decades, the church itself is
now nothing more than ruins. And while the cemetery
is no longer used either, the occasional plastic
flower suggests that the residents here haven't been
entirely forgotten.

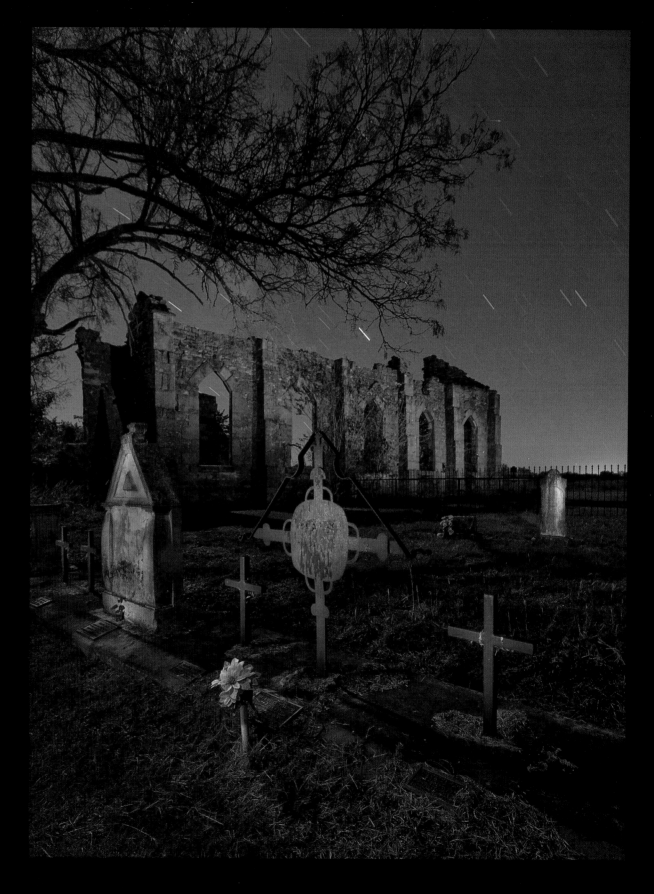

ST. DOMINIC CEMETERY
CHURCH & CEMETERY RUINS
D'HANIS, TEXAS . OCT 07

INDUSTRIAL DECAY

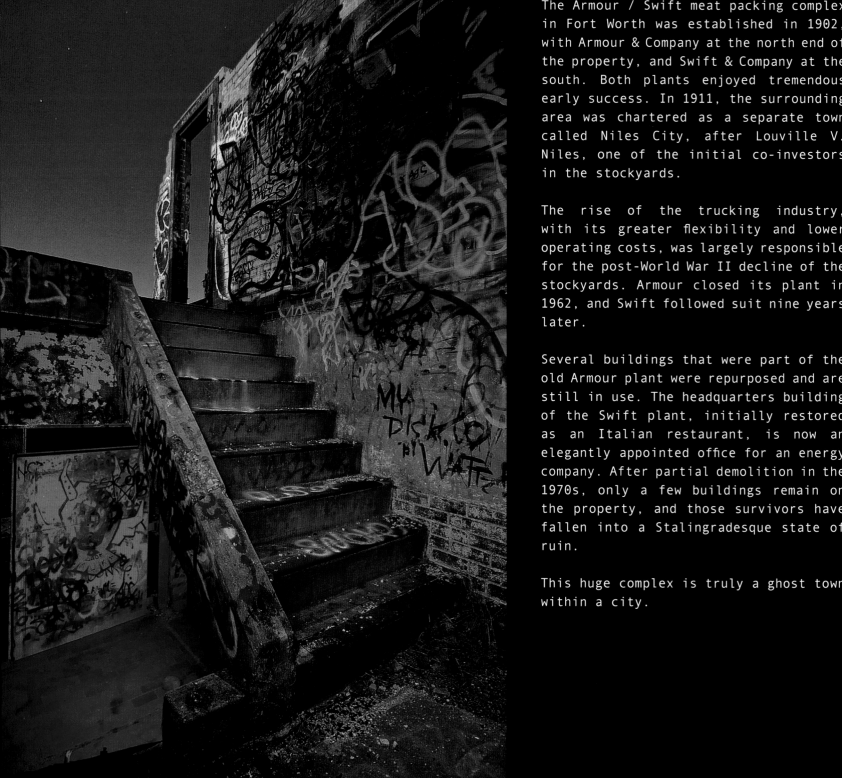

The Armour / Swift meat packing complex in Fort Worth was established in 1902, with Armour & Company at the north end of the property, and Swift & Company at the south. Both plants enjoyed tremendous early success. In 1911, the surrounding area was chartered as a separate town called Niles City, after Louville V. Niles, one of the initial co-investors in the stockyards.

The rise of the trucking industry, with its greater flexibility and lower operating costs, was largely responsible for the post-World War II decline of the stockyards. Armour closed its plant in 1962, and Swift followed suit nine years later.

Several buildings that were part of the old Armour plant were repurposed and are still in use. The headquarters building of the Swift plant, initially restored as an Italian restaurant, is now an elegantly appointed office for an energy company. After partial demolition in the 1970s, only a few buildings remain on the property, and those survivors have fallen into a Stalingradesque state of ruin.

This huge complex is truly a ghost town within a city.

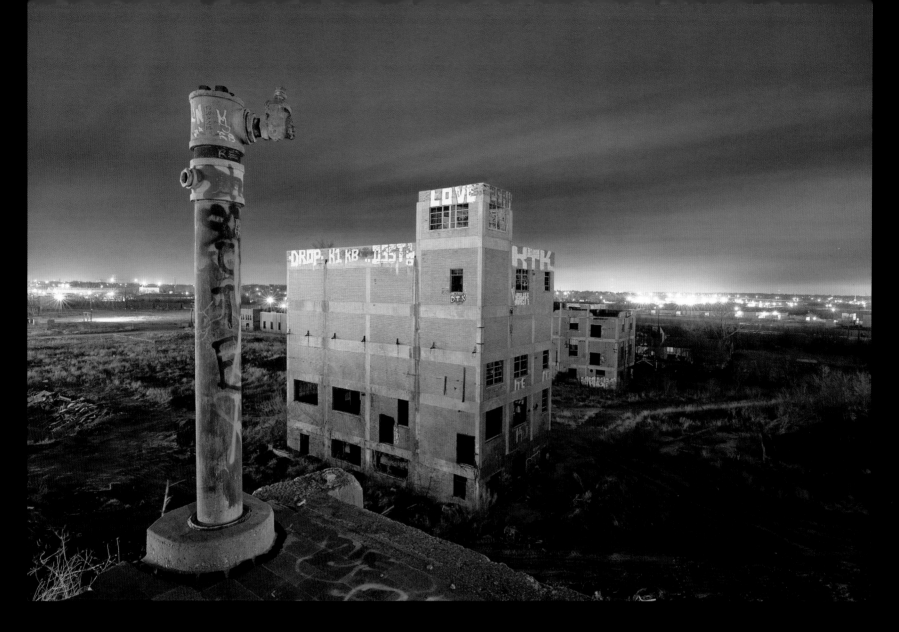

SWIFT REVISITED
SWIFT MEAT PACKING PLANT RUINS
FORT WORTH, TEXAS . FEB 08

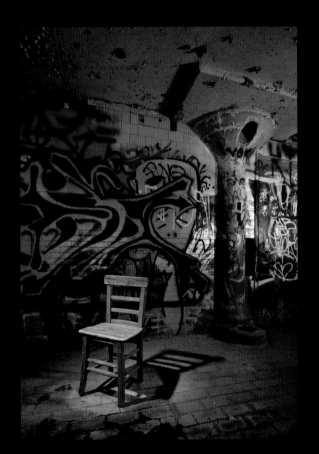
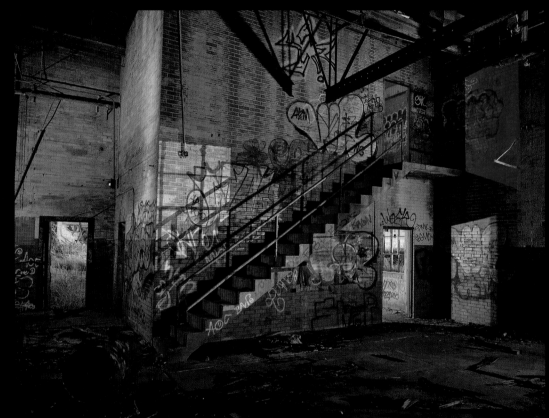

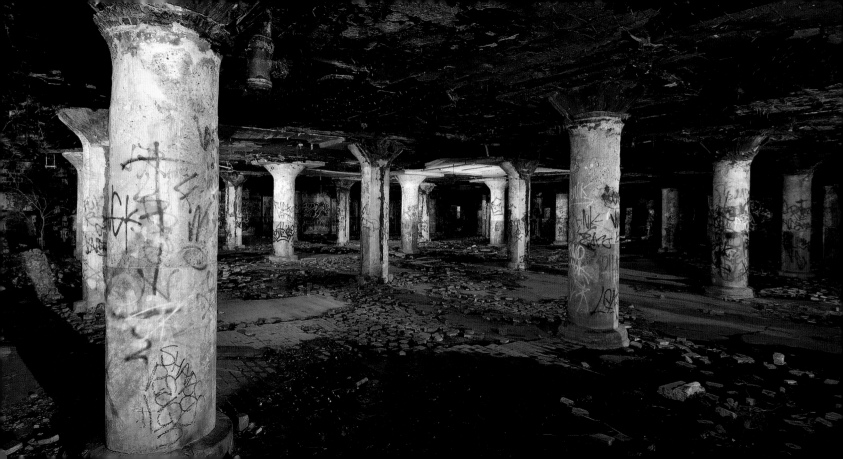

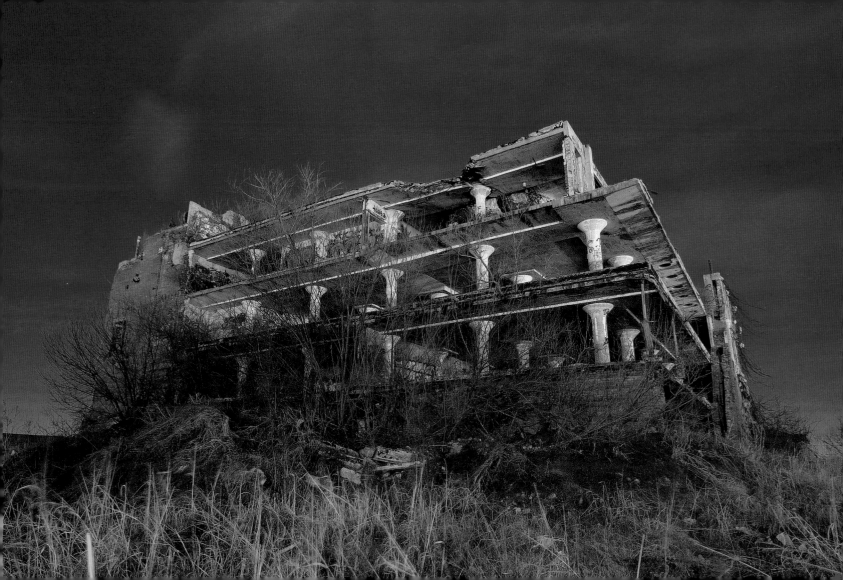

VISITORS
SWIFT MEAT PACKING PLANT RUINS
FORT WORTH, TEXAS . FEB 08

The Swift Meat Packing ruins have been used several
times in television and film. In the 1990s, "Walker,
Texas Ranger" shot an episode or two on the property,
and the short-lived series "Prison Break" renovated
a portion of the property to stand in as a Guatemalan
penitentiary. The main building used in shooting,
renamed "Penetenciaria Federal de Sona," is shown
at lower left, extensively modified from its original
appearance for use on the show.

Serious snow is fairly rare in this part of Texas, so
when I saw this storm on the way, my thoughts turned
immediately to Swift.

The transformative effect is extraordinary: rubble
and weeds blanketed, scrubby trees frosted feathery
white... somehow this place of death reveals its

GULAG
SWIFT MEAT PACKING PLANT RUINS
FORT WORTH, TEXAS . FEB 10

TOWER, MOON AND PASSING PLANE
ABANDONED GLOBE AIRCRAFT FACTORY
BLUE MOUND, TEXAS . OCT 08

BLDG #10 REVISITED
FORMER GLOBE AIRCRAFT FACTORY BUILDING
BLUE MOUND, TEXAS . OCT 08

Originally founded as Bennett Aircraft corporation around 1940, Globe Aircraft built a variety of small planes for both commercial and military purposes. After Globe's bankruptcy in 1947, its facility just north of Fort Worth was used by Bell Helicopter for design and development until sometime in the 1960s.

Since then, the property has stood abandoned. The night I visited, a thunderstorm was passing through on the northern horizon, but lightning is notoriously elusive. Unnoticed in the field, this lucky bolt was

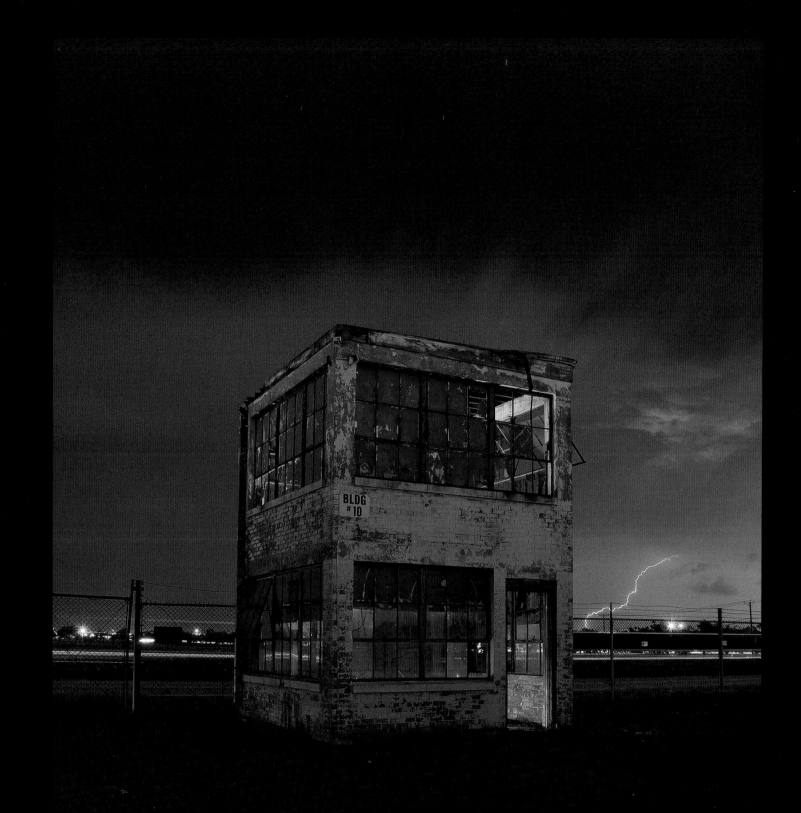

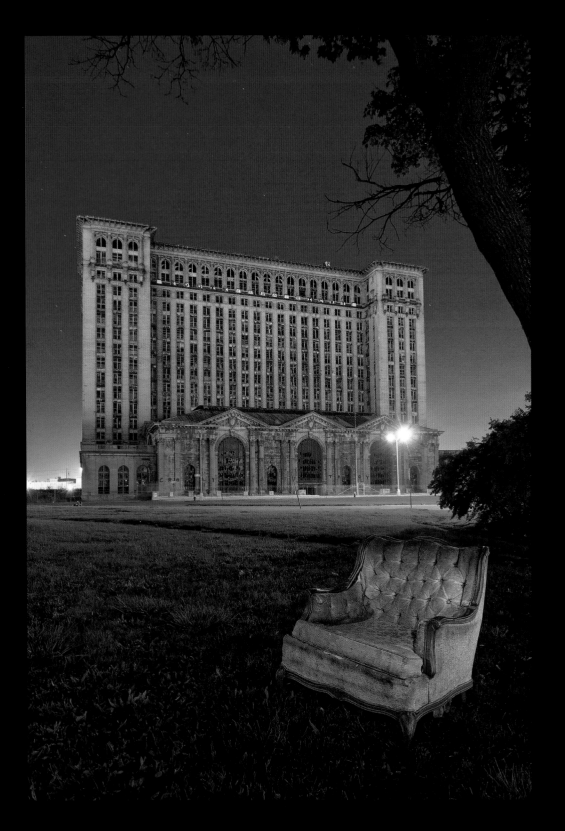

MCD AND THE CHAIR
ABANDONED TRAIN STATION
DETROIT, MICHIGAN . OCT 08

Built in 1913 with all the architectural grace of that era, the Michigan Central Depot towers above its surroundings in downtown Detroit, a few blocks west of where the old Tiger Stadium once stood.

The building is just flat enormous: eighteen elegant stories and half a million square feet of floorspace... all abandoned since the 1990s.

I had only a couple of hurried hours here, and I'd love to go back someday. I could spend an entire weekend shooting and exploring this spectacular old relic of Detroit's golden era.

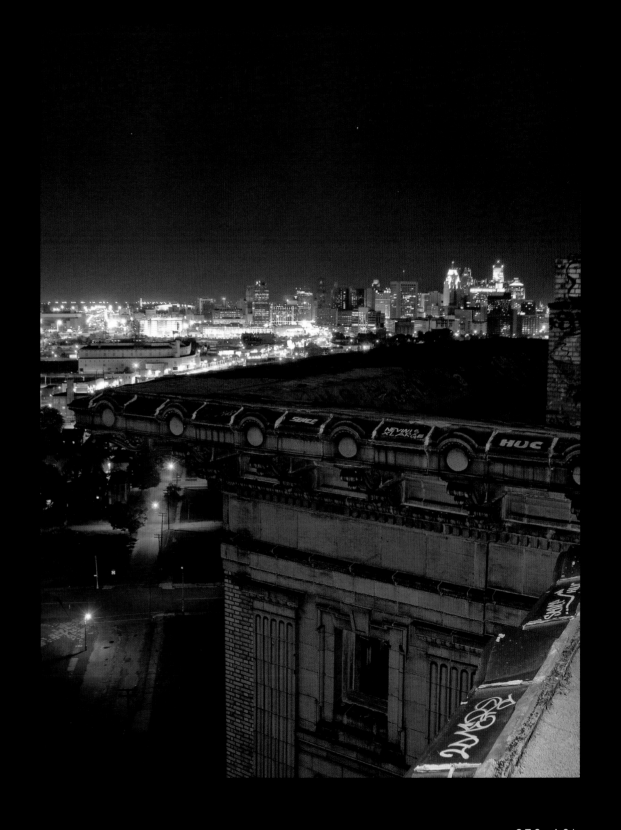

230 AGL
ABANDONED TRAIN STATION
DETROIT, MICHIGAN . OCT 08

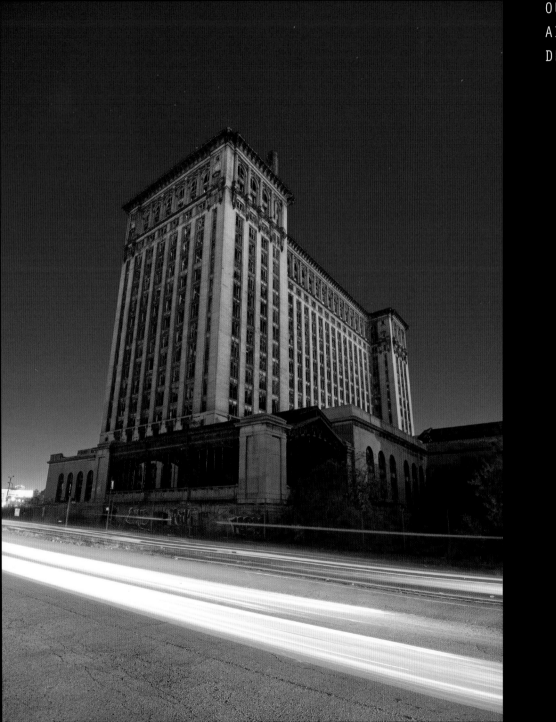

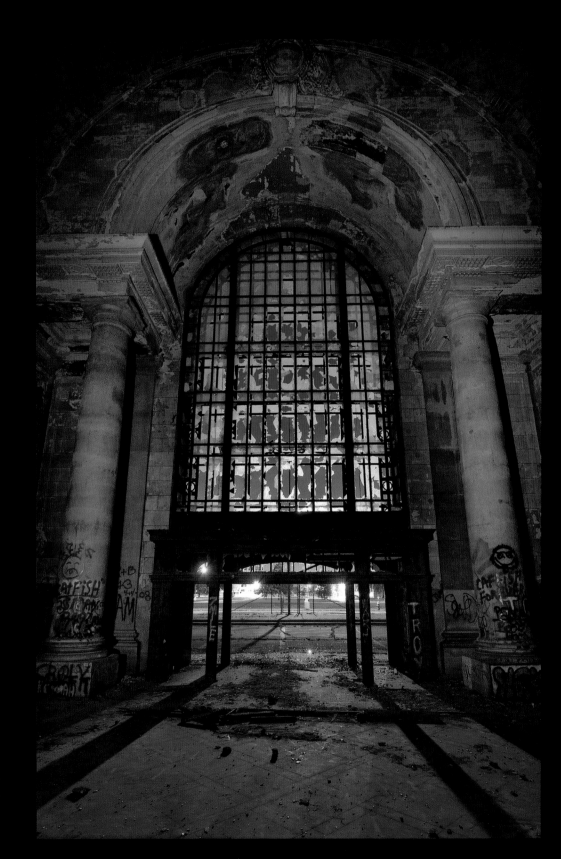

SHATTERED HISTORY
ABANDONED TRAIN STATION
DETROIT, MICHIGAN . OCT 08

Moonlight and the night sky make stained
glass of the depot's broken windows.
Though it stands open to vandals and
the elements, its structure remains
very much intact — a testament to a
bygone era of quality workmanship.

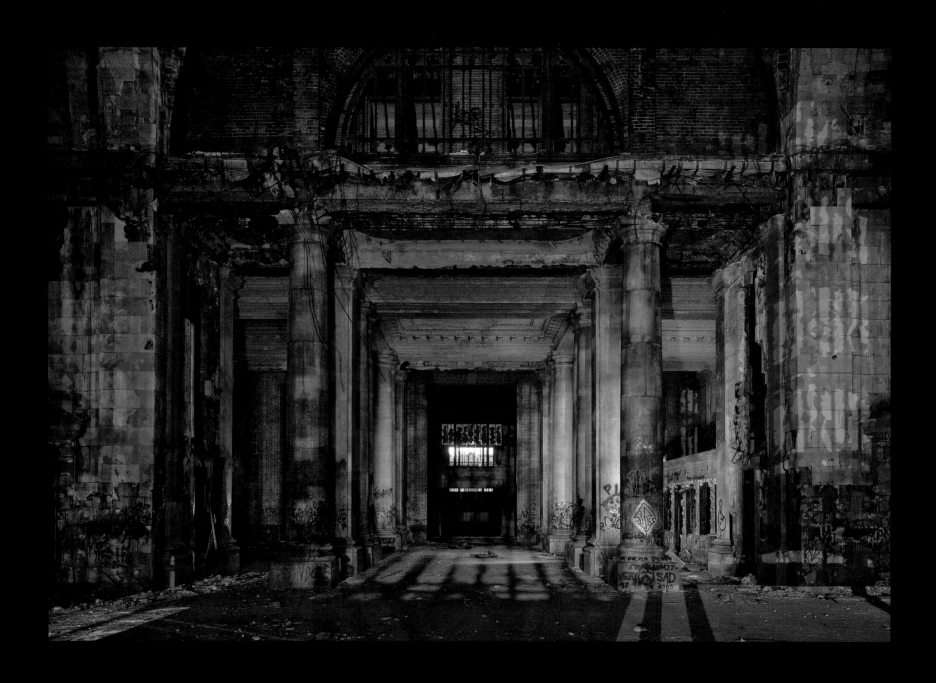

MERCURY STATION
ABANDONED TRAIN STATION
DETROIT, MICHIGAN . OCT 08

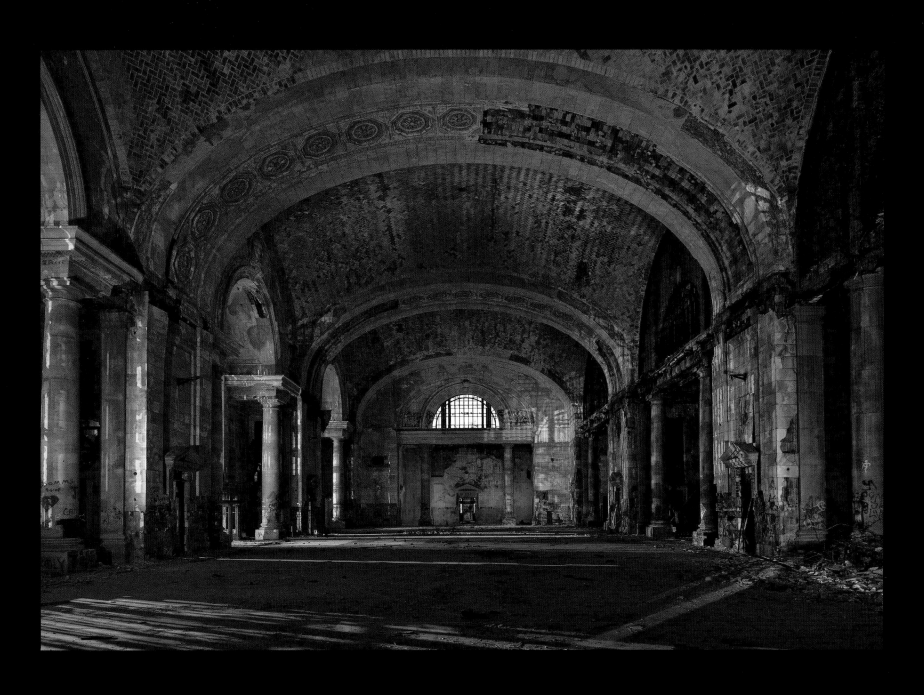

THE MAIN HALL
ABANDONED TRAIN STATION
DETROIT, MICHIGAN . OCT 08

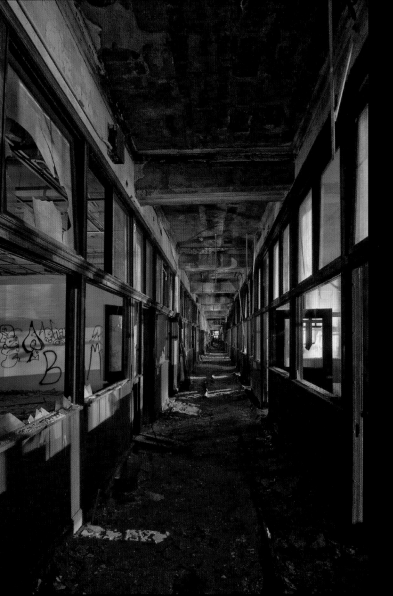

PACKARD OFFICES
ABANDONED AUTOMOTIVE PLANT
DETROIT, MICHIGAN . OCT 08

Designed by legendary industrial architect Albert Kahn
and built in 1907, this plant produced Packards into the
mid-1950s, when stagnant design concepts, executive
mismanagement, and an ill-advised acquisition of
Studebaker led to the company's demise.

Today, the shell of this sprawling old manufacturing
complex sits fully abandoned. Over forty acres of
land in urban Detroit, dormant for over five decades.
What you see in the image at right is less than half
of this massive site.

Wandering around here, it's easy to get lost. You
could explore this place for days and still not see
it all. Along my path through the site, I spotted the
burned-out shell of an old Winnebago and intended to
go back to shoot it... but I never found it again.

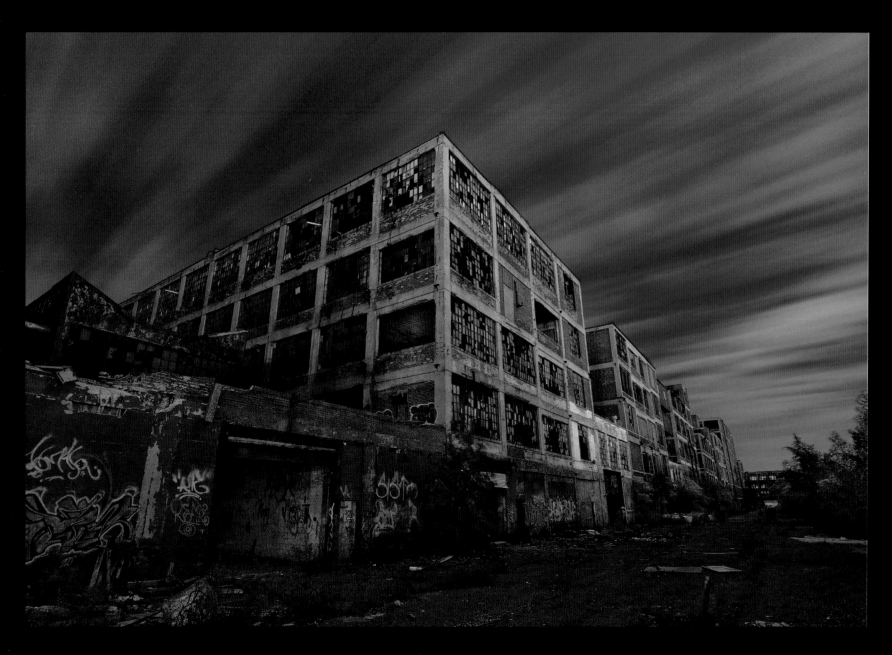

PACKARD MOTORS
ABANDONED AUTOMOTIVE PLANT
DETROIT, MICHIGAN . OCT 08

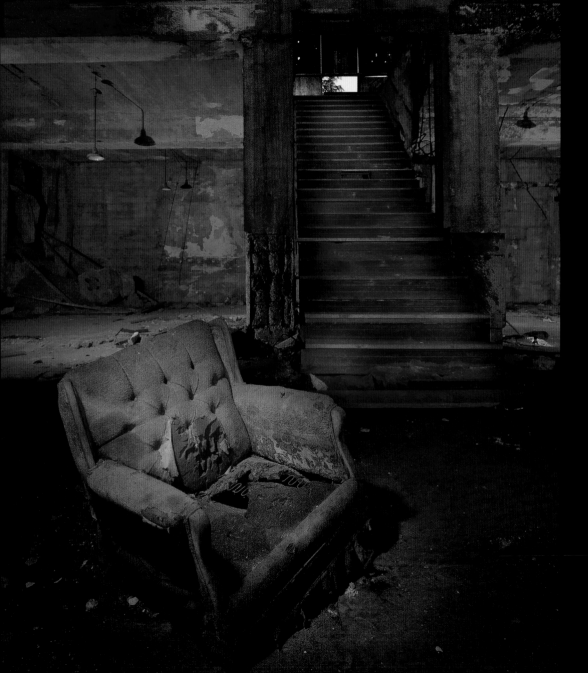

REMAINS OF AN EMPIRE
ABANDONED TRAIN STATION
GARY, INDIANA . OCT 08

Like the city itself, the train
station in Gary was once grand
and bustling with activity; now
it stands forgotten, a cracked
and crumbling remnant of the

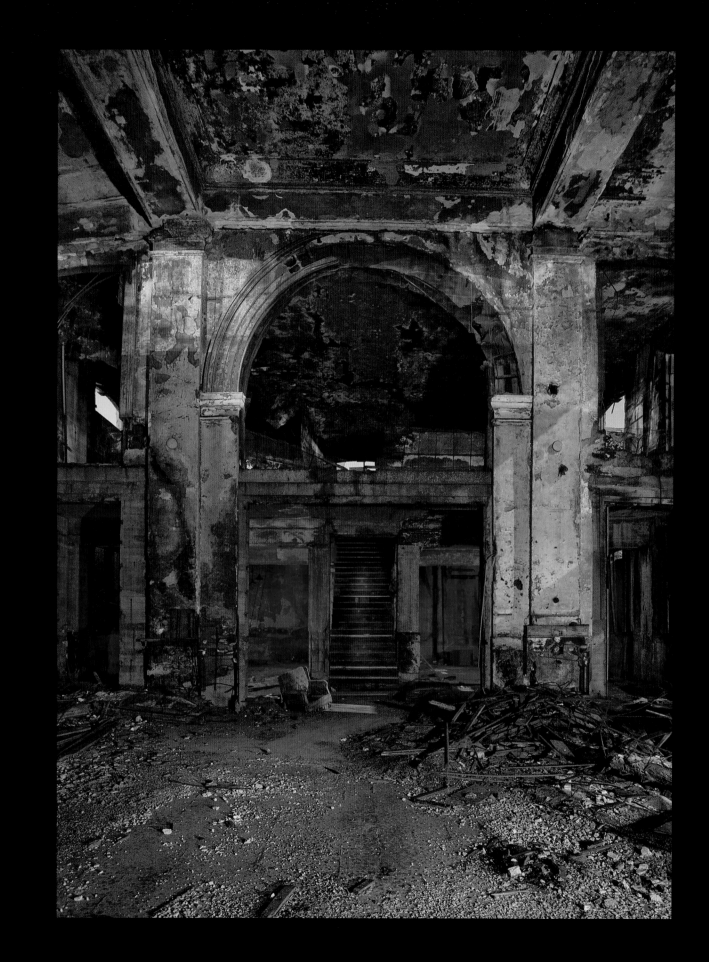

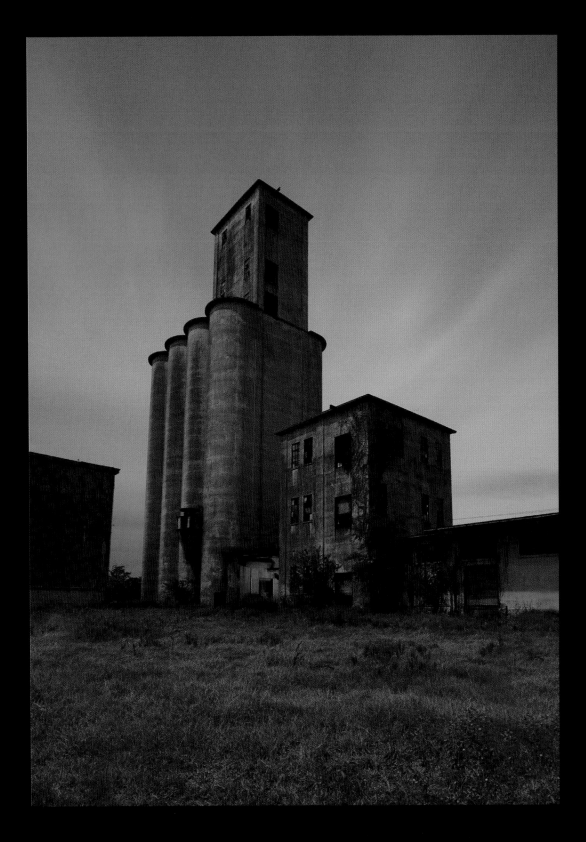

LOCATION, LOCATION, LOCATION
ABANDONED GRAIN ELEVATOR
NAVARRO COUNTY, TEXAS . OCT 10

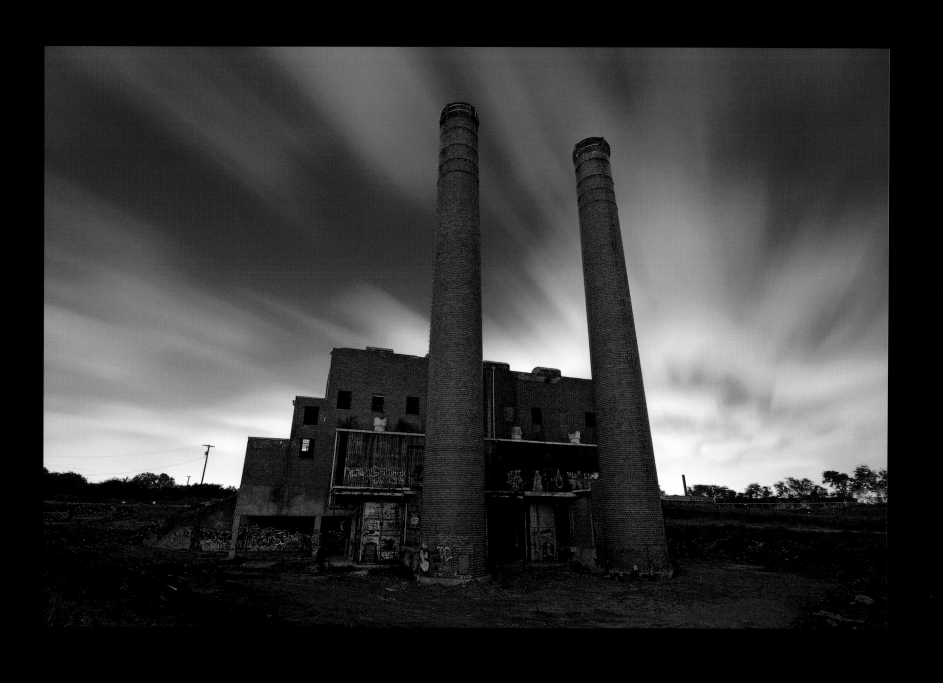

CLOUD DRAMA
ABANDONED INCINERATOR
FORT WORTH, TEXAS . APR 08

EPA . ABANDONED INCINERATOR . FORT WORTH, TEXAS . DEC 07

About three miles south of downtown Fort Worth, the old Echo Lake Incinerator has stood unused for over four decades. Built in the 1950s, it served the city for only a few years before changing EPA regulations forced its closure, as well as that of its sister facility north of downtown.

Thanks to sturdy brick and concrete construction, the building has largely maintained its structural integrity despite neglect and abuse. However, when I climbed its 25-foot ladder — in the dark — I found severe water damage and a couple of cave-ins on the building's tar and gravel roof.

During the 1980s and '90s, the incinerator evidently became a hotbed of drug activity. At some point, a woman who visited to make a purchase fell forty feet to her death, ending up in a massive, 20-foot deep trash hopper on the ground floor.

It's a fairly dangerous place to go poking around in the dark. On the third floor, two large rectangular cutouts appear in the middle of the walkway, forcing you to navigate a twelve-inch-wide strip of concrete that separates the holes from a wall; one misstep and you could easily duplicate that hapless drug addict's fall.

8 7 6 5 4 3 2 1
ABANDONED INCINERATOR
FORT WORTH, TEXAS . APR 08

OVERTAGGED
ECHO LAKE INCINERATOR
FORT WORTH, TEXAS . JAN 13

Inside the entrance to the long-abandoned Echo Lake Incinerator in Fort Worth, Texas. Abandoned locations are usually a hotspot for graffiti artists or "taggers", and Echo Lake has been spray-painted many times over in the 40+ years since it's closure.

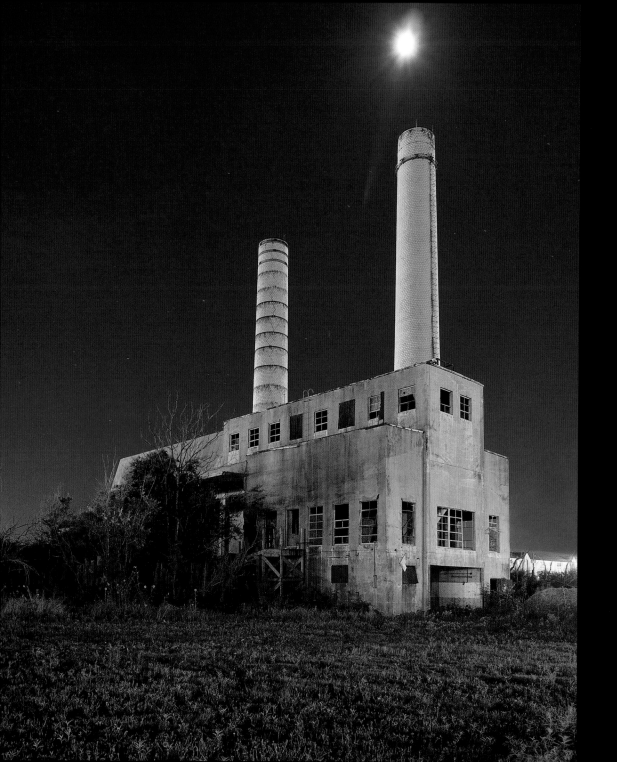

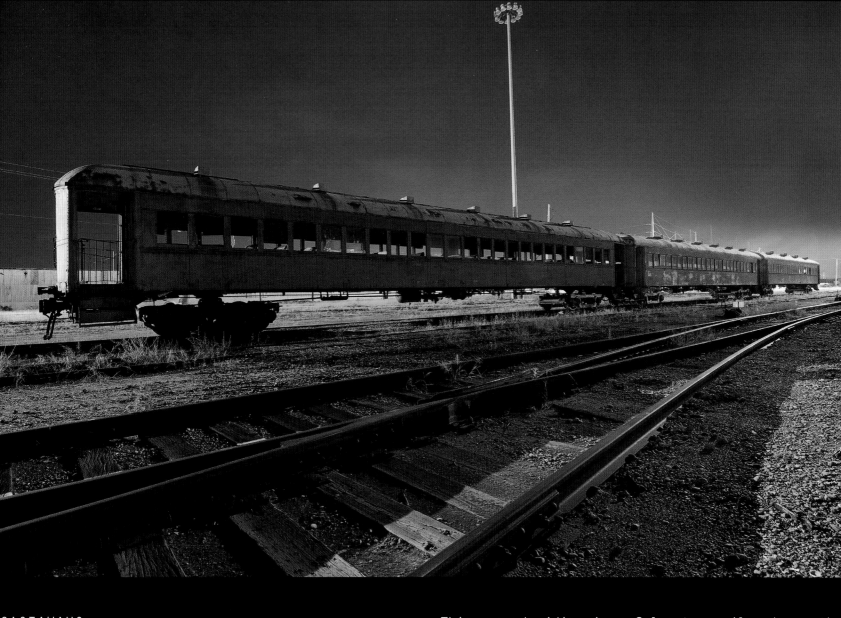

CASTAWAYS
ABANDONED RAIL CARS
GALVESTON, TEXAS . JUN 10

This unused siding in a Galveston railyard was the end of the line for these old passenger cars. The intense sodium side-lighting, normally the bane of my existence, actually enhances this particular shot – and the overhead tower, mercifully, was turned off.

Rust in Peace.

URBAN EXPLORATIONS

PRADA MARFA
SOCIAL COMMENTARY SCULPTURE
FAR WEST TEXAS DESERT . JAN 08

In the remote deserts of West Texas, things aren't
always what they seem.

In this case, what appears to be an operational
Prada store is in fact a piece of "social commentary
art" conceived and executed by two German artists in
cooperation with a design firm called Ballroom Marfa,
whose operation is based in the artsy, eclectic west
Texas town of Marfa.

This faux Prada store in the middle of absolute
nowhere has fooled — and bewildered — many an
unwitting motorist along this desolate stretch of
Highway 90. The adobe structure is fully outfitted
with electricity, glass windows, a security system,
and actual merchandise from Prada's Fall 2005 line.

The ubiquity of commerce? The schism between bleak
reality and human self-indulgence? I'm not sure what
the artists had in mind, but this image seems to
speak to a lot of people.

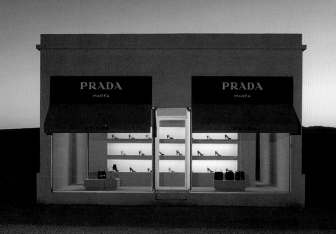

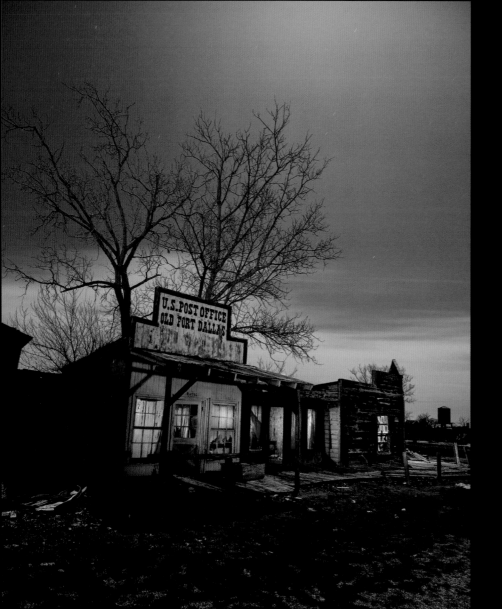

U.S. POST OFFICE
OLD FORT DALLAS

LOVE SHACK
ABANDONED OLD WEST THEME PARK
FERRIS, TEXAS . JUL 10

Just south of Dallas stands a one-time theme park originally called "Historic Fort Dallas." Once used for parties, events, and television shoots, the park also operated briefly as "Shadow Creek Ranch," but has now been abandoned for several years.

Fittingly, the rust and decay now overtaking this artificial ghost town are rapidly turning it into the authentic item.

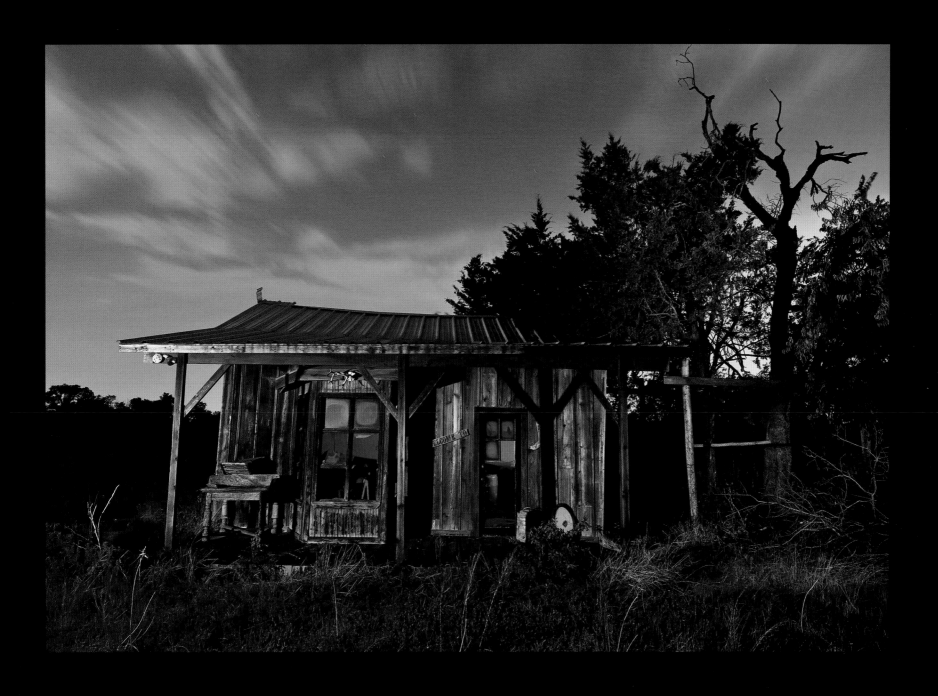

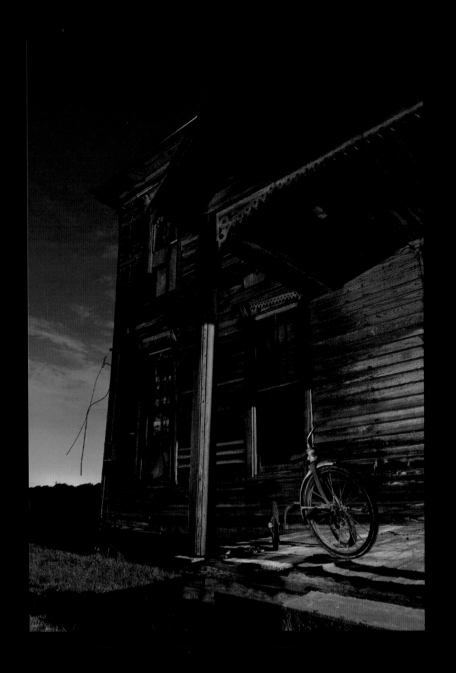

THE KLUTTS HOUSE
ABANDONED FARMHOUSE
NEAR ROCKWALL, TEXAS . JUN 10

Just east of Dallas, on a working ranch near the town of Rockwall, this falling-down farmhouse still sports traces of its once-stylish Victorian trim. Even with porches sagging and paint scoured away by the relentless Texas wind, the old Klutts house retains a certain faded dignity.

ALL GROWN UP NOW...
ABANDONED FARMHOUSE
NEAR ROCKWALL, TEXAS . JUN 10

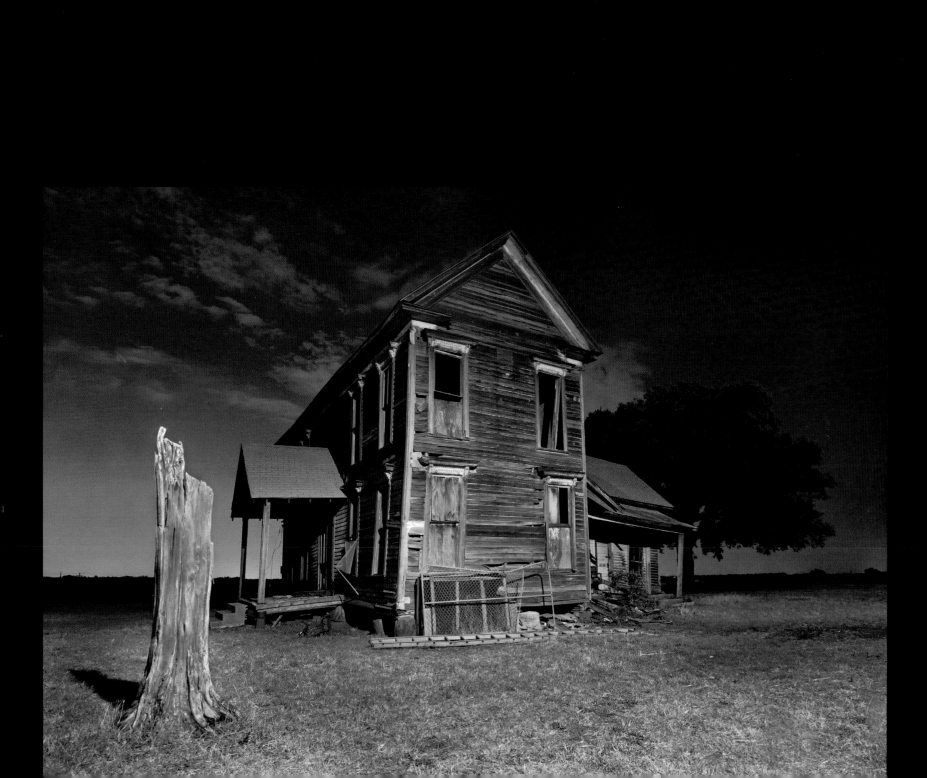

THE FABULOUS BAKER HOTEL
THE BAKER HOTEL
MINERAL WELLS, TEXAS . MAR 08

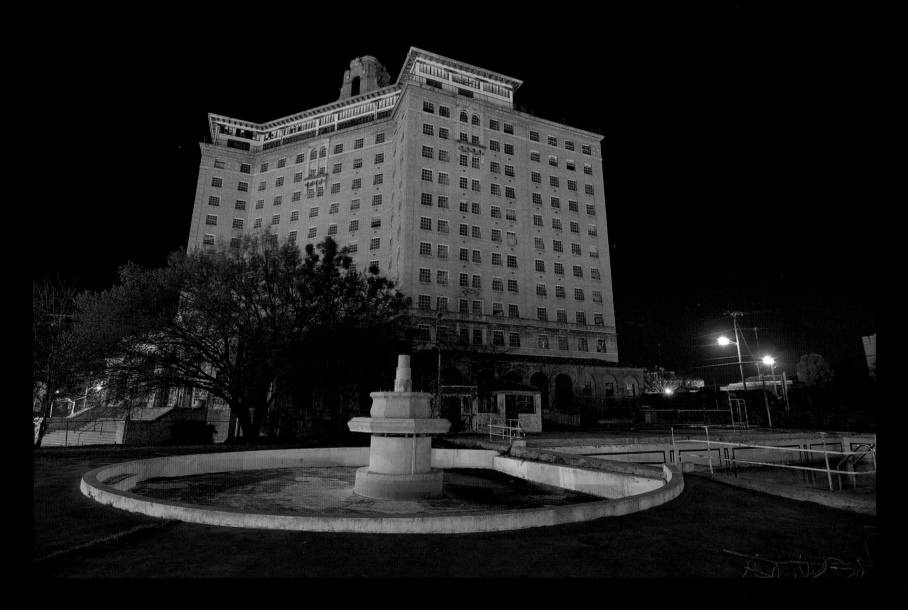

About eighty miles west of Dallas, the town of Mineral Wells was home to 7,000 people when hotel magnate T.B. Baker arrived in the 1920s. Hoping to capitalize on the town's popular mineral spring and the health benefits it was believed to offer, Baker built a towering architectural masterpiece to serve as both a 450-room luxury hotel and a world-class health spa.

In its heyday, the Baker boasted live music by Guy Lombardo and other great dance bands of the time, and hosted such celebrities as Will Rogers and Marlene Dietrich. But over the decades, as medical science advanced, public confidence in the curative power of the mineral waters began to wane. Finally, in the early 1970s, the Baker Hotel closed its doors for the last time.

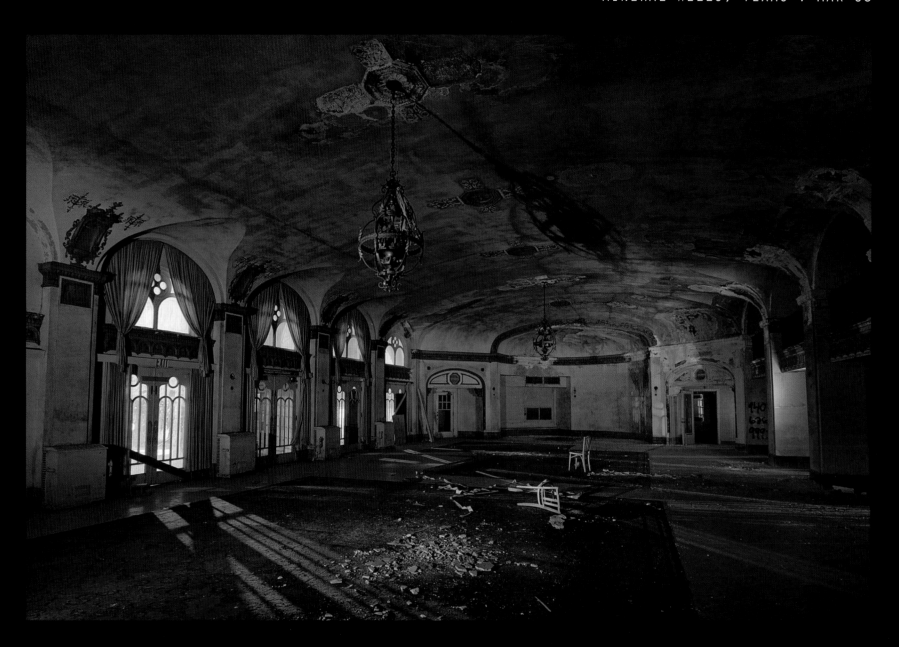

But a half-century of history has left its mark — or so some people believe. The Baker is widely regarded as one of the most haunted places in America, and certainly the spookiest spot in Texas. At the Baker, ghosts abound: a woman who plunged to her death from the rooftop... a mischievous tripper of electrical circuits... a boy who died in the hotel when his parents brought him there in hope that the waters would cure his leukemia.

During the thirty-plus hours I've spent personally exploring this spectacular building, I've kept an open mind — but I've never seen anything unexplainable. Perhaps some of these "ghosts" are really just explorers like me, wandering the midnight hallways in search of photos...or the unknown.

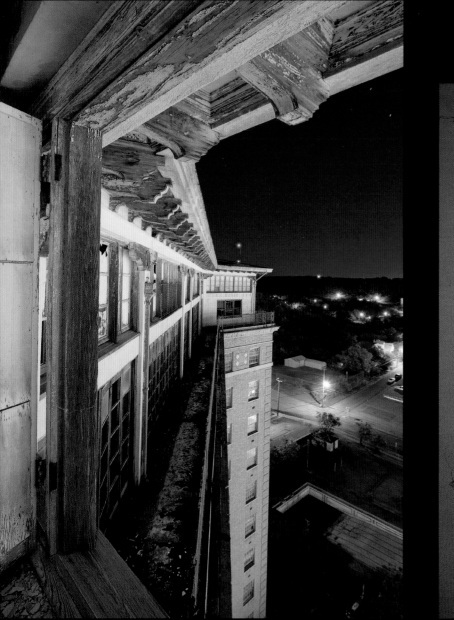

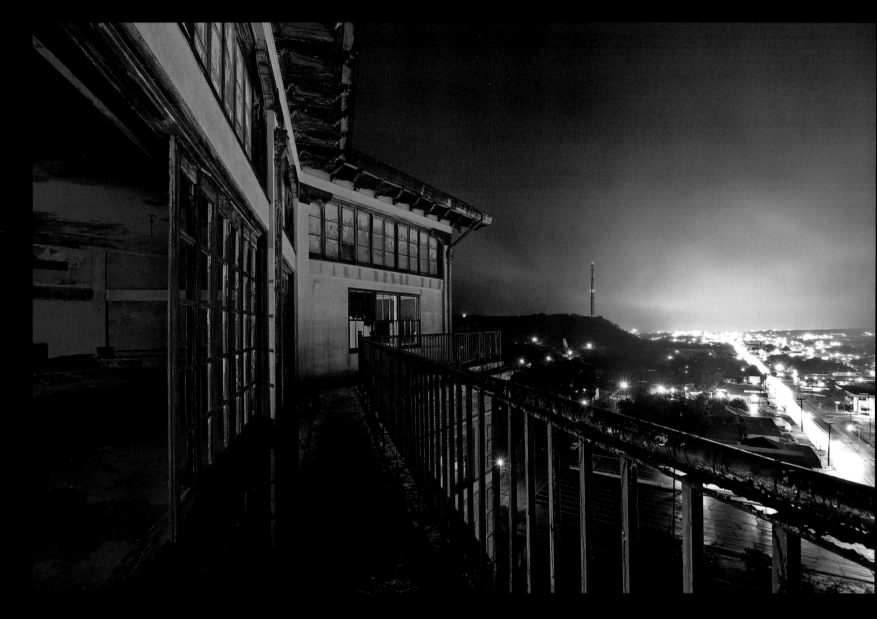

In 1933, T.B. Baker passed ownership of the hotel to his nephew, Earl Baker, who operated it for the next thirty years. Earl had always said that he would close down the hotel when he turned seventy, and true to his word, he did just that on April 30th, 1963. In 1965, a group of local leaders carried out a plan to reopen the hotel — but her time had passed, and she was closed for good in 1972.

And so the Baker stands, a ghost now herself, still dominating the skyline of the little town she once made famous.

BALLROOM BLITZED
THE BAKER HOTEL
MINERAL WELLS, TEXAS . OCT 09

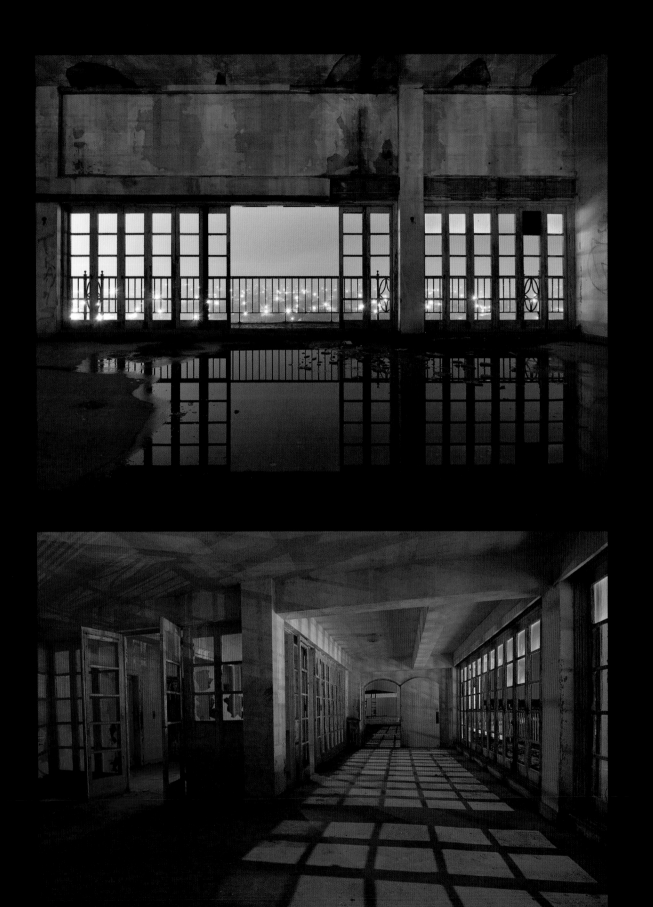

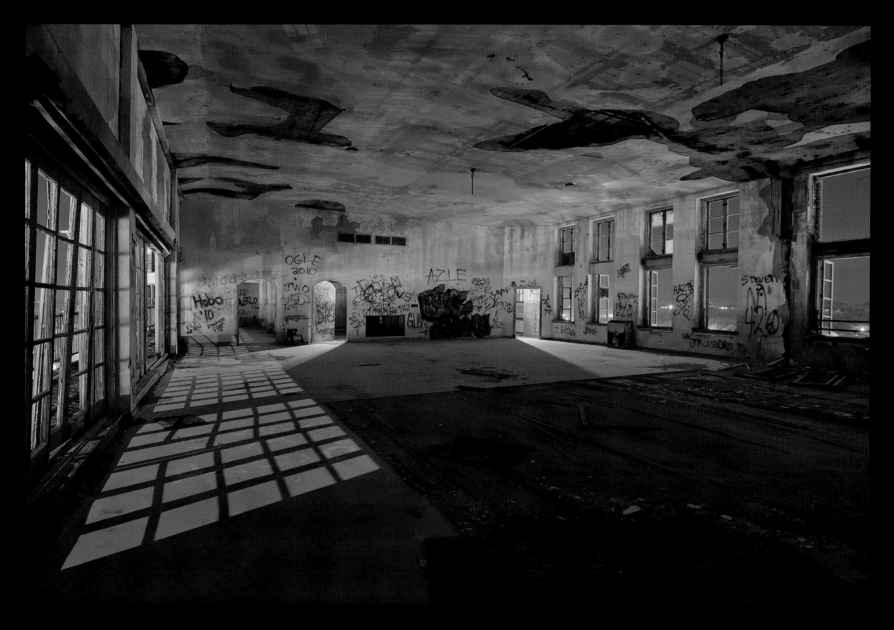

They called it the Cloud Ballroom because two long
walls of glass opened it to the skies. Extravagant
parties were once held here, with fashionably dressed
couples swaying to the music of the great touring
bands of every decade from the 1930s to the '60s.

Now long empty, it retains little of its former
grandeur — but a little mist, a little moonlight, and
the Cloud Ballroom can still inspire the imagination.

MOONLIGHT BALLROOM
THE BAKER HOTEL
MINERAL WELLS, TEXAS . OCT 09

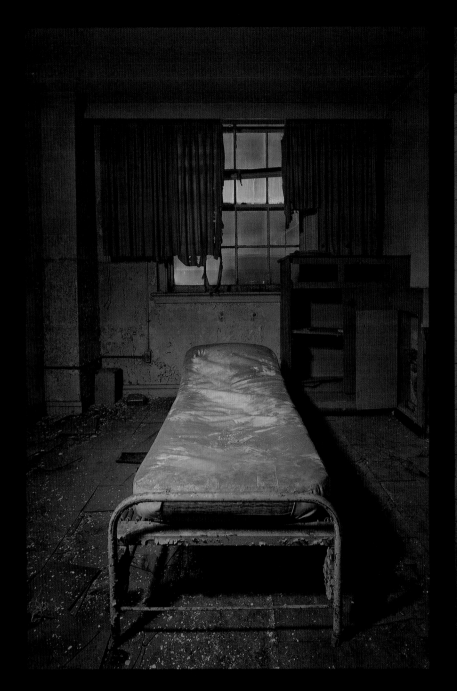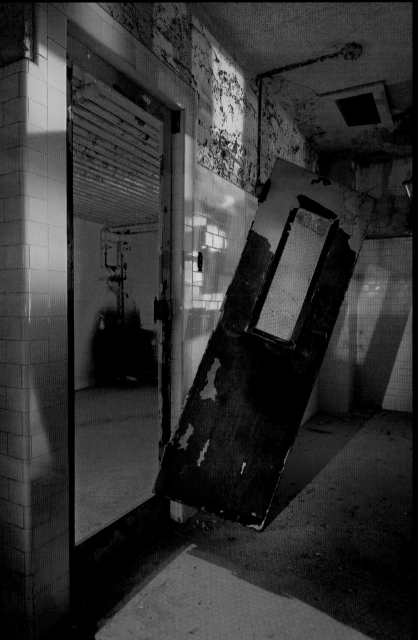

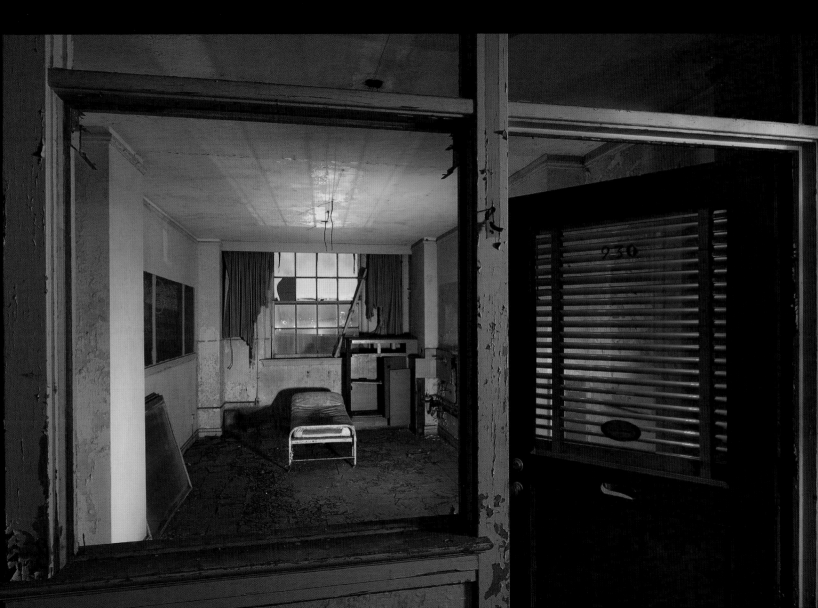

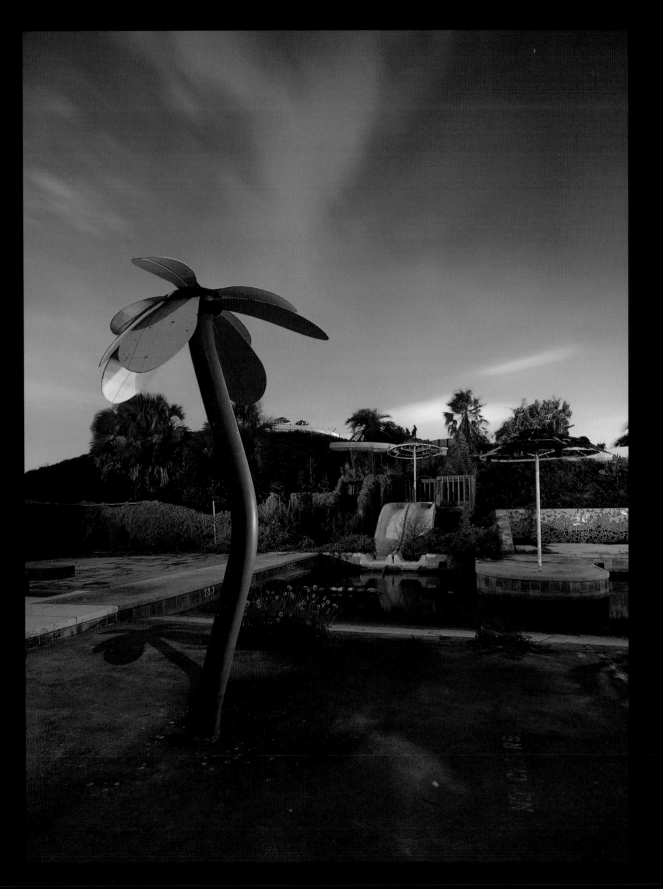

PARADISE LOST
ABANDONED WATER PARK
GALVESTON, TEXAS
JUN 10

A metal palm tree stands at the center of the children's play area at the abandoned Jungle Surf Water Park in Galveston. Closed since 2005, the tiny park took a hit from Hurricane Ike in 2007, which certainly didn't enhance its prospects for reopening.

The whole water park is a shambles, and several sections of the large waterslide seem to be missing. At the top of the hill, just to the right of the metal palm, you can barely see two tiny thatched umbrellas that mark the top of the big waterslide.

THE FLAGSHIP
ABANDONED HOTEL
GALVESTON, TEXAS
JUN 10

Struck by Hurricane
Ike in 2008, the iconic
Flagship Hotel and
pier took heavy damage
and were left exposed
to the elements. Many
windows were blown out
and some exterior walls
were ripped away, giving
a head start to the
demolition crews that
soon followed.

It's always a shame when
unique structures like
this are destroyed —
and having stayed here
once with my family
when I was a kid, I was
especially sorry to see
the Flagship go.

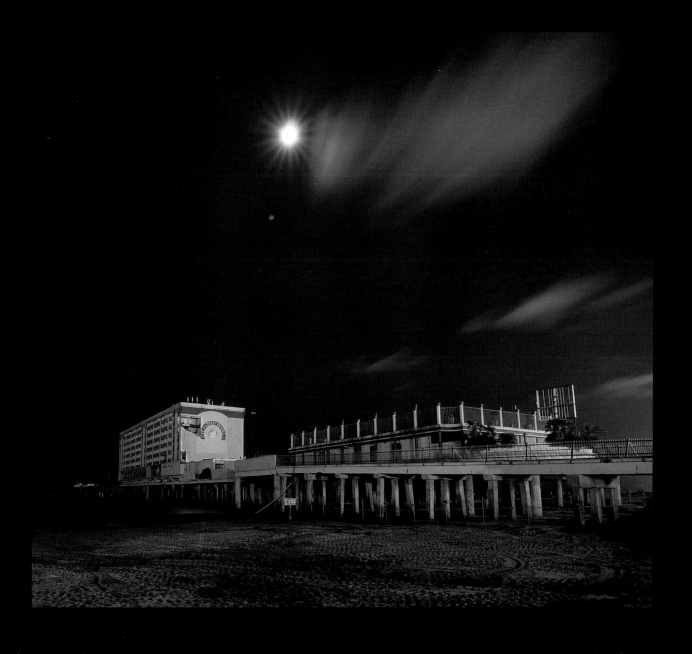

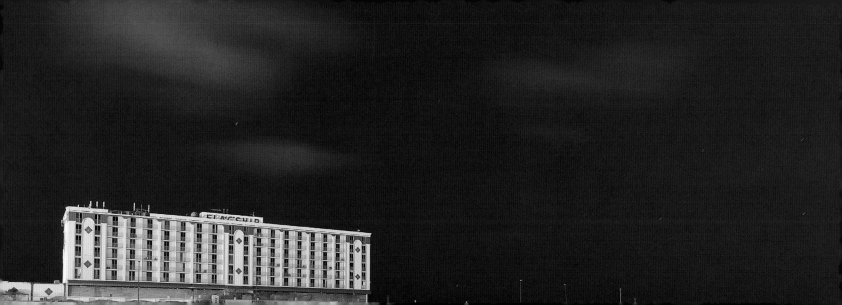

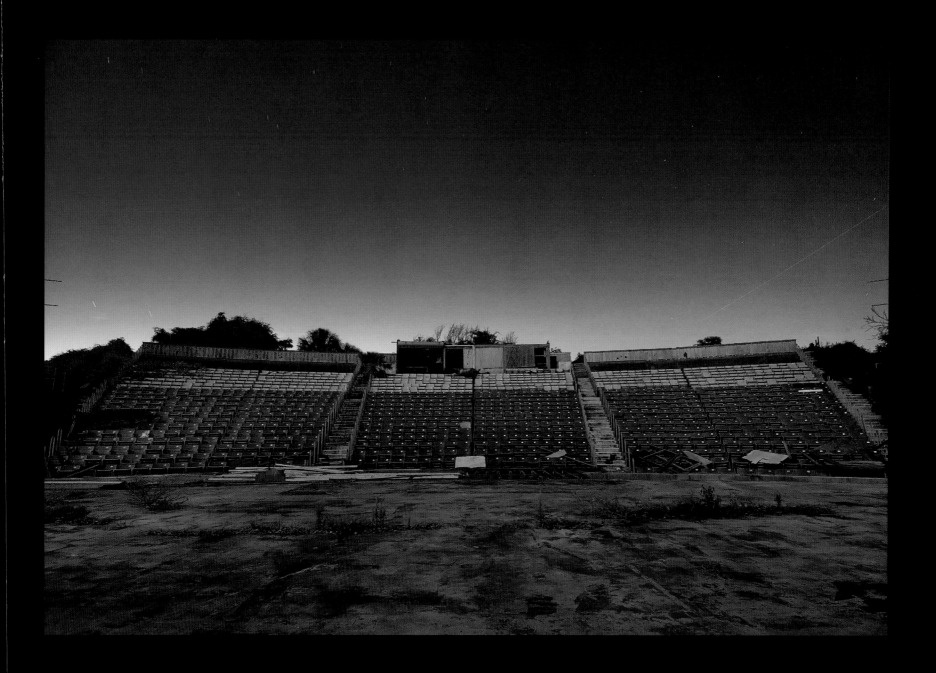

The view from the stage of the Mary Moody Northen
Amphitheater, built in 1976 with a donation from the
Texas philanthropist. It was abandoned around 2004.

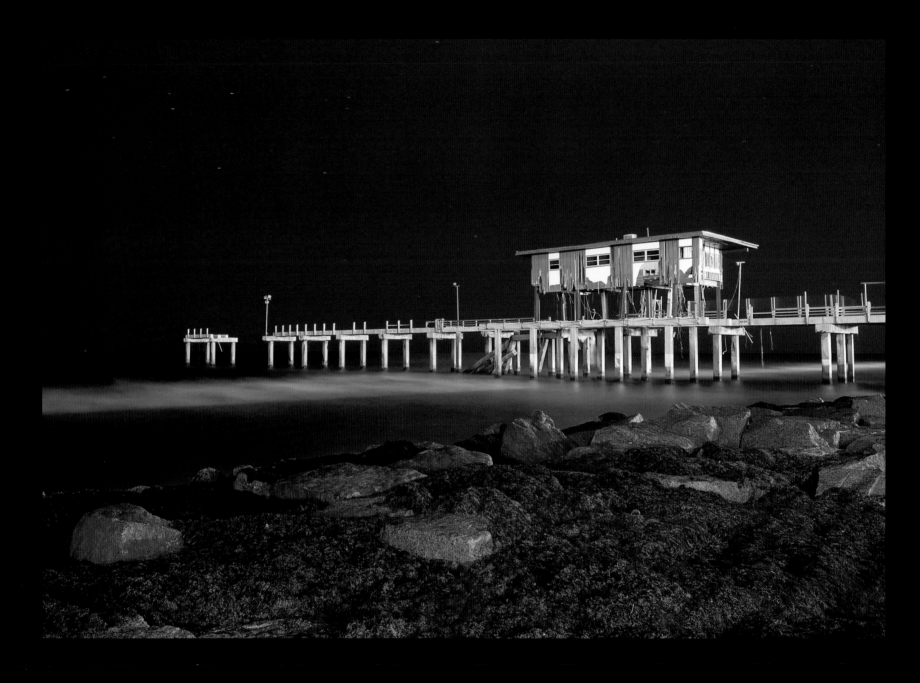

When Hurricane Ike set its sights on Texas in 2008,
two men decided to weather the storm in a small
two-story building on Galveston's 89th Street fishing
pier. That night, they held on for their lives while
the entire lower floor was torn away by raging waters.

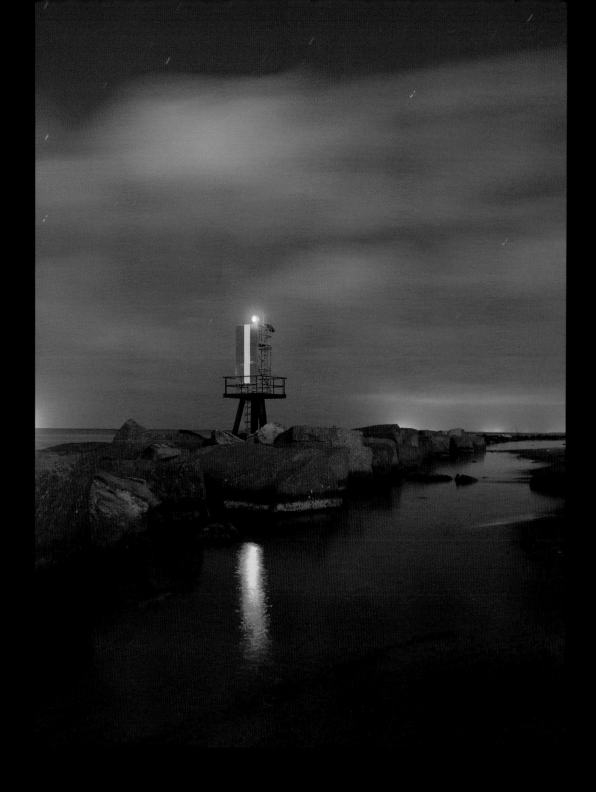

On the walk back to my car after shooting the old Battery Croghan site pictured in Chapter Two, I was struck by this channel marker and the vivid green light by which it guides cargo ships into Galveston Bay. The glow in the distance is from vessels and oil platforms out at sea.

Funny thing on the way back to the car... the Gulf of Mexico tried to drown me in a sneak attack as I walked along the breakwater. A large tanker had just passed through the channel, and when the wave hit the breakwater a couple minutes later, it overflowed the boulders. I was caught in this narrow channel you see in the photo as it began to rapidly fill with sea water, so I quickened my pace and found my way to higher ground just in time to avoid the flood.

Lesson learned; never turn your back on an ocean.

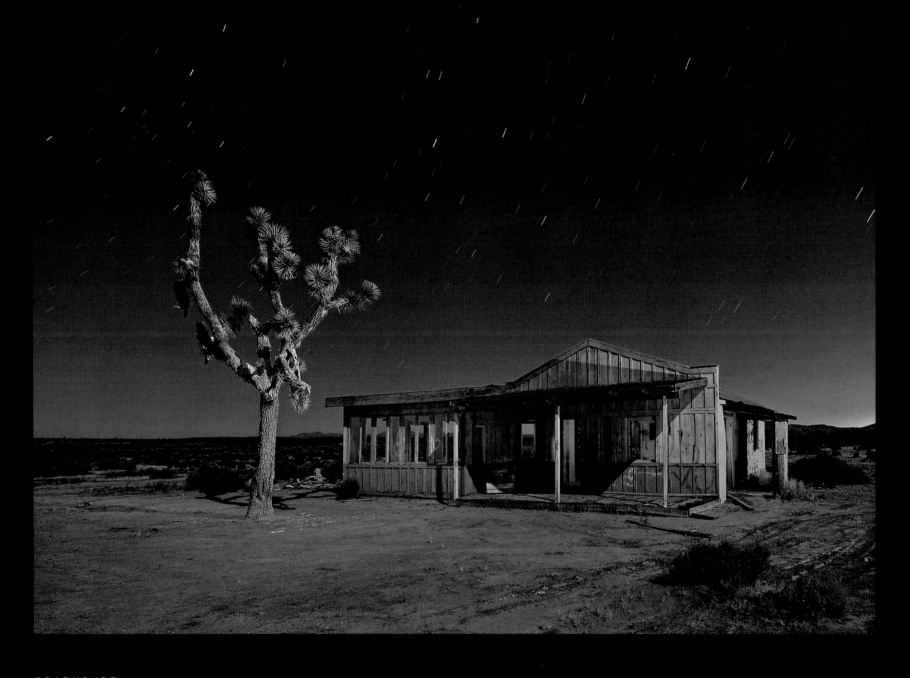

ROADHOUSE
ABANDONED MOVIE SET
EL MIRAGE, CALIFORNIA . JUN 11

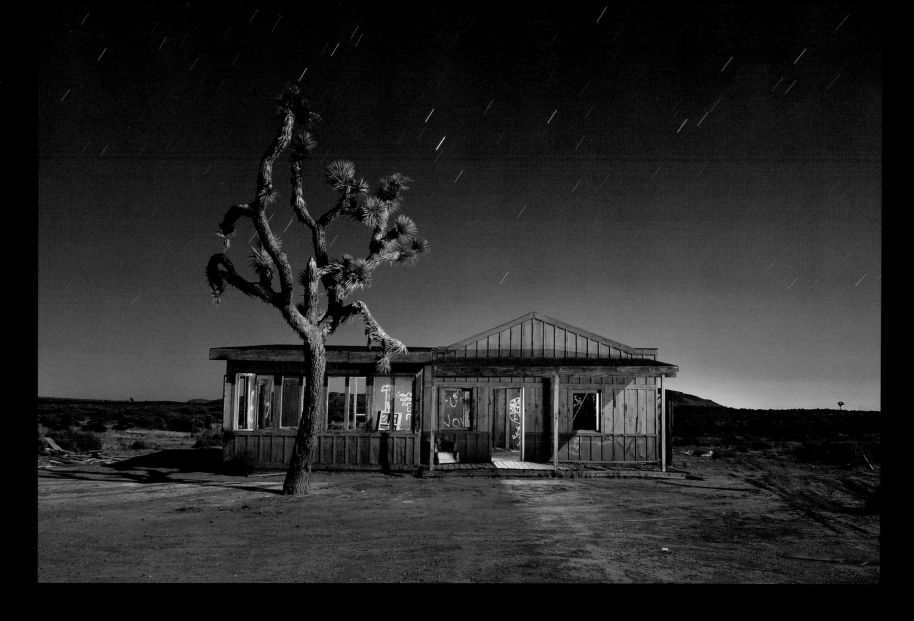

There are at least two things worth photographing around the Mojave Desert town of El Mirage, California: a top-secret military installation patrolled by armed men in black SUVs... and a faux-roadhouse built as a movie set.

Well, I got one of the two.

EL MIRAGE
ABANDONED MOVIE SET
EL MIRAGE, CALIFORNIA . JUN 11

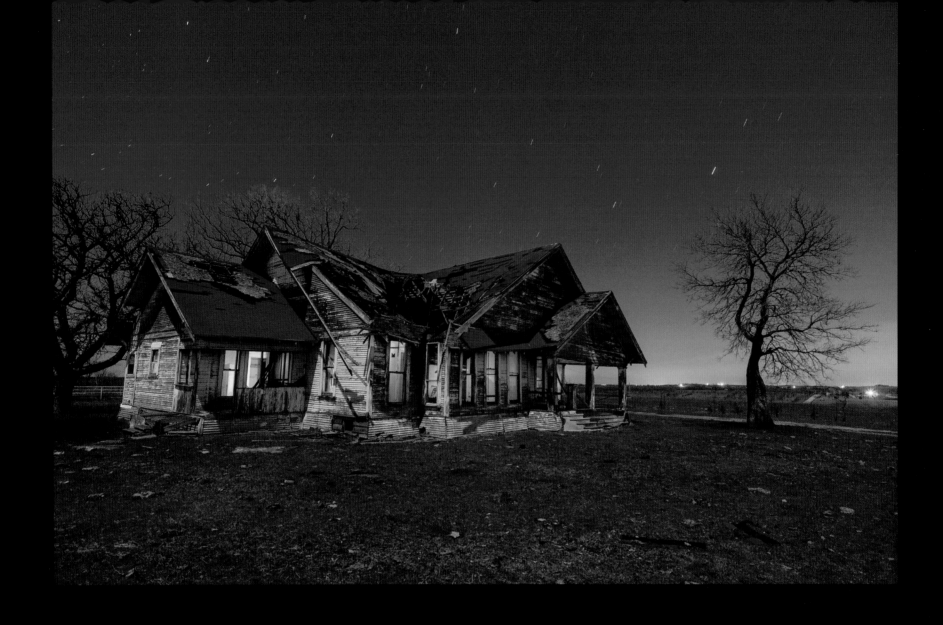

METEORITE
ABANDONED FARMHOUSE
SANGER, TEXAS . FEB 13

Shooting this abandoned farmhouse near Sanger, Texas
was an adventure, between falling through the floor in
the main hallway of the house, and being confronted
by a curious bull while making these exterior photos.

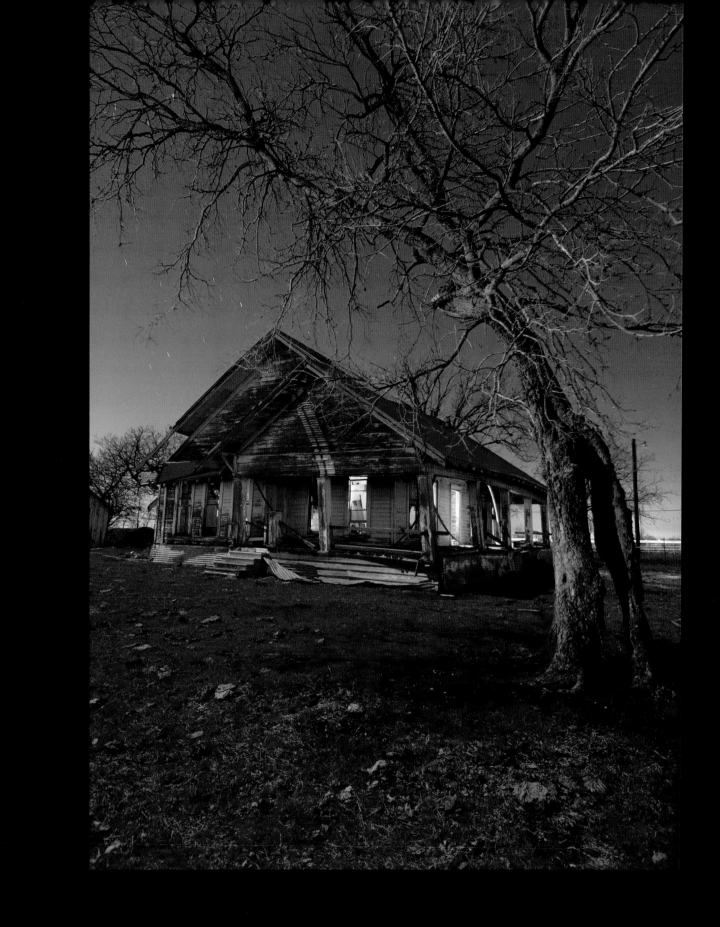

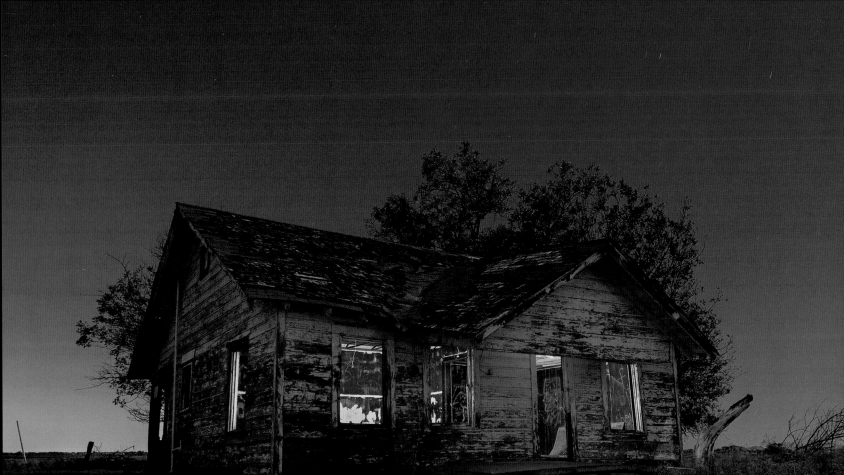

In 1975, elderly brothers Jim and Kenneth Keith were longtime partners in the cattle ranch they'd inherited from their father, George D. Keith, and they also shared the old stone homestead. It was a large and prosperous spread, and since neither man had any heirs, rumors circulated that they were keeping a fortune in guns and rare coins in the house.

One Saturday night, two men entered the house and shot Jim Keith to death. They forced Kenneth Keith to open a safe, then left him tied to a chair while they ransacked the house. Around 3:00 in the morning, the intruders left empty-handed, having failed to find the rumored fortune.

But the rumors had been partly true: the Keith brothers had once kept a fine collection of coins in the house, but had donated it to a museum the previous year.

Unwilling to return to the scene of his brother's murder, Kenneth Keith moved in with neighbors and left the homestead empty. Seven months later, when suspects were indicted for Jim's murder, a mysterious fire destroyed the Keith family home.

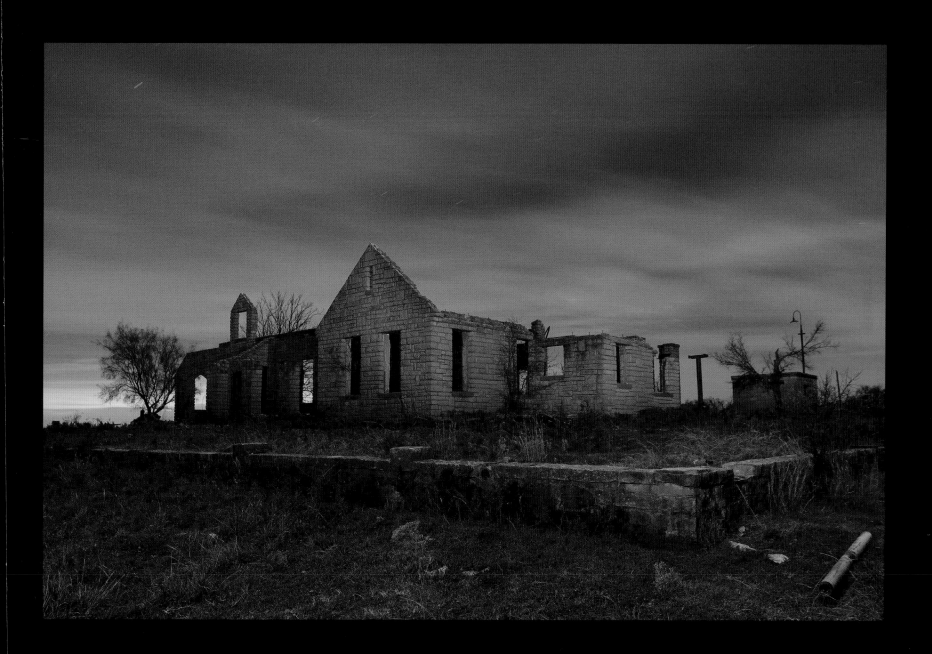

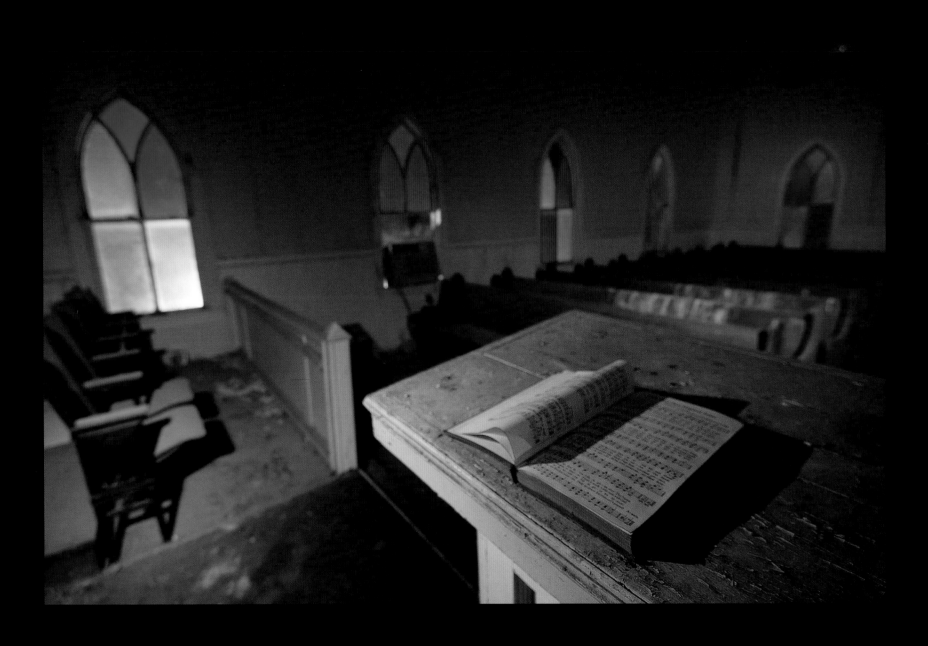

THAT OLD TIME RELIGION
ABANDONED CHURCH
JERMYN, TEXAS . JUN 10

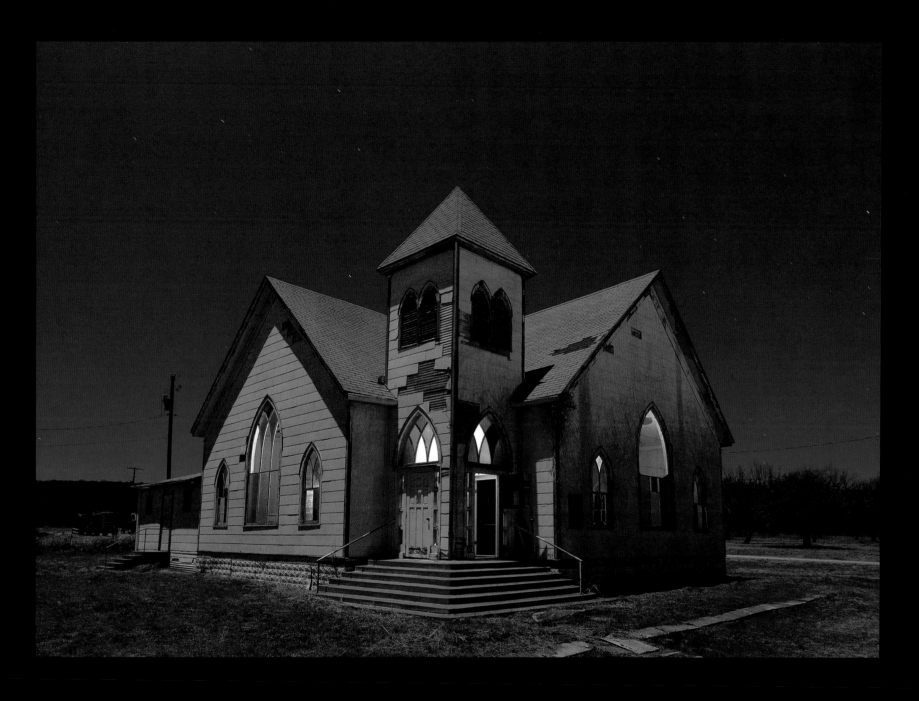

JERMYN FIRST METHODIST CHURCH
ABANDONED CHURCH
JERMYN, TEXAS . JUN 10

Constructed in 1910, this church served the tiny
north Texas community of Jermyn for several decades
before being abandoned. At some point, locals patched
it up and began holding services again, but in the
early 2000s, it fell again into disuse.

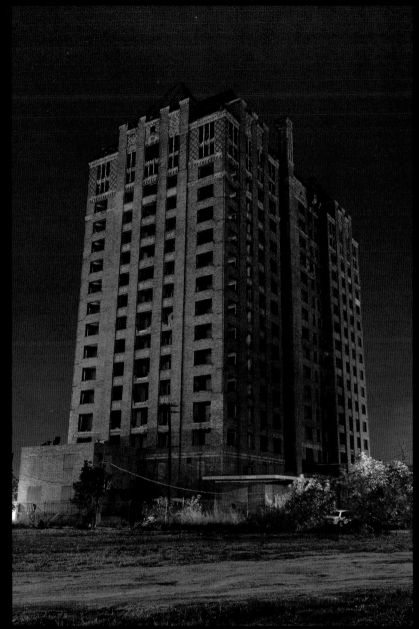

PIANO FORTE'
ABANDONED HOTEL
DETROIT, MICHIGAN . OCT 08

In the richly-detailed ballroom of Detroit's abandoned
Lee Plaza Hotel, this once-grand piano rests amid a
flurry of vintage sheet music.

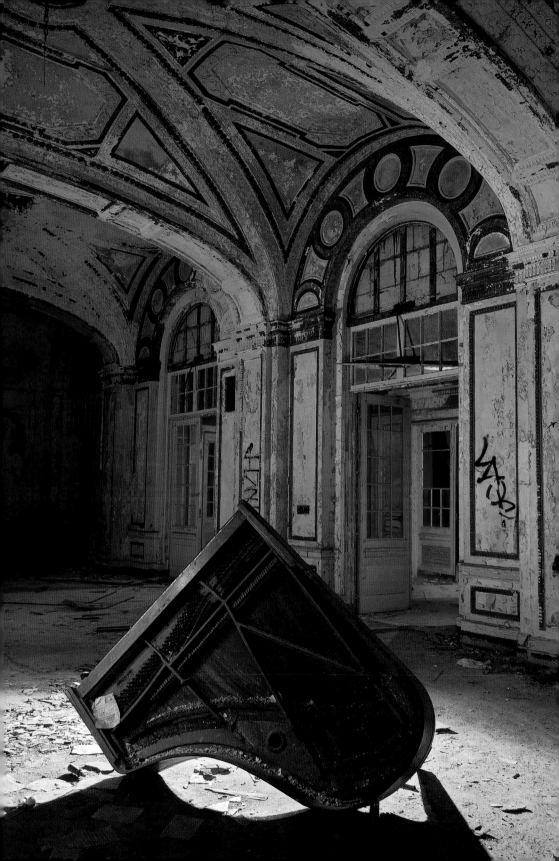

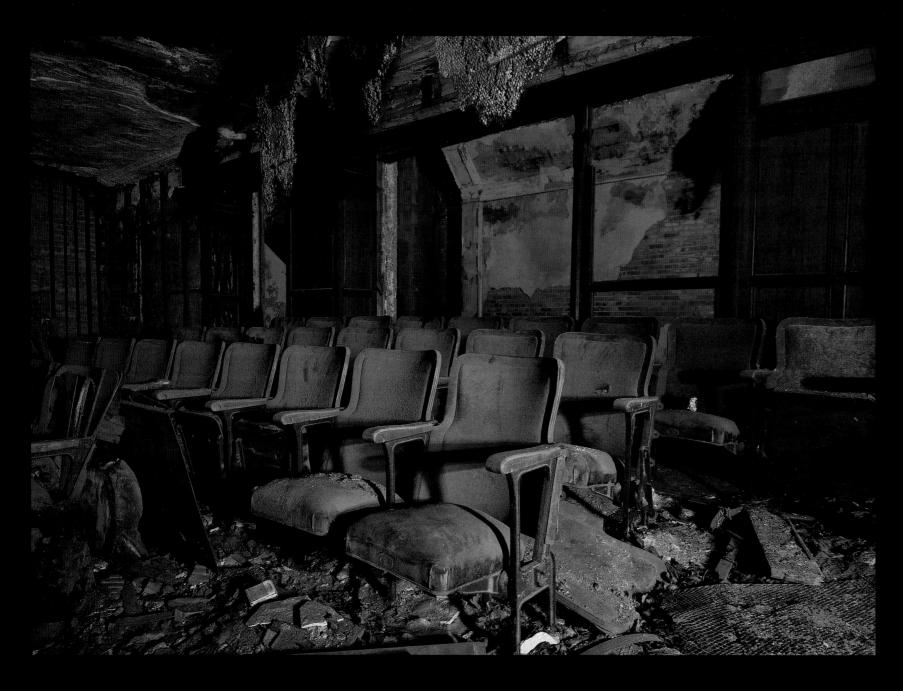

AND FORGIVE US OUR TRESPASSES...
ABANDONED METHODIST CHURCH
GARY, INDIANA . OCT 08

Built in 1926, the First Methodist Church in Gary was designed not only as a place of denominational worship, but also as a gathering place for the entire community — complete with a theater, gymnasium, office space, and even retail store frontage. It served the town until the mid-1970s, when a diminishing population made it impractical for the church to maintain the building. In 1975, it was sold to Indiana University, which never found a purpose for it.

Eventually, the old church saw limited use as a dance center and halfway house, but later fell into abandonment and decay; a sad end for such a glorious piece of architecture.

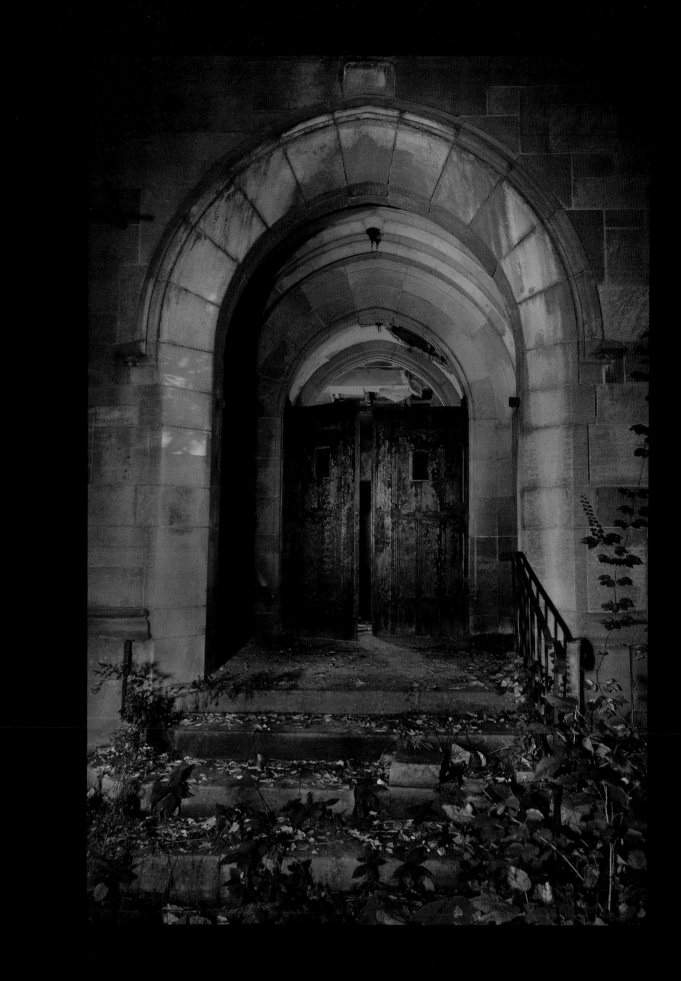

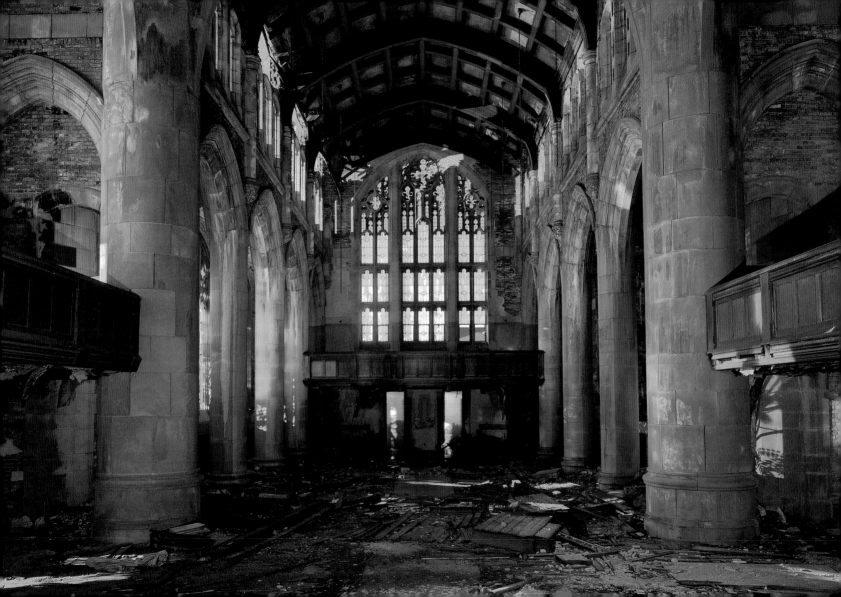

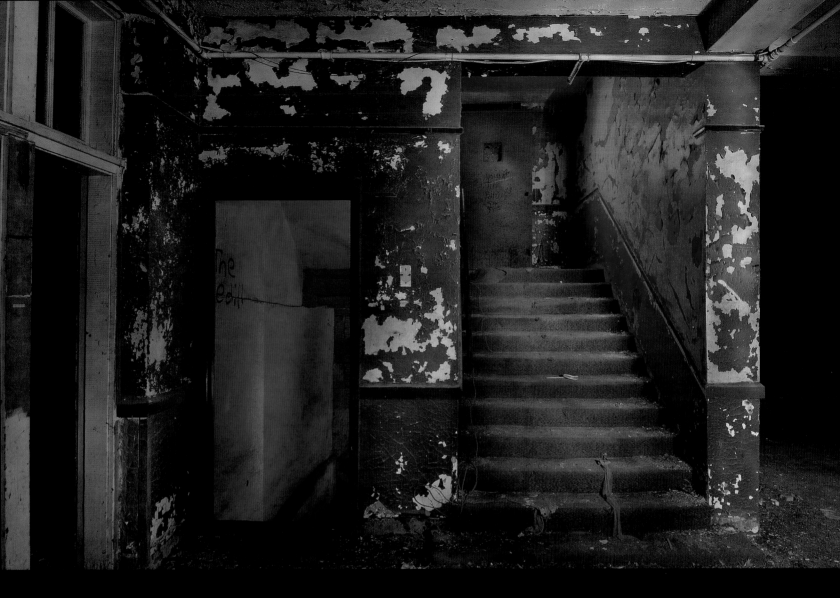

The original Stamford Inn was built in 1900 in a small town of the same name about fifty miles north of Abilene. On Christmas Eve in 1924, a fire broke out at the inn, and five people perished in the blaze — including a man known only as Ernest, who was trying to save others from the flames when the floor collapsed beneath him. His body was found in the basement, draped over the water heater.

The original structure was completely destroyed, and a new Stamford Inn was built shortly thereafter. When its life as a hotel ended, the building was reopened first as a nursing home, and later, as a private club. It's now been abandoned since the early 1980s.

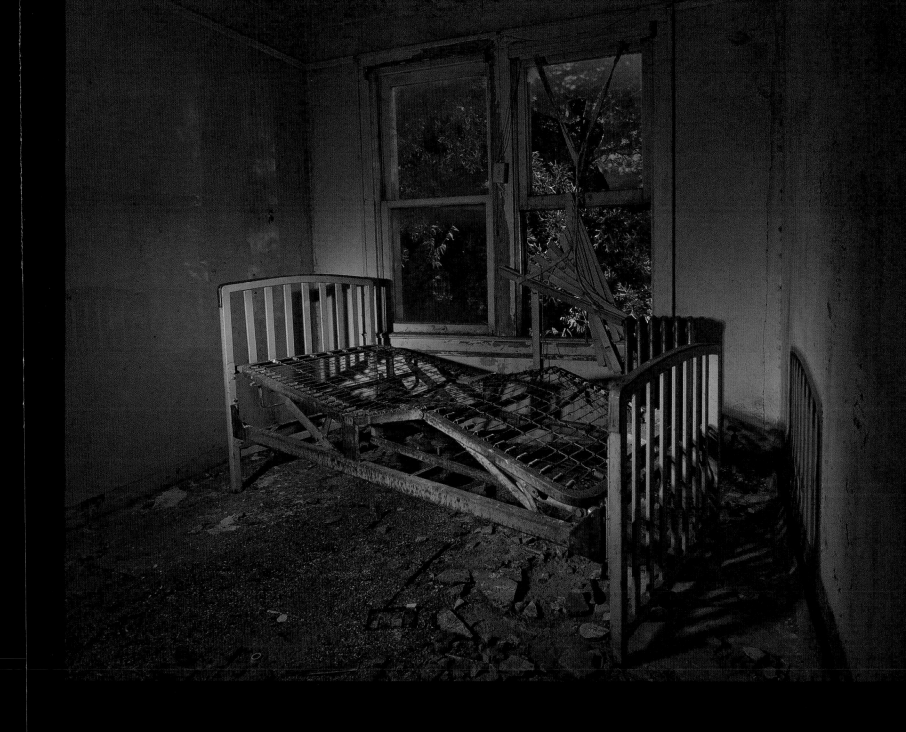

CRAFTMATIC
ABANDONED HOTEL
STAMFORD, TEXAS SEP 20

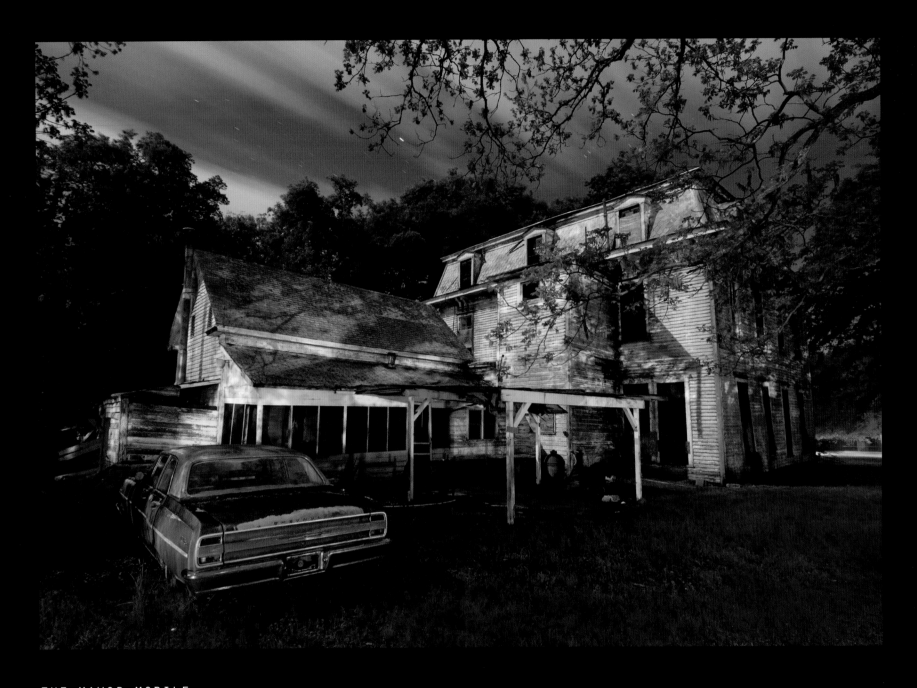

THE MAYOR-MOBILE
ABANDONED MANSION
PARIS, TEXAS . APR 12

Northeast elevation of the now abandoned former
mayor's mansion in Paris, Texas, complete with a 1963
Chevy Malibu sinking into the dirt out back. Fact
is, I have no idea whether the Chevy belonged to the
Mayor or not...but it made for a clever title.

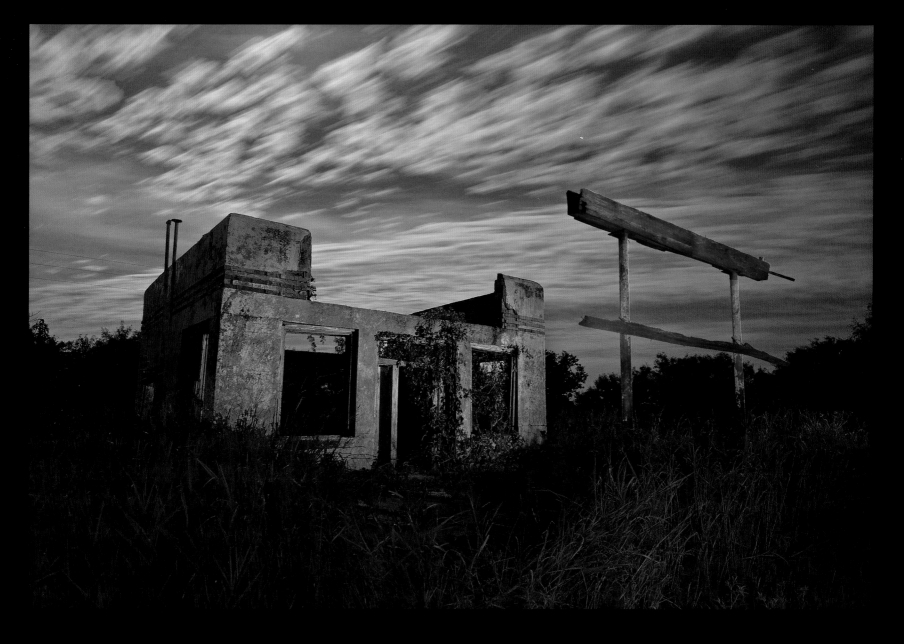

When I initially shot this ruined little building
a few miles east of the town of Palo Pinto, Texas,
I assumed it to be an abandoned gas station. But a
friend who shot there a few months later encountered
the property owner, who told him that, in fact, it
had been a Trailways bus station.

Whatever the purpose, I was fortunate to have visited
this decaying old structure on an evening when some
nice clouds were moving slowly across the sky, adding
a measure of drama to the scene.

TORII
ABANDONED BUS STATION
PALO PINTO COUNTY, TEXAS . AUG 08

SERVICE
MOVIE SET
LAKE LOS ANGELES, CALIFORNIA . JUN 11

The Four Aces is a purpose-built movie set located in
the high desert near the curiously-named community of
Lake Los Angeles - curious because it's not in Los
Angeles, and the largest body of liquid anywhere near
it is in your car's cup holder as you motor past

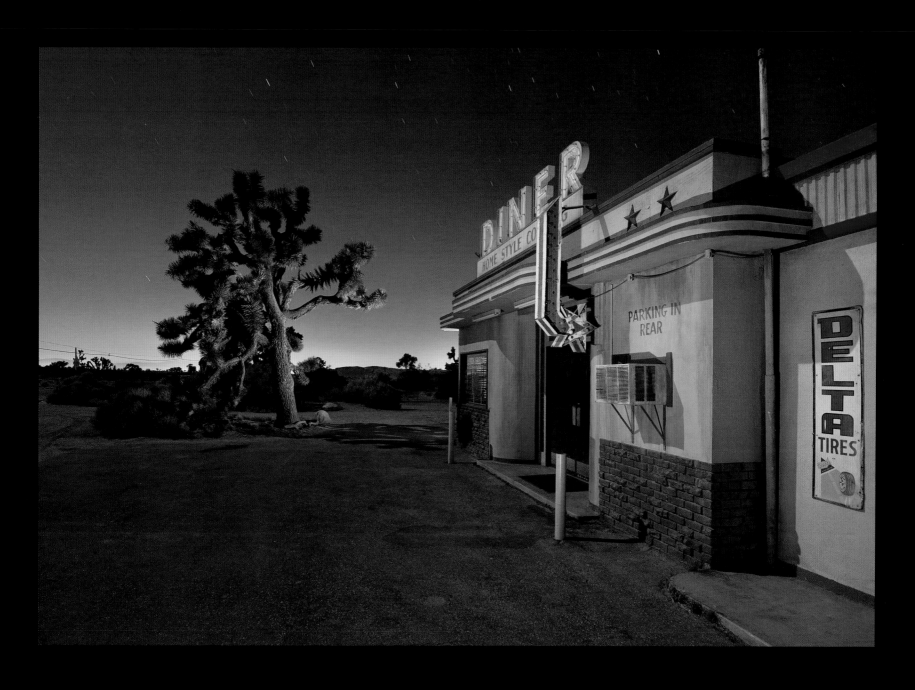

DINER
MOVIE SET
LAKE LOS ANGELES, CALIFORNIA . JUN 11

CLUBHOUSE
CONDEMNED APARTMENT COMPLEX
HURST, TEXAS . JUN 09

Wandering through this abandoned apartment complex in Hurst, Texas, was a bizarre experience. Many of the units were still strewn with clothes, electronics, packages of food, even photo albums and other personal effects – but all had been thoroughly ransacked by vandals, leaving virtually nothing of value behind.

It's enough to drive even the most innocent of castaways to drink...

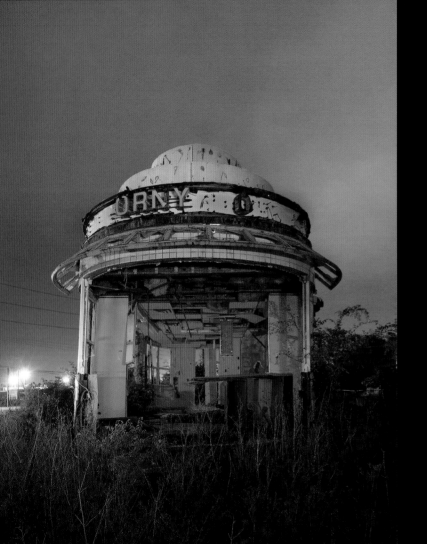

_ORNY?
ABANDONED HOT DOG STAND
SHREVEPORT, LOUISIANA . MAY 08

Ditched in a field near a railyard in Shreveport, this old hotdog stand is slowly being overtaken by shrubs and weeds.

I've often wondered where this little stand was originally located, and what it looked like in operation. An internet search reveals many other photos of it – but all taken right here in this field.

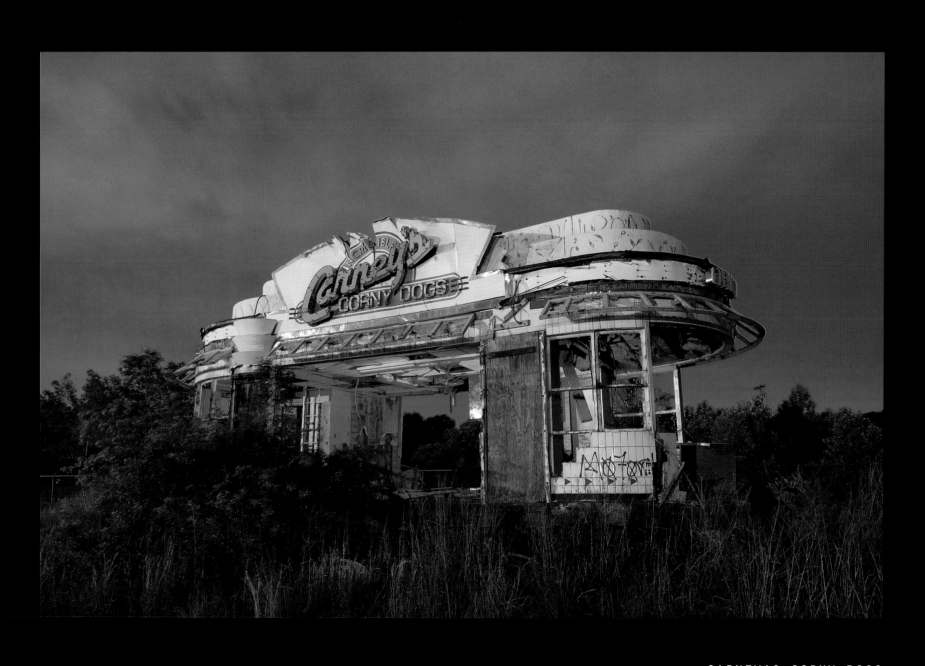

CARNEY'S CORNY DOGS
ABANDONED HOT DOG STAND
SHREVEPORT, LOUISIANA . MAY 08

XS DK
ABANDONED RETIREMENT HOME & ORPHANAGE
SHERMAN, TEXAS . JUN 08

This retirement home and orphanage was built in 1929 by the Woodmen's Circle, a fraternal organization and life insurance company founded in the late 1800s. The home operated until about 1970, when financial problems closed it down and the property was abandoned.

Today it's little more than a gutted and rotting shell, sitting on its little hilltop out on the west side of town.

THE FORGOTTEN HOME
ABANDONED RETIREMENT HOME & ORPHANAGE
SHERMAN, TEXAS . JUN 08

MURAL
ABANDONED RETIREMENT HOME & ORPHANAGE
SHERMAN, TEXAS . JUN 08

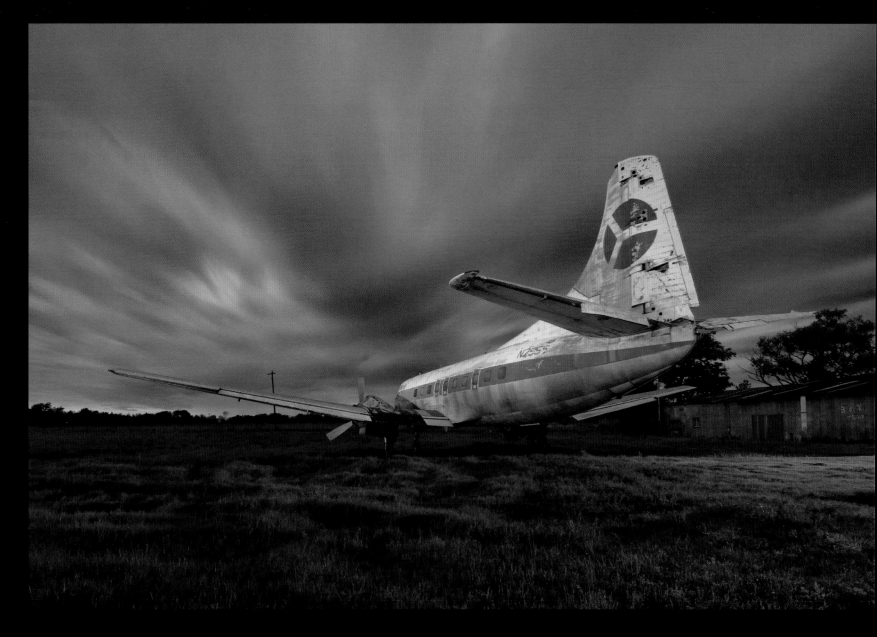

This is an abandoned Martin 404 passenger plane, parked in a field off state highway 82 near Paris, Texas.

Built in 1952, this particular aircraft (tail number N255S) flew under at least three different airlines, including Air South, which was acquired by Florida Airlines in 1975. Florida Airlines itself was then a victim of the Airline Deregulation Act of 1978, and no longer able to compete with the majors. In 1982, Florida Airlines ceased operations. N255S then wandered around through several other assignments until 2000, when the FAA grounded her last carrier,

Pro-Air, for regulatory violations, thus ending her nearly 50-year flying career. Now she just sits gathering dust and rust, awaiting the scrapyard truck that will surely come for her one day.

The property on which this aircraft is parked is the site of the now defunct Flying Tiger Airport & Flight Museum, which was home to many retired military warbirds several years ago, but today, all you'll find on the grounds is this decaying airliner, a crippled old Piper Cub, and a few scavenged Cessna fuselages discarded out back in the weeds.

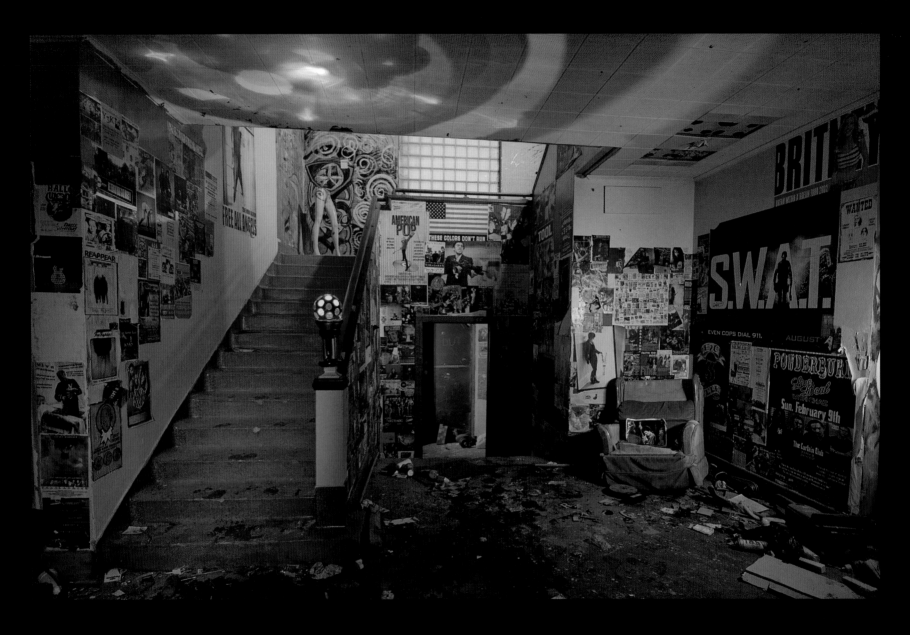

When I heard about this building, my first thought was that it sounded like a place I had visited to work with a local band once, some years earlier (I'm a musician when I'm not being a photographer). Sure enough, this was it — a former office building in a very rough industrial neighborhood, remade into a series of rehearsal spaces for area musicians. It was strange to see a familiar place like this so dark, empty, and trashed. The basement was partially flooded, and appeared to serve as an occasional base camp for the area's homeless. Left behind when the musical entrepreneurs moved on was quite an array of castoffs – among them a tacky guitar-shaped clock, an empty bass drum case, and the stylishly-shod mannequin that posed for me at the top of the stairs. It was a fascinating place to explore.

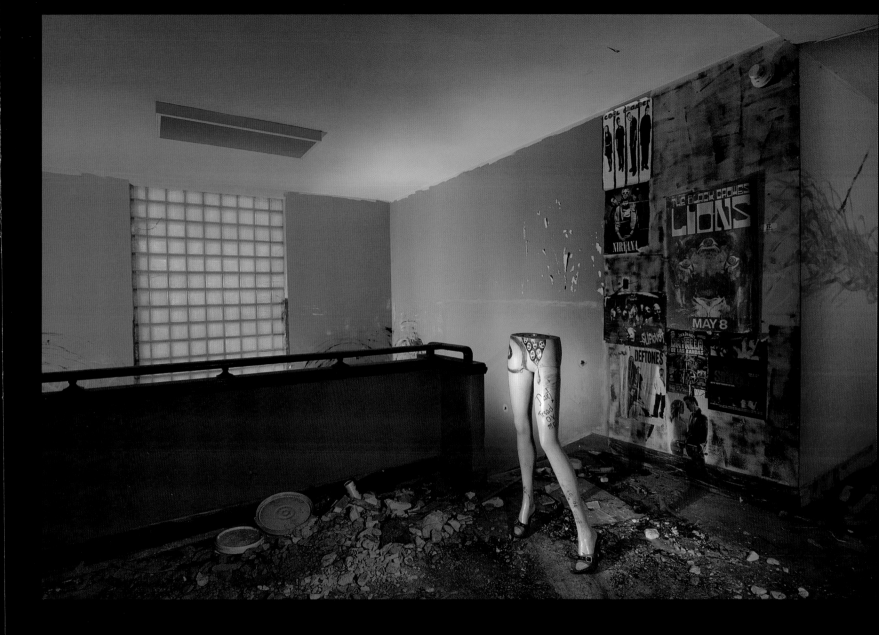

RGB 5.0
ABANDONED BAND REHEARSAL HALL
DALLAS, TEXAS . MAR 08

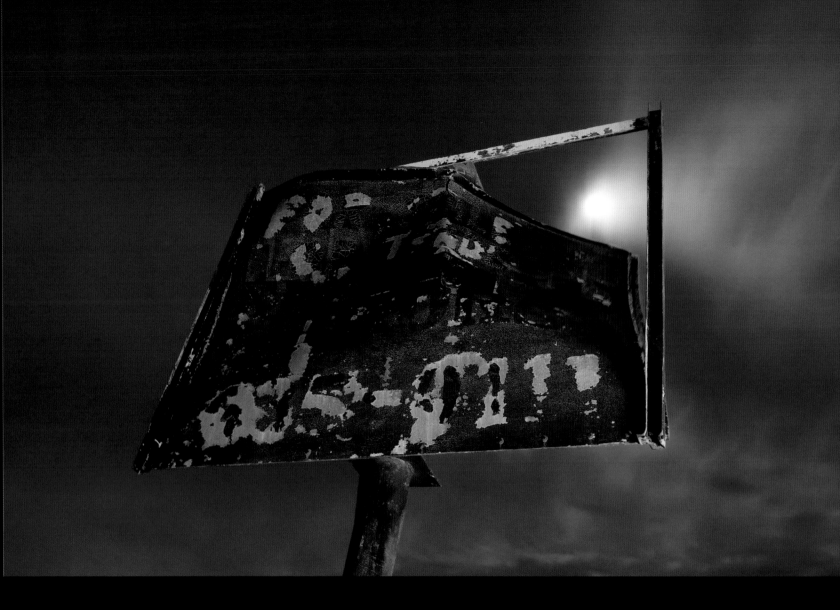

Like Prada Marfa, the little object on the facing page is not quite what most people imagine it to be when they see it on the side of the road near the town of Munson, Texas.

What appears to be a UFO touching down on the North Texas plains is actually a pre-fabricated "Futuro" house, one of only a hundred ever built by a Finland-based company in the late 1960s and early '70s. This deteriorating example once served as a sales office for the used-car dealership whose ragged roadside sign is pictured above.

With its tiny bath and kitchen, the Futuro was a complete home... albeit an incredibly cramped one. Sadly, this particular Futuro has fallen victim to heavy vandalism since I shot it in 2008. It would have been nice to see it restored and cared for; just fifty Futuros are known to survive worldwide, and only a handful have been preserved as the unique cultural artifacts they are.

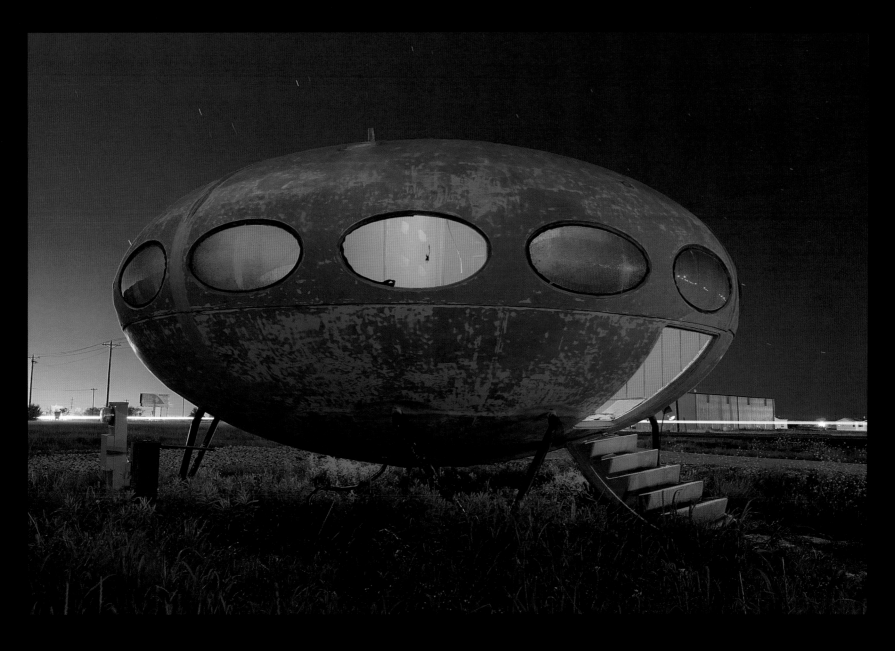

CLOSE ENCOUNTER
ABANDONED FUTURO HOUSE
MUNSON, TEXAS . APR 08

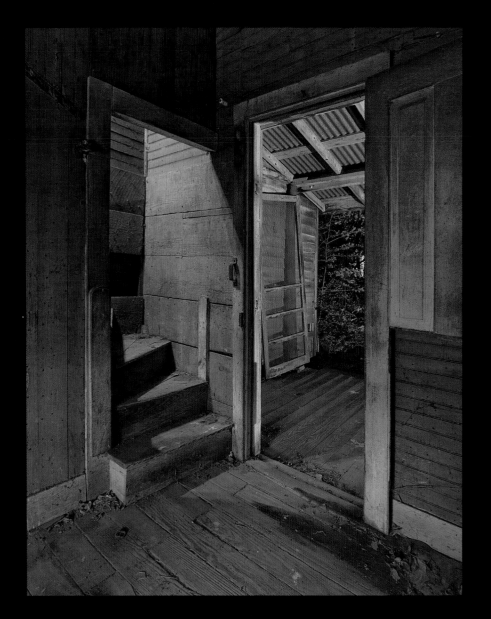

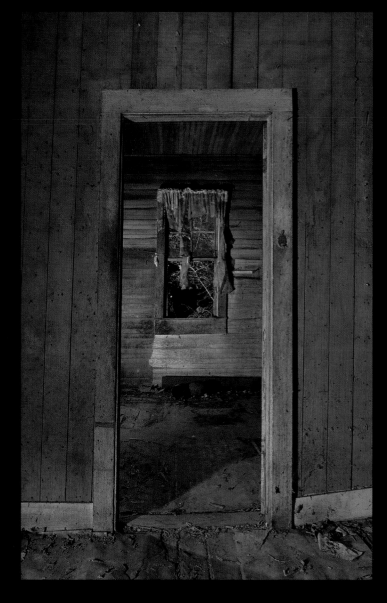

This beautiful little abandoned house in the whimsically-named town of Poetry, Texas, was the scene of one of the more disturbing adventures I've had while photographing abandoned locations.

I had shot the house once before, and had become familiar with the layout both upstairs and down. I'd been up to the attic and knew that its floor was generally sound and free of obstacles, so in preparation for executing the lighting for the shot at left, I merely glanced around the corner of the stairs to make sure nothing new was in the way — necessary because, once I opened the shutter, I would have to climb the stairs in total darkness to fire my strobe.

The stairwell is tiny: you have to duck to enter, and once you're inside, you have about two inches of clearance on either side of your shoulders. The turn is sharp, the ascent is steep, and there's another turn at the top.

When I shined my flashlight up the stairway, everything looked fine, so I killed the light, returned to the camera, and opened the shutter. Then I felt my way over to the stairs and started up, ready to fire off the strobe that would light the stairway for the shot.

As I neared the upper landing, a sudden, frantic racket burst from the darkness just above me. Someone or something was panicked by my approach — and whatever

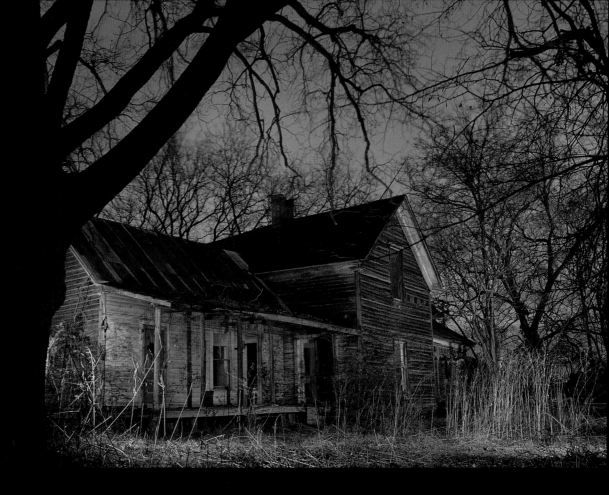

POETRY HOUSE
ABANDONED HOUSE
POETRY, TEXAS . FEB 09

it was, I realized, its most likely avenue of escape was right down the very stairs I was standing on.

In that claustrophobic, pitch-dark stairwell, I spun around and tore down those steps with the speed of the truly motivated. I got out of the path to the back door and quickly switched on a flashlight — but nothing had followed me down the stairs.

I watched and waited for about five minutes, but there was no further commotion. So of course, in classic horror-movie tradition, I decided to check out the attic.

Up the stairs I crept, flashlight in hand, and this time, I reached the attic without incident. But I found no person, no animal, no sign of anything out of the ordinary.

So I continued with my shoot, and two exposures later, produced the staircase shot on the previous spread. I still have no idea what was up there.

But it sounded huge.

Sadly, the Poetry house fell victim to arson in the fall of 2009 and was completely destroyed in the fire.

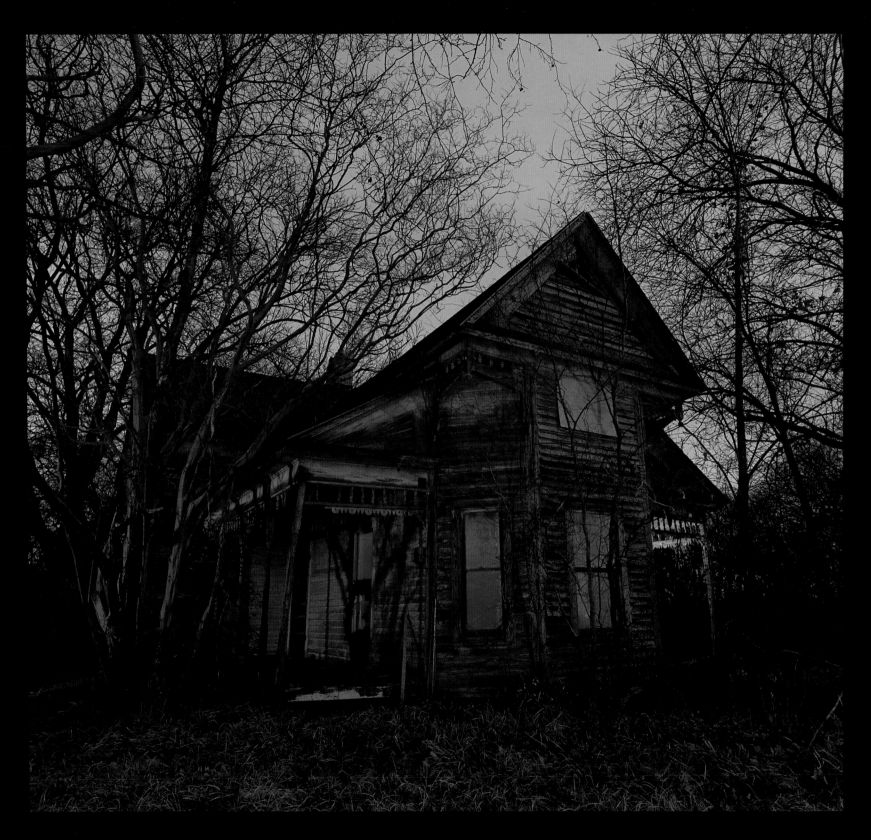

POETRY HOUSE

DOMESTIC DISTURBANCE
CONDEMNED NEIGHBORHOOD
EL PASO, TEXAS . JAN 08

In old central El Paso stands a small neighborhood of 1950s vintage — rows and rows of neat little houses with postage-stamp yards, all abandoned. The neighborhood's architectural style and proximity to Fort Bliss suggest that it may originally have been one of many post-war military housing developments.

In 2006, the city experienced what was regarded as a 50-year storm, causing the Rio Grande to rise nearly nine feet, flooding this little neighborhood.

By the time I took these images in 2008, the development was already slated for demolition, and a year later, it had been razed.

Some years after the Civil War, former Confederate Major Eugene Van Patten headed West and built a unique desert resort high in the Organ mountains of New Mexico.

With stunning wild vistas, fourteen rooms of native stone, and a dining hall supplied by its own vegetable gardens, the Van Patten Mountain Camp became a popular retreat in spite of its remote location 17 miles east and 2000 feet up from Las Cruces.

Early guests arrived by stagecoach, and the coach station house (above) is one of the few structures still intact. Among Van Patten's guests were some of the most famous people of the period, including Mexican revolutionary Pancho Villa and Sheriff Pat Garrett, the man who shot Billy the Kid.

In 1915, financial difficulties forced Van Patten to sell the camp to an Illinois doctor who operated it as a tuberculosis sanatorium — with his beloved wife as his first patient.

Now abandoned for over six decades, the camp's stone-and-mud-plaster buildings are slowly returning to the earth.

DRIPPING GREEN
VAN PATTEN MOUNTAIN CAMP RUINS
ORGAN MOUNTAINS, SOUTHERN NEW MEXICO . JAN 08

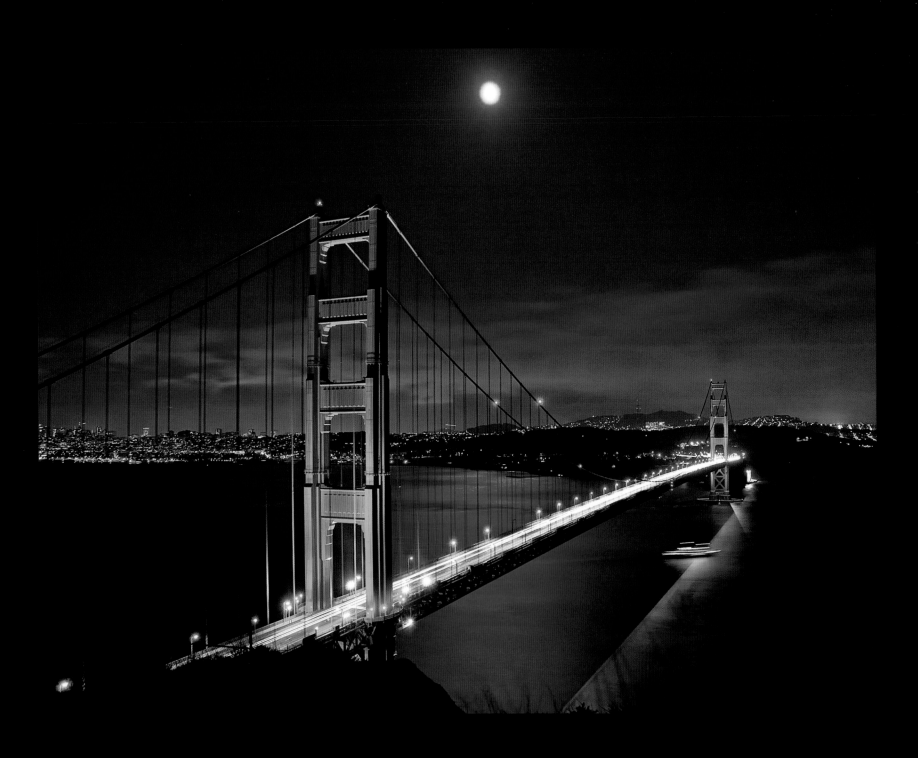

BLUE MOON AT THE GOLDEN GATE
THE GOLDEN GATE BRIDGE
SAN FRANCISCO, CALIFORNIA . AUG 07

The Golden Gate is so well-known and so frequently
photographed as to be almost a cliché — but I wasn't
going to let that stop me. During my first shooting
trip to San Francisco, I found myself drawn back
nearly every night to the Marin Headlands in search

of another new vantage point from which to photograph
this amazing triumph of engineering and architecture.
The headlands is one of the most peaceful and beautiful
places I've ever been... especially at 2:30 in the
morning.

THE GOLDEN GATE IN FOG FROM HAWK HILL
THE GOLDEN GATE BRIDGE
SAN FRANCISCO, CALIFORNIA . AUG 07

OCEAN BLUE
SEAL ROCKS
SAN FRANCISCO, CALIFORNIA . AUG 07

One of my first light-painting excursions was here
among the ruins of an extraordinary public bathhouse
built in the early days of San Francisco. It was a
million-dollar project in a time when that was an
unimaginable sum.

The Sutro Baths opened in 1896 with a museum of
souvenirs from the owner's travels, an 8,000-seat
concert hall, and five hundred private dressing rooms.
Supported by massive Ionic columns, Sutro's vast
greenhouse-like structure sheltered multiple swimming
pools filled by the ocean tides.

STAIRWAY TO NOWHERE
SUTRO BATH RUINS
SAN FRANCISCO, CALIFORNIA . AUG 07

Though thousands flocked to the baths, operating costs eventually became overwhelming. Over the decades, the site was adapted to other, less costly uses... but there on the windswept coast, rusted by salt spray and battered by storms, the structure of the complex inevitably weakened and was finally condemned.

Ironically, during demolition in 1966, this building meant to celebrate the ocean was destroyed by fire.

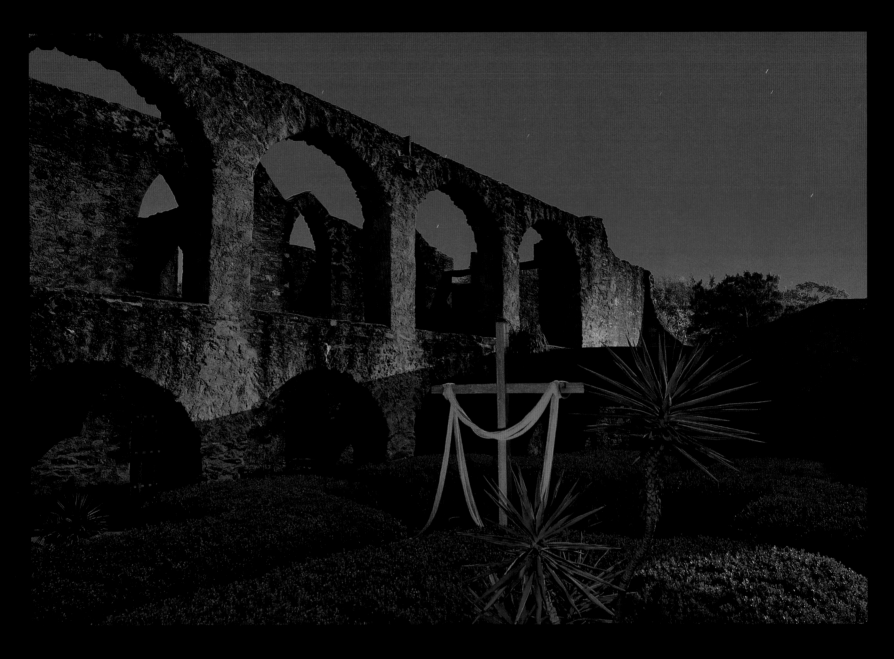

...FOR THIS IS MY BLOOD
MISSION SAN JOSE
SAN ANTONIO, TEXAS . APR 08

One of several old missions located in the city of San Antonio, Mission San Jose doesn't attract as many visitors as its more famous counterpart, the nearby Alamo, but it is arguably the most beautiful and best-preserved of the group.

The architecture of many of these old Spanish missions has a timeless quality - these walls could be a thousand years old, instead of merely hundreds.

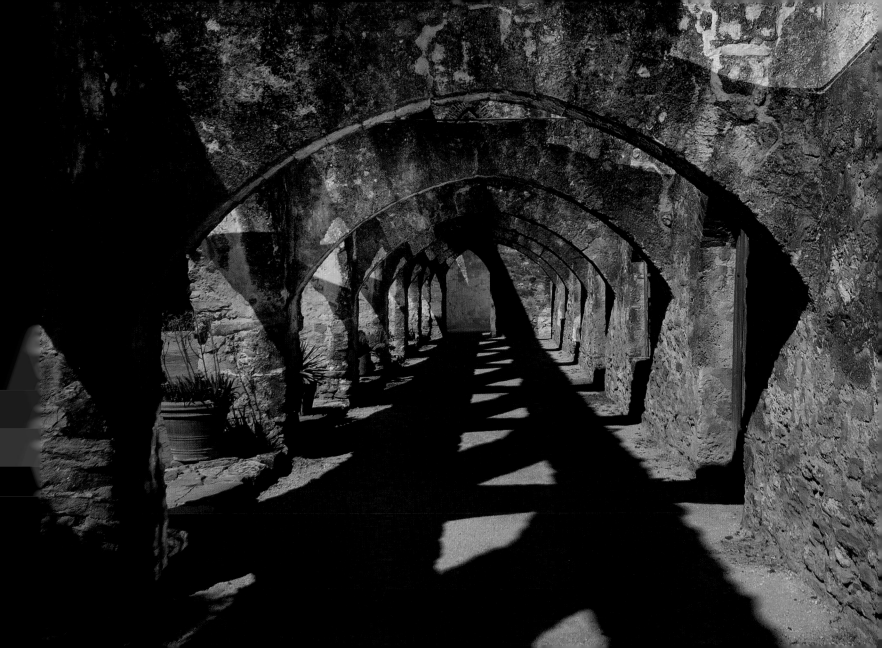

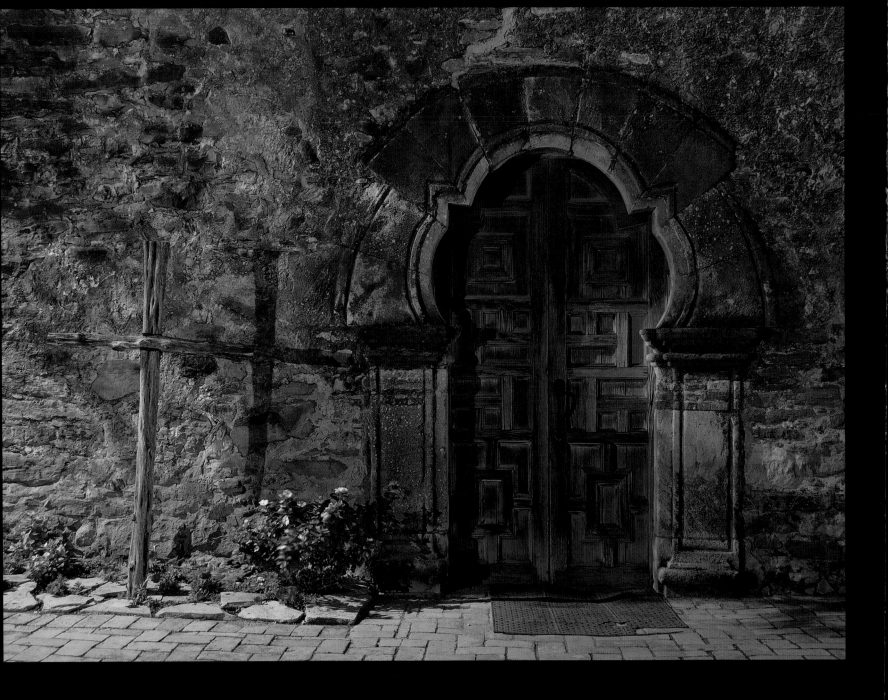

THE DOOR
MISSION ESPADA
SAN ANTONIO, TEXAS . APR 08

Built by Franciscan missionaries in 1731, this beautiful church was a reincarnation of the first mission ever established in what would eventually become the state of Texas. Now an historic landmark, the mission still serves the faithful of its community.

As a light-painter, I'm happiest when there's little or no ambient light on a scene — even the moon can be a hindrance at times. But when a great subject is

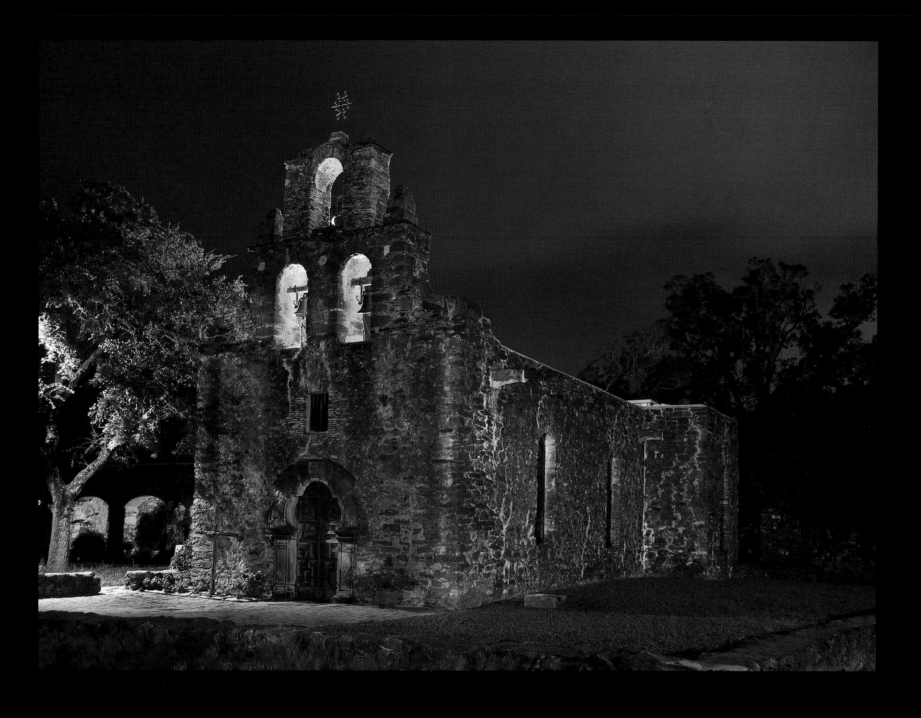

contaminated by lightspill that I can't avoid, I take it as a challenge and try to work around it.

At this historic mission in San Antonio, the challenge was complicated by three different types and "temperatures" of light: sodium vapor, mercury vapor, and tungsten. I painted the ornate cross at the top with a natural, ungelled spot, but the rest of the light effects here are strictly ambient.

MISSION ACCOMPLISHED
MISSION ESPADA
SAN ANTONIO, TEXAS . APR 08

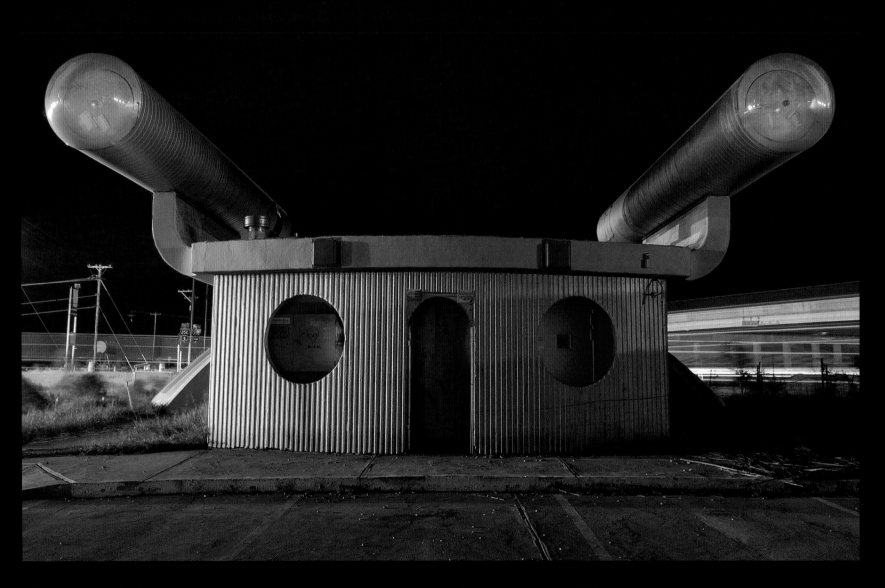

STARSHIP PEGASUS
ABANDONED TOURIST ATTRACTION
ITALY, TEXAS . OCT 07

Opened around 2004, the Starship Pegasus was a space-themed miniature golf course, arcade, and restaurant near the I-35 access road in the tiny central Texas town of Italy. Modeled after the original Enterprise from "Star Trek," the traffic-stopping structure was Phase One of an ambitious master plan that would have included an adjacent "College of Space Exploration"... if the venture had succeeded.

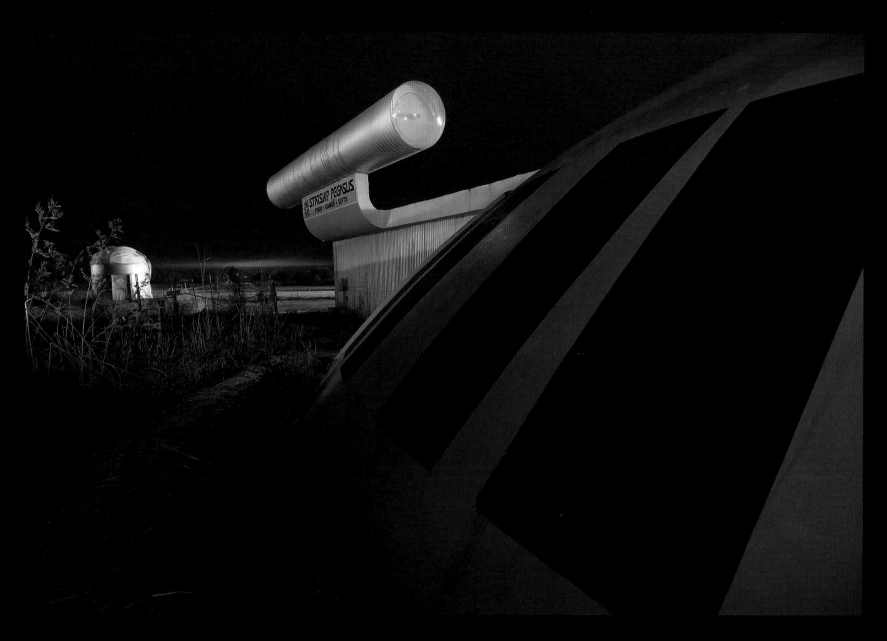

STARSHIP
ABANDONED TOURIST ATTRACTION
ITALY, TEXAS . OCT 07

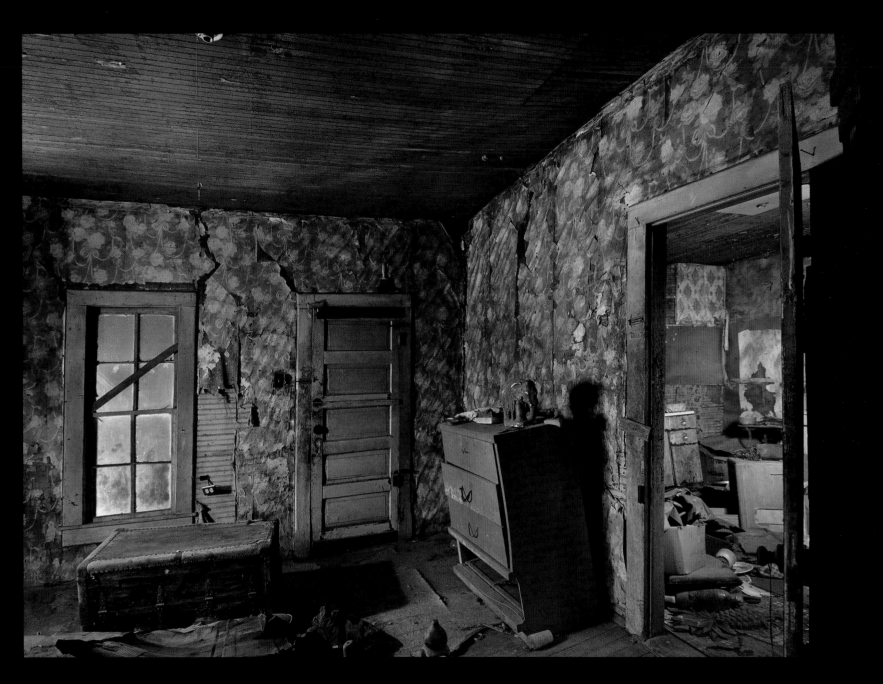

HOME SWEET HOME
ABANDONED FARMHOUSE
ROYSE CITY, TEXAS . MAY 11

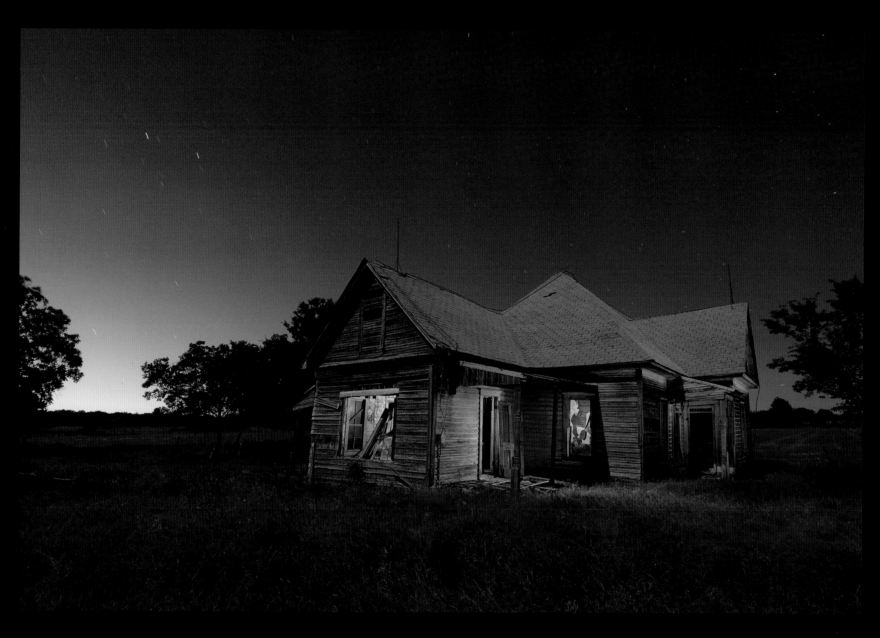

NIGHT FARM
ABANDONED FARMHOUSE
ROYSE CITY, TEXAS . MAY 11

Rock-A-Hoola! The best waterpark name in history, hands down.

Considered America's first waterpark, Rock-A-Hoola opened northeast of Barstow in 1962, an oasis for families driving through the Mojave Desert. In its convenient location on the road to Las Vegas, Rock-A-Hoola was "The Fun Spot of the Desert," with a man-made lake, a campground, and various rides and attractions.

Though they look like Japanese toriis, the imposing structures at right were actually support standards for The Big Bopper, a giant eight-lane waterslide that was billed at the time as the world's largest. It served as Rock-A-Hoola's main attraction until dwindling attendance in the 1980s led to the park's closure and sale.

After being sold in 1990, the park was refitted and reopened twice over the years, but finally shut down permanently in 2004.

In a 1998 promotional spot, Rock-A-Hoola looks like a whole lot of fun — it's a shame no one's been able to make a go of the park since the original owners sold it.

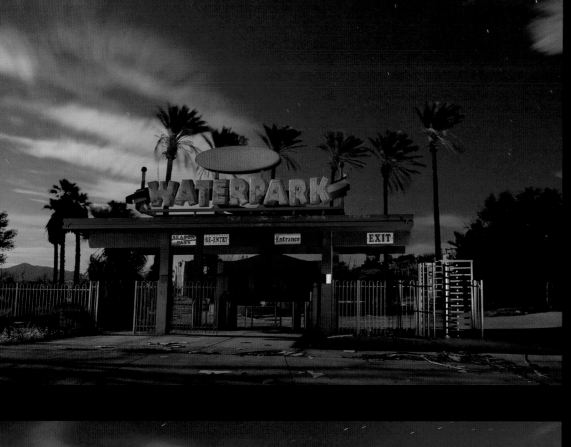

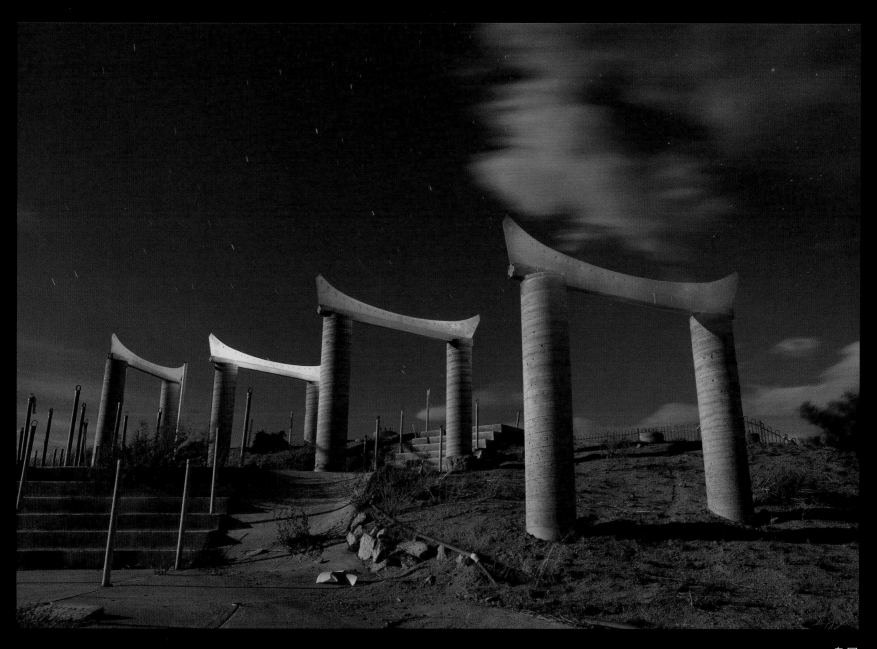

鳥居
ABANDONED WATER PARK
MOJAVE DESERT, CALIFORNIA . JUN 11

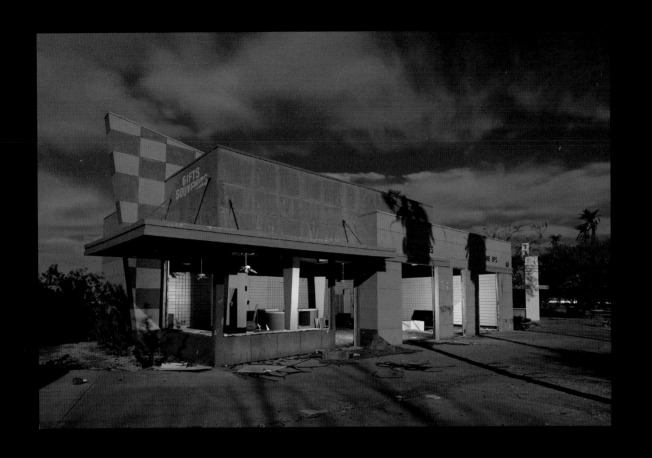

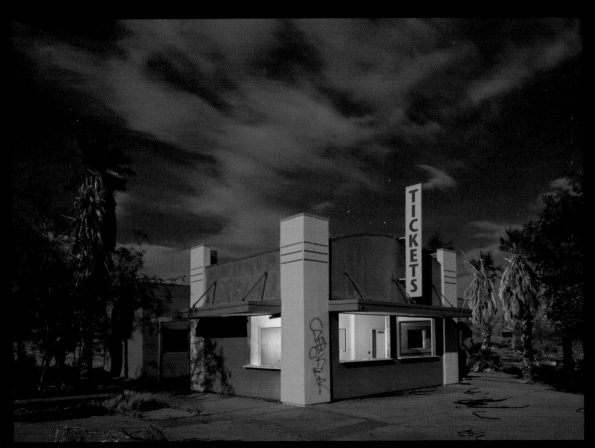

Above the dying Salton Sea in far southern California, an empty trailer sits mired in mud, and a slightly used his-and-hers La-Z-Boy perches atop a dune.

Situated below sea level and directly on top of the San Andreas Fault, Salton is the largest lake in California, and it was once the site of many lakeside homes and businesses. But in the 1970s, a flood forced residents to evacuate, leaving homes and vehicles half-buried in mud and debris. That started the decline.

At 227 feet below sea level, the Salton Sea has no outflow. Everything that makes its way into the sea via streams and runoff — pesticides, fertilizers, heavy metals, sewage — stays there. And ever since a controversial 2003 water deal drastically reduced the flow of the Colorado River to the area, contaminants in the Salton Sea have steadily grown more concentrated.

Among the many consequences of this is the ever-increasing salinity of the Salton Sea, which makes its water inhospitable to life. The sea's "beach" is a sulfurous sludge of sand, salt, and dead fish decaying underfoot, impossible to avoid when walking. And although the water looks blue from a distance, that's only a reflection of the sky: its actual color is a dark, murky yellow.

Yet some 450 people live on the shores of this environmental disaster. They're a breed apart, steadfastly unconvinced of any danger and dedicated to their way of life in this bizarre wasteland.

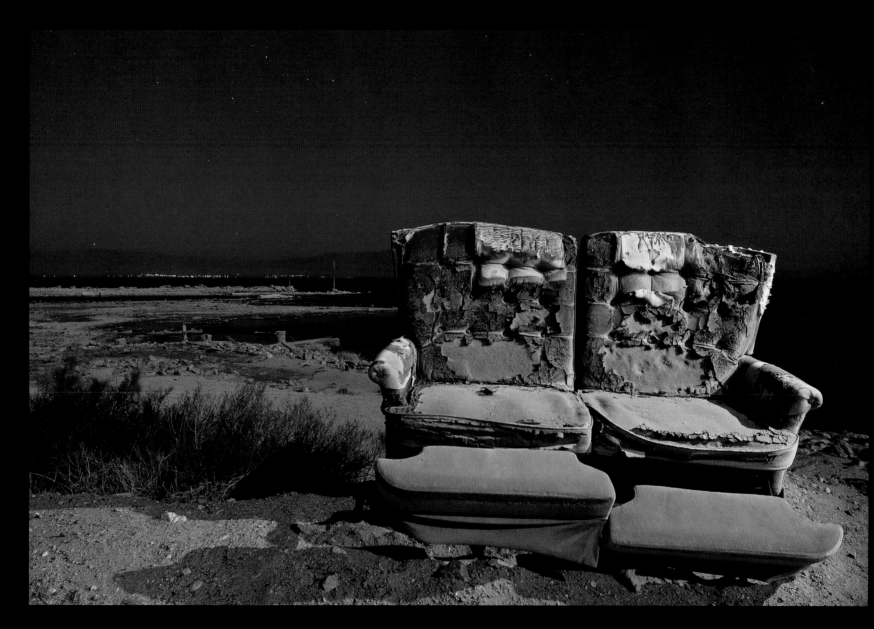

SALTON SEATING
SALTON SEA
JUNE 11

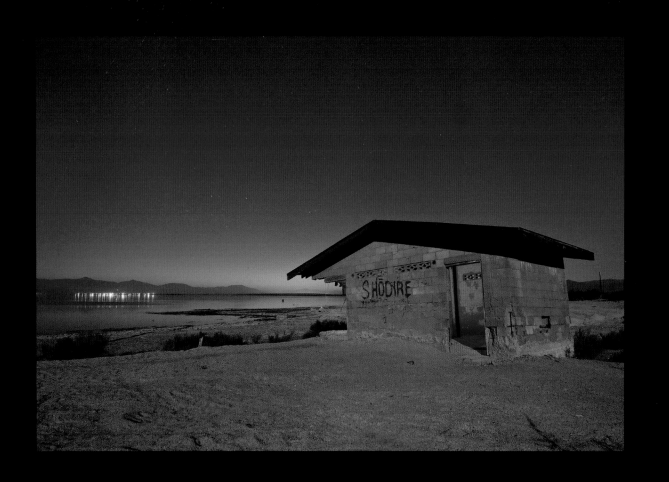

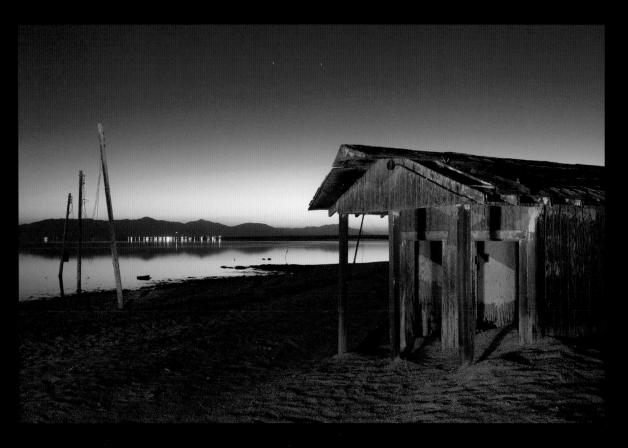

NORTH SHORE
ABANDONED MARINA
SALTON SEA . JUN 11

Abandoned buildings tip drunkenly in Salton's unstable soil, and the sea's hypersalinity is evident in the gritty crust of salt on every surface.

At left, the sand slowly swamps an old public restroom — except it's not just sand. Look closely, and you can see some of the more recently deceased fish mixed in.

The Salton Sea is an ongoing disaster, a cautionary tale for a nation struggling to protect its land, its water, and its people from environmental hazards. But in spite of its appalling condition... there is still beauty to be found.

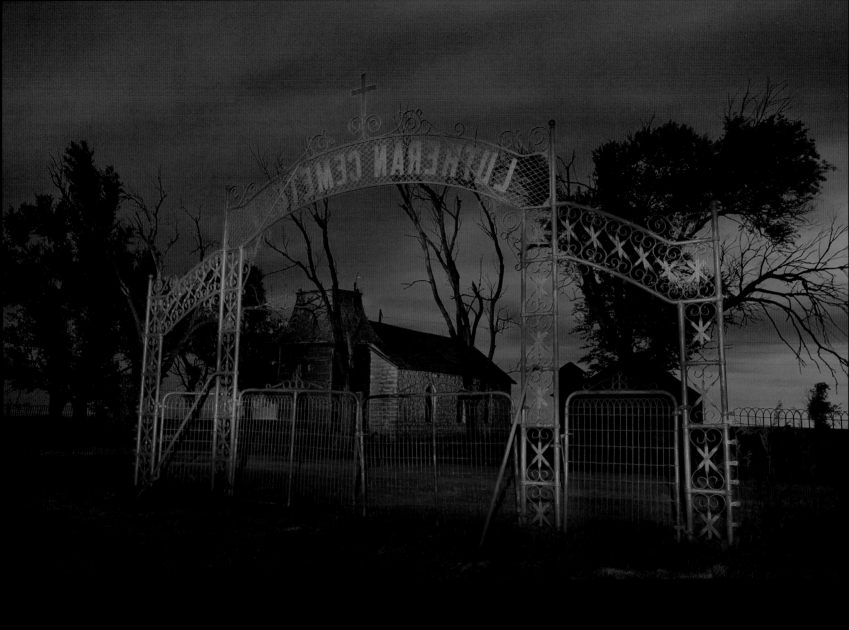

After a long ordeal of driving, shooting, and getting run off far too early from the first two locations of the evening, I finally found my way to this compelling location in Barton County, Kansas.

This abandoned Lutheran church and school, as well as the associated cemetery across the way, must surely

Although the interiors of both buildings are gutted, their basic structures are remarkably stable, having been built in a time when things were made to last.

Oh, and the title? It's the little guy on the corner of the fence post in the picture at right, just to the left of the wooden church entry.

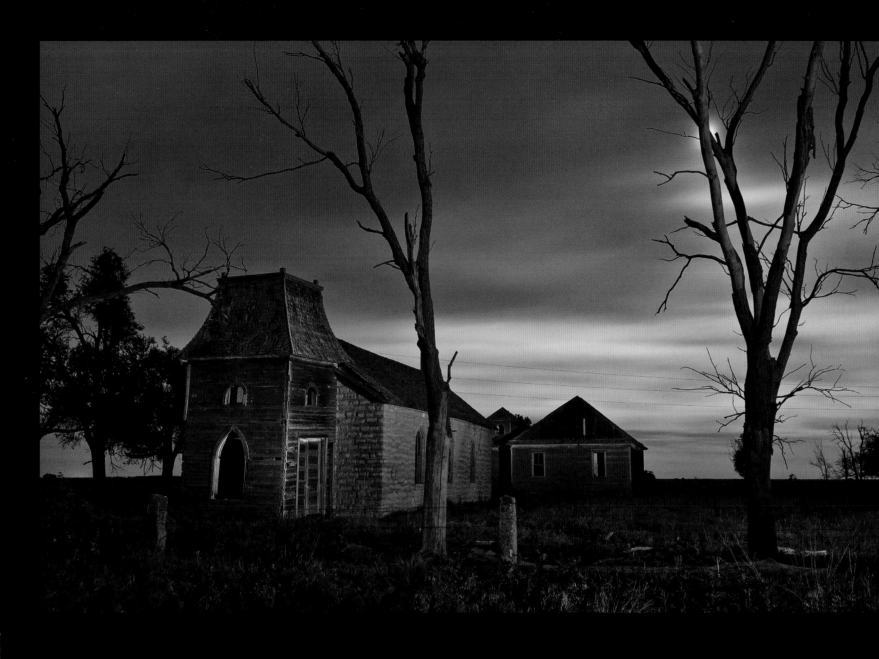

FIREFLY

ABANDONED CHURCH & SCHOOLHOUSE

REMOTE NORTH CENTRAL KANSAS . JUL 09

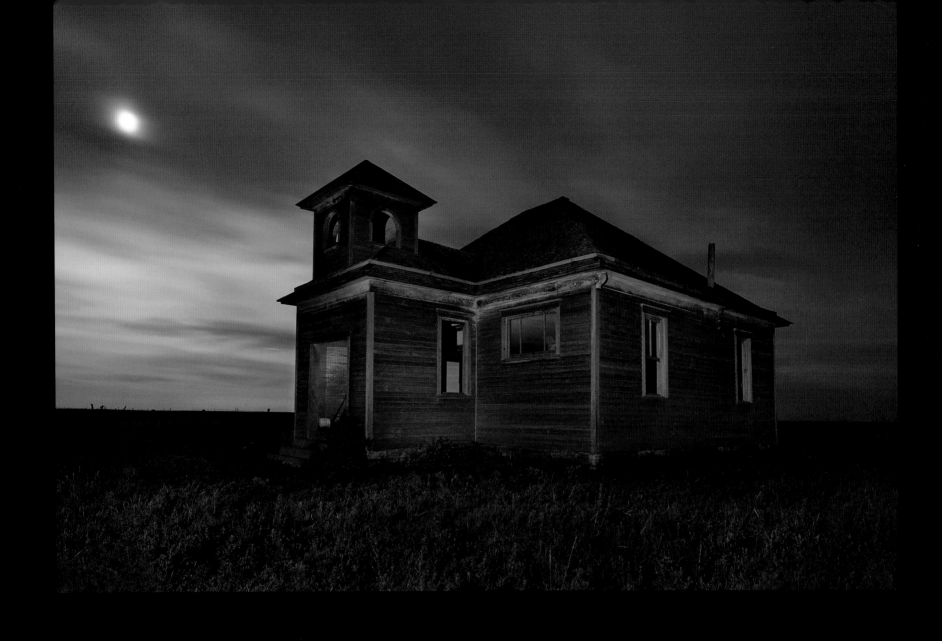

ONE-ROOM
ABANDONED SCHOOLHOUSE
REMOTE NORTH CENTRAL KANSAS . JUL 09

CEDAR POINT SCHOOL
ABANDONED SCHOOLHOUSE
CEDAR POINT, KANSAS
JUL 09

Throughout the Kansas
countryside, I've found
abandoned schoolhouses
of every style and
construction method, some
as recent as the 1940s,
some much older. But
whatever its age or style,
every schoolhouse has the
traditional school bell,
hung in a tiny belfry,
to call the children to
class.

POLLARD HOUSE
ABANDONED FARMHOUSE
NEAR LYONS, KANSAS . JUN 09

I learned of this old structure through research
and planned to make it the centerpiece of my trip
to Kansas. To my eye, it's iconic: the distinctive
Victorian architecture, the classic windmill, the
idyllic setting on a gentle rise... a perfectly
photogenic subject. I had grand ideas for several
different shots of this spectacular relic of the
Midwestern plains.

But just a few minutes after making this single test
exposure, my partner and I were run off the property
by a highly dedicated off-duty state trooper.

Having been summarily ejected from an abandoned
schoolhouse by its drunken owner earlier in the
evening, I was now pretty frustrated. But this single
shot, taken at 1:30 in the morning in an utterly
isolated spot in remote northern Kansas, was pretty
good consolation.

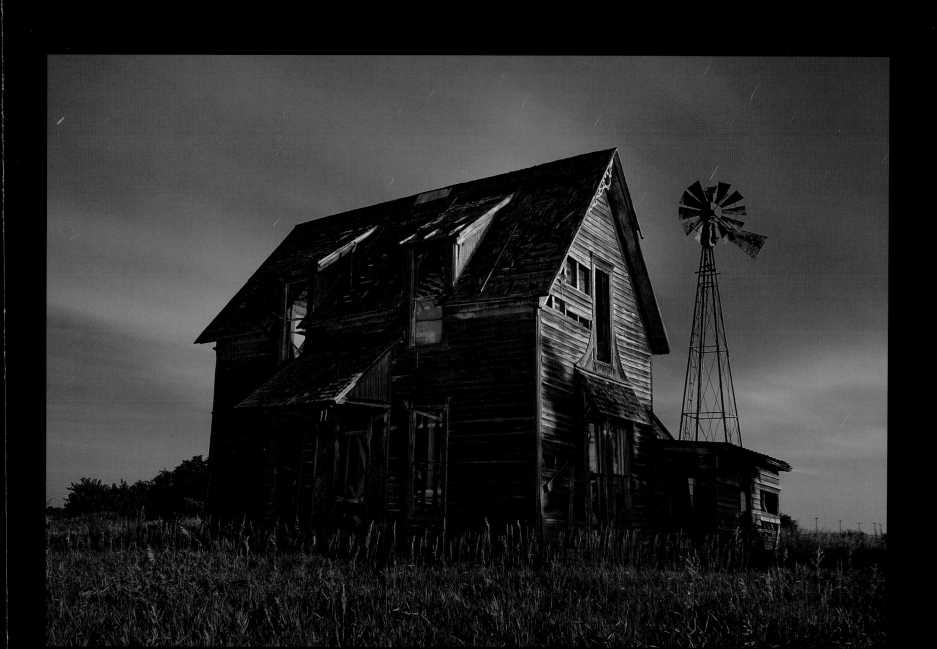

A WORD ON TOOLS & TECHNIQUES

When people look at my work for the first time, they're often somewhat perplexed by what they see. Lights and colors of unexplained origin, clouds streaking by at impossible speeds, bodies of water eerily frozen in time. The surreal nature of the images makes many people wonder how these visual effects are achieved. It therefore bears taking a moment to briefly overview the equipment and techniques I use to make these photographs.

All the photos in this book were taken with Digital SLRs. Prior to September 2008 I used a Nikon D80; from that point forward they were made with a Nikon D300. I use a good, solid tripod to hold the camera, a wireless remote release to open and close the shutter, and an ultra-wide-angle lens to provide the tableau-like perspective I usually try to capture with my compositions.

The exposure times for the images in this book vary from a fraction of a second to as long as ten minutes, with the vast majority falling in the range of one to three minutes. Because moonlight usually serves as the primary ambient light in my photographs, nearly all of these shots were taken on or near nights of the full moon.

The lighting effects in my photos are produced by the careful application of a variety of flashlights and photographic strobes, triggered manually, often with theatrical gels placed in front of the light source to create the color effects. These lighting effects are created in real-time, while the shutter is open - not after the fact in Photoshop or other post-production software. It is my general principle to manipulate the photos as little as possible, and to remain true to a conventional photographic process in every way I can.

What you see in my photos is an accurate portrayal of the scene that presented itself in the field. The only thing I add is light.

WEBSITES

www.noelkernsphotography.com
www.flickr.com/photos/nkerns

The book you're holding in your hands is the product of a great many things that went right for me, and I would be remiss if I didn't take a moment to express my gratitude to all the people whose love, sweat, creativity, generosity and vision conspired to make it possible.

Early on, I was fortunate to have had two schoolteachers whose knowledge of photography helped guide me along the path. Ms. Christi Gay taught me the basics of the black-and-white darkroom process. I doubt she even remembers, but what I learned from her primed me for my lifelong love affair with the medium. And through my high school years, Mr. George Edwards gave me a great education in both the technical craft and the artistic potential of photography. I am indebted to them both for the knowledge and artistic passion they shared with me.

When I made the transition into night photography, I encountered a community of urban-exploring night photographers whose work both captivated and inspired me. Folks like Amy Heiden, Andy Frazer, Basim Jaber, Bob Azzaro, Joe Reifer, Mike Hows, Jeff Morris, Mike Brown, Scott Haefner, Lance Keimig, and the grand poobah of urbex night photography, Troy Paiva. They took me in as one of their own, supporting and encouraging me as my work developed into what you see in this book today.

A shout-out is due to my part-time road trip and night-shooting companion, Chris Burt. Thanks for handling the lion's share of the driving so many times!

Of course, my family has been extremely supportive of all my endeavors over the years, including this one.

Many thanks to my mother, Dorothy Helen Kerns, for her unconditional love and support; to my sister and primary copy editor, Carol Marie Kerns, guilty on all the same counts as my mother; and of course my late father, Raymond Clyde Kerns, whose unexpected gift of a camera started me down the path that eventually led to this book. And finally, deep gratitude to my son, Grant Raymond Kerns, the brightest star in the sky of my life. Talk about your unconditional love...

Thanks, too, for the hard work put in by Gary Shove and the team at Carpet Bombing Culture to organize my photographs and stories into a cohesive, polished publication. Cheers, mates!

Finally, I wish to thank you – for allowing me to share my passion for the secret beauty in these forgotten places.

Sincerely,

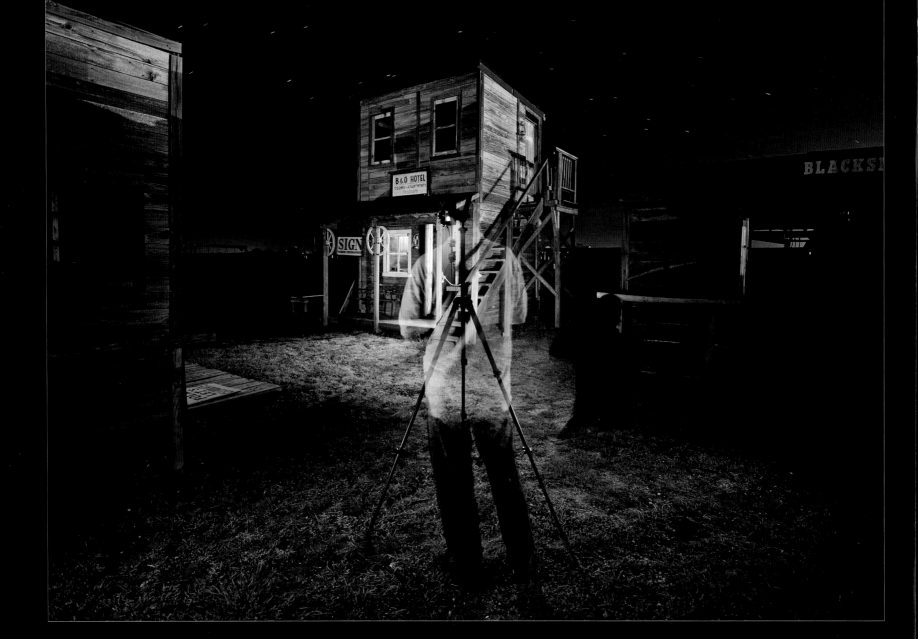